IMAGES
of America

SHELTON

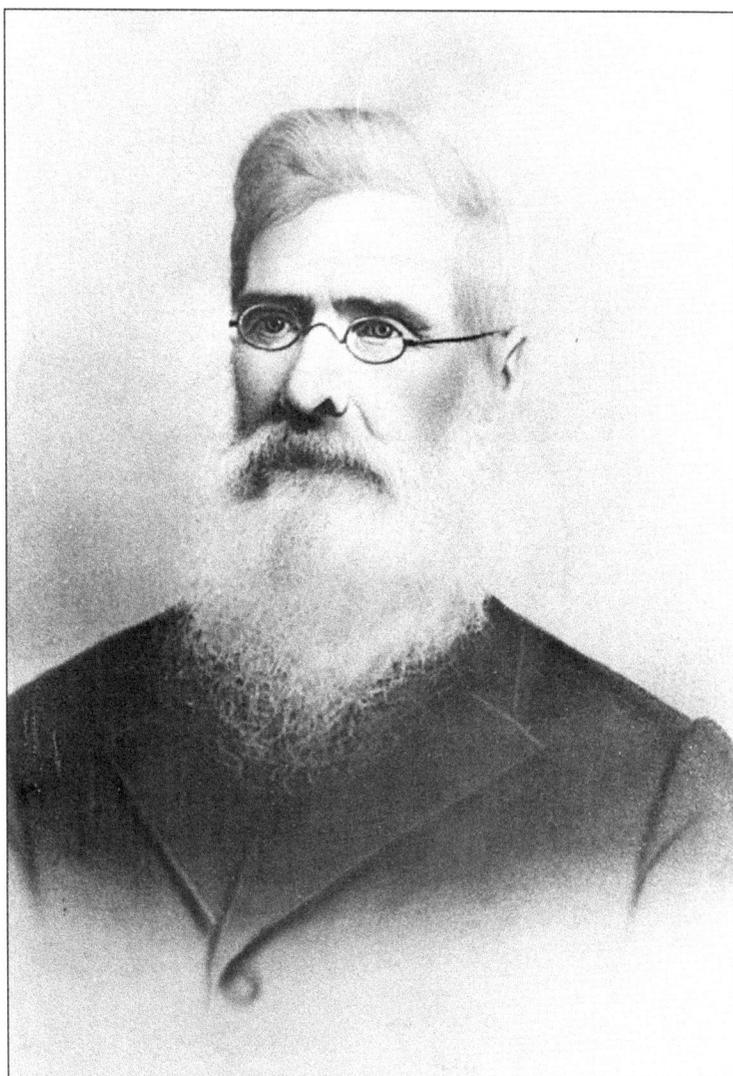

Born in North Carolina on September 15, 1812, David Shelton was the eldest of 13 children. His family moved to Missouri when he was about eight. David married Frances Wilson in 1837. With their first five children, they set out on the Oregon Trail in 1847. The Sheltons settled in what would become east Portland. In 1853, David and his brother, Tillman, traveled to the westernmost point of Puget Sound at Big Skookum (Hammersley Inlet). There, in 1854, he claimed 640 acres north of Goldsborough Creek. David Shelton was at various times a carpenter, farmer, legislator, mayor, school superintendent, county commissioner, and lieutenant. He died in Shelton on February 15, 1897. (Courtesy of the Mason County Historical Society.)

ON THE COVER: The butt end of one of the largest trees cut by Simpson Timber Company, the Neby fir, is too big for the sawmill in Shelton. Logged from land on the east fork of the Satsop River, it is being cut up for firewood to stoke the boiler of one of Simpson's locomotives about 1900. (Courtesy of the Mason County Historical Society.)

IMAGES
of America

SHELTON

Margret Pauley Kingrey

ARCADIA
PUBLISHING

Published by Arcadia Publishing
Charleston, South Carolina

Library of Congress Control Number: 2008938761

For all general information contact Arcadia Publishing at:
Telephone 843-853-2070
Fax 843-853-0044
E-mail sales@arcadiapublishing.com
For customer service and orders:
Toll-Free 1-888-313-2665

Visit us on the Internet at www.arcadiapublishing.com

To Daniel and Minnie Belle (Ridings) Myers,
the adventurer and the settler.
We need both to create history and give us an appreciation of it.

CONTENTS

ACKNOWLEDGMENTS

Many thanks to the staff of the Mason County Historical Society (MCHS), who assisted with picture suggestions, answered my numerous questions, and encouraged me in this project. Thank you to John Tegtmeyer, Sylvia Nelson, Susan Kneeland, Barbara Kay Kneeland, Lillian Hanscom, Sandra Pauley, Don and Mary Kay Pauley, and Virgil Fox for pictures and meals while I was in Shelton researching this book.

Additional thanks go to Justin Taylor of Taylor United, Inc.; Frank Bishop of Little Skookum Shellfish, LLC; Bev Barnes, program coordinator of Exceptional Foresters; Weldon Wilson, photographer for government and media relations of the Washington State Patrol; and Simpson Timber Company for pictures and their generous gift of time to explain their operations and the histories of their organizations.

Although several meetings took place with representatives of the Squaxin Island Indian Museum Library and Research Center, regrettably no images were obtained from them for this publication. Those interested in the Native American history and culture can visit the Squaxin Island Museum and Research Center at 150 SE Swuh-Deegs-Altxw, Shelton, Washington, off Highway 3 opposite the Little Creek Casino, or their Web site at www.squaxinislandmuseum.org.

I also wish to thank my editor at Arcadia Publishing, Sarah Higginbotham, for keeping me moving forward despite my trepidations otherwise and for sending M&Ms! To my husband, Everett, a big thank you for your support and encouragement through this and all my endeavors.

INTRODUCTION

Already having moved his family across the United States from Missouri to Oregon Territory in 1847, after five years of living in what would become the east side of Portland, David Shelton decided to relocate once again. Not one to stay long in a place, David Shelton uprooted his family and migrated to Olympia, Washington Territory. Returning to Missouri, he brought more family members across the Oregon Trail and set out with his brother Tillman Shelton in 1853 to explore the westernmost region of Puget Sound and lay claim to 640 acres of land along the north side of the Cota Valley from the shore back into the dense forest. And so began the history of the town named after David Shelton.

There were other settlements in the area before David Shelton brought his family to his claim on Puget Sound. There was a community at Arcadia (also known as Arkada), a sawmill on Hammersley Inlet owned by Col. Michael T. Simmons, another at Kamilche, and a settlement at Oakland established by V. P. Morrow. Maj. Hugh Goldsborough had a home on the south side of the valley, but he did not stay. The Washington Territory had been newly formed, and a new county was established as well. David Shelton was a delegate to the legislature, and in the same year that he built his house, 1853, the county of Sawamish was created.

During the ensuing 30 years, Shelton established a school district of which he was the superintendent for 30 years; was a member of the Masonic lodge at Oakland, which later moved to Shelton; and was mayor of the town. It was not until the 1880s that the Shelton claim began to grow. In part, that may have been because other areas of Puget Sound were easier to reach. Located at the western end of Hammersley Inlet, the Shelton claim was not an easy trip. Big Skookum, as Hammersley Inlet was called, was a treacherous passage, especially for larger sailing ships. Trees along the northern shores of Puget Sound had been logged and mills established there were hungry for more timber.

In 1882, W. H. and Frank Kneeland arrived from Pennsylvania to buy land from David Shelton 3 miles up the valley and established a sawmill. They built a flume to transport lumber to the sound for shipment. This was a total failure, and the two left. Not one to give up, W. H. Kneeland returned three years later to stay and build a community. Investors from Seattle chose Shelton's valley to build the Satsop Railroad, and David Shelton platted his land. In 1884, he sold some of it to the railroad builders, and some he sold to farmers. With the establishment of Shelton as the county seat of Mason County (the name had been changed from Sawamish in 1864 and from Oakland in 1888), the town of Shelton was assured of being the center of business and government for the surrounding area.

There were a few dirt roads for horse and buggy, but travel was predominantly by water or over the railroad lines that sprang up during the last 20 years of the 19th century. Difficulties in travel did not stop people from gathering into a community at Shelton, and they enjoyed their first July Fourth celebration in 1887. Grant C. Angle, who arrived to start the *Mason County Journal* in 1886, made sure everyone knew about the party and everyone dressed up to come into town, arriving

from the logging camps and farms. The festivities began with steam whistles blowing; there was a parade, a picnic, a dance, and fireworks. Thus began Shelton's penchant for celebrations.

The majority of people lived outside the town on farms or in logging camps, and Shelton was a weekend town for loggers and farmers. There were a number of hotels and saloons but also churches. Sometimes making the trip in was too difficult for a family, so women gave their shopping list to the engineer of the train from the logging camp and had him bring the groceries out on the return trip to camp on Sunday. Some wives, like Mrs. A. H. Anderson (Agnes Healy), were not up to this kind of living and left for Seattle to establish homes. She knew, however, that her husband's many business interests were primarily in Mason County, and she did not forget the town of Shelton with monetary donations for a variety of worthy causes.

Sol Simpson, however, who came to build a railroad for Port Blakely Mill owner Capt. William Renton in 1887, lived at the logging camps with his wife, like other families. Sol Simpson went on to establish the Simpson Timber Company, which has been a presence in Shelton for more than 100 years. The Simpson family, including Mark E. Reed, Sol and Mary Simpson's son-in-law, brought many innovative practices to logging and changes to Shelton. Sol Simpson replaced ox teams with horses, and then he brought the spool donkey to the woods. He was quick to take advantage of new technology. Mark E. Reed brought humane treatment to the camps in terms of better living quarters for the loggers, and he gathered coalitions of businessmen to start Lumbermen's Mercantile. He also changed forestry by serving in the legislature and getting laws passed that would be advantageous to the timber industry. He built mills and instituted sustained-yield forestry practices, having learned of that idea from a University of Michigan professor in the late 1920s. His family built the elegant Colonial House, but he was not the first in town to own a car.

Shelton has changed over the years. There are no more railroad tracks on Railroad Avenue, and a number of the old buildings are gone, destroyed by fire or just torn down to be replaced by others. With the booms of the 1880s came the busts, and economies, like the weather, can turn bad. But Shelton has never lost its downtown as some towns have, and although more mature perhaps, new ideas are still welcomed, as are new people. There are other industries and other celebrations that sustain the town and perpetuate the community.

One

EARLY LOGGING
COMMUNITIES

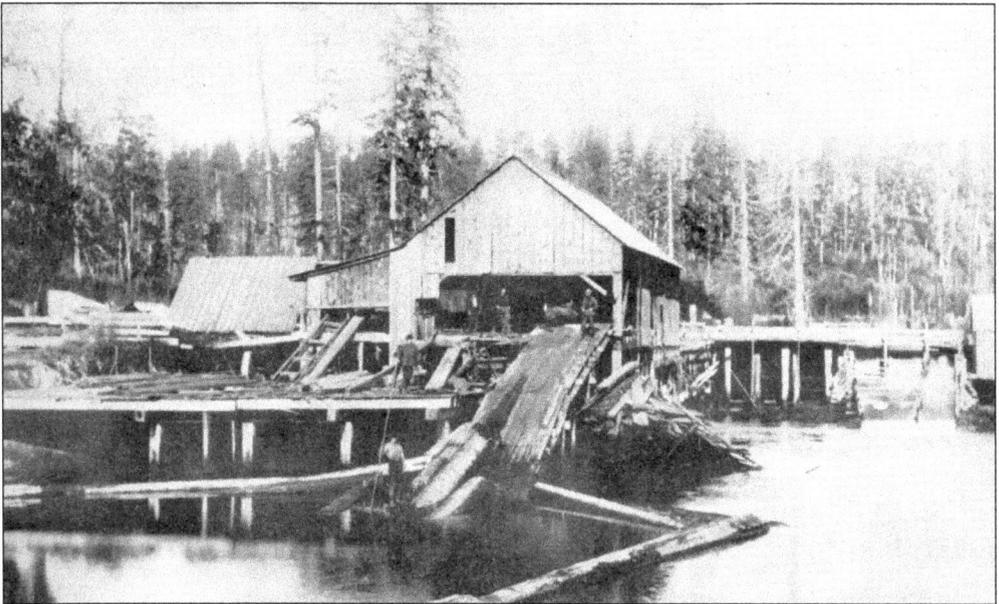

Enoch Willey built this sawmill at John's Creek when he and his family arrived at Oakland in 1871. The mill pictured here about 1880 shows Eli Willey standing on the logs and Harry Willey standing on the dock. Also pictured are Fred, Frank, and Walter Willey, though they cannot be identified individually in the photograph. Initially, Mark Fredson was a partner in the mill. (Courtesy of MCHS.)

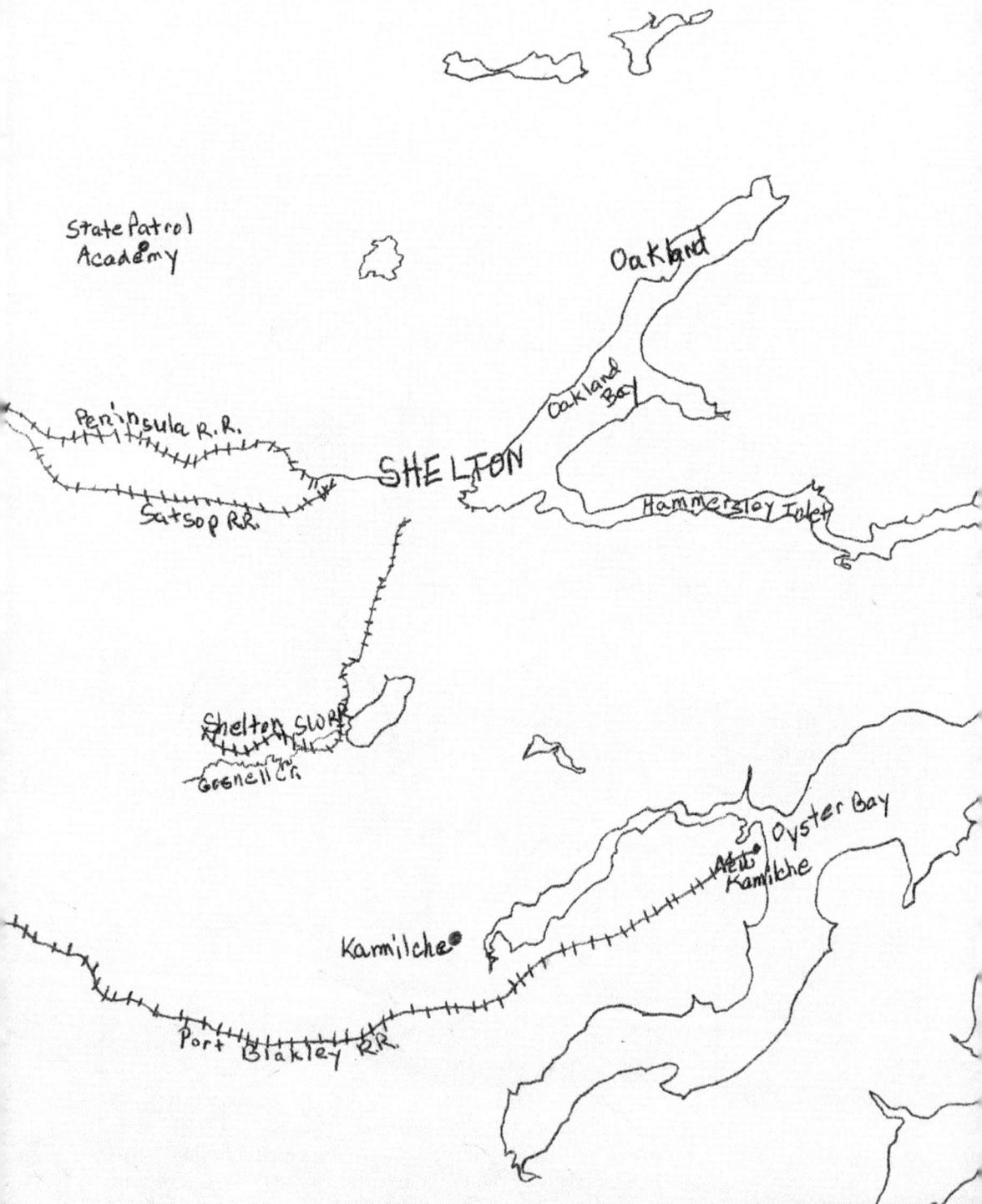

State Patrol
Academy

Oakland

Peninsula R.R.

Oakland
Bay

SHELTON

Satsop R.R.

Hammersley Inlet

Shelton SW RR

Gosnell Cr.

Oyster Bay

New
Kamilche

Kamilche

Port Blakley R.R.

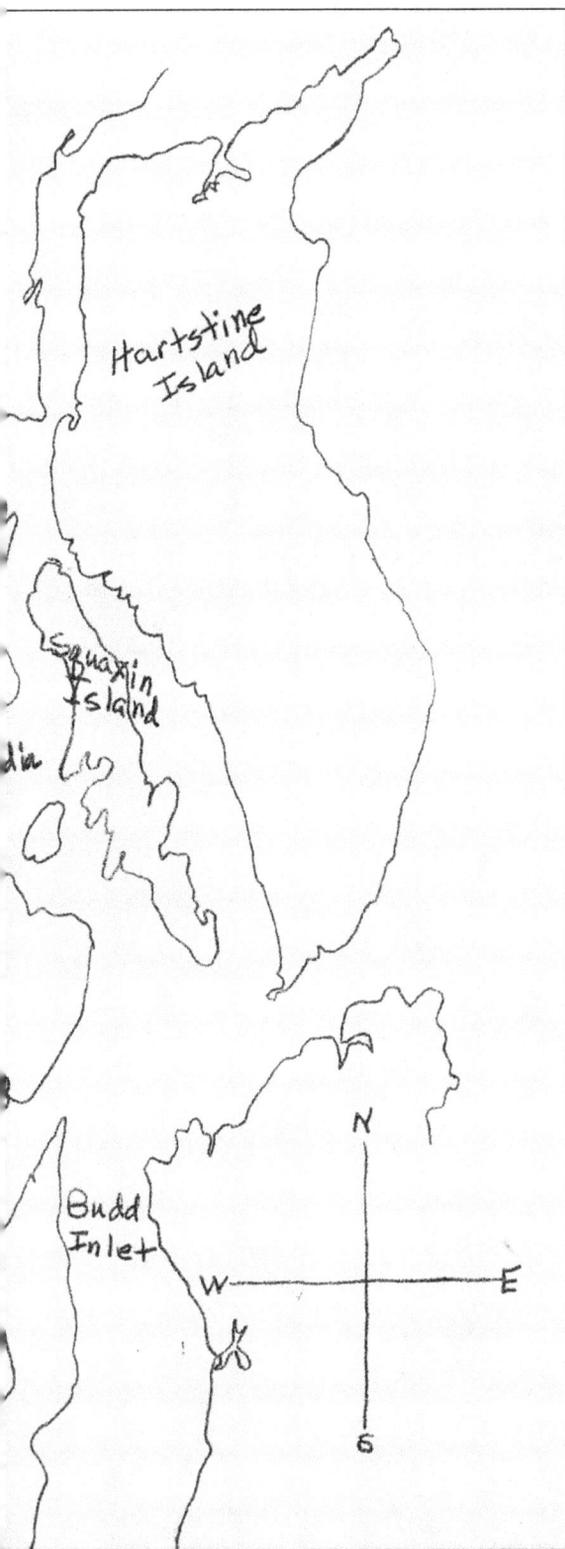

Hartstine Island

Squaxin Island

dia

Budd Inlet

N

W —————— E

S

This map is a depiction of the areas around Shelton that are mentioned throughout the book. The lines with crosshatches signify railroads, although only some are shown here. Budd Inlet is the waterway to Olympia. Oyster Bay is on Totten inlet. The small island off Squaxin Island is Hope Island. The smallest is Steamboat Island. They were included to demonstrate the narrow passages boats had to travel to and from Shelton and New Kamilche. Hammersley Inlet is referred to as Big Skookum. The inlet into Kamilche is called Little Skookum. Travel was almost exclusively by water, or one walked along the trails of the local Native Americans. The Sa-He-Wa-mish group occupied the watershed of Hammersley Inlet. The Totten Inlet watershed was inhabited by the Sawamish/T'Peeksin group. The Squaxin territory was the Carr Inlet watershed, which included Hartstine Island, Squaxin Island, and Arcadia. (Courtesy of Margret Kingrey.)

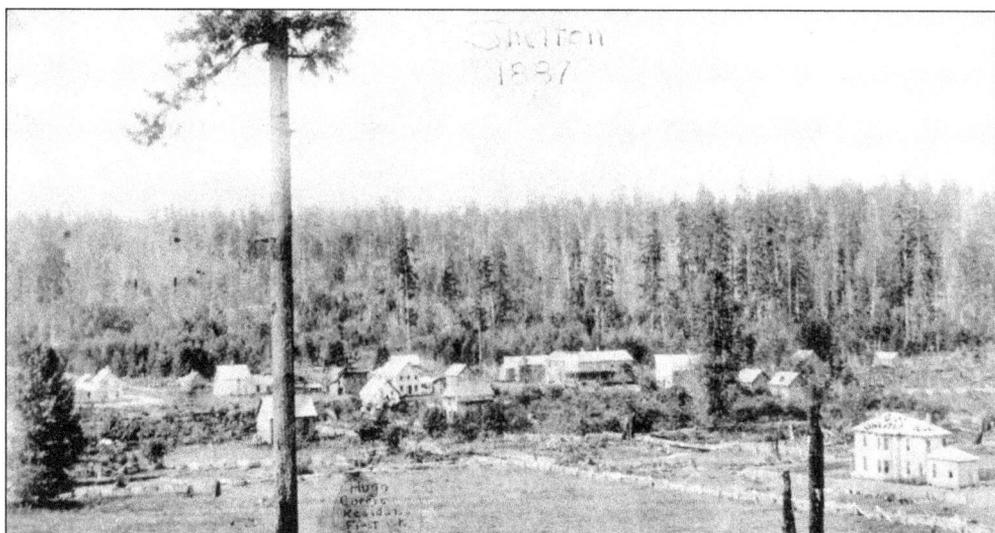

Shelton is pictured as it looked in 1887. The large house on the right was occupied at one time by A. H. Anderson, a timber baron and entrepreneur. The field in front belonged to David Shelton's farm. The Satsop Railroad crossed the road about the middle of the picture. Goldsborough Creek ran along the bottom of the hill at the back of the picture. (Courtesy of Simpson Timber Company.)

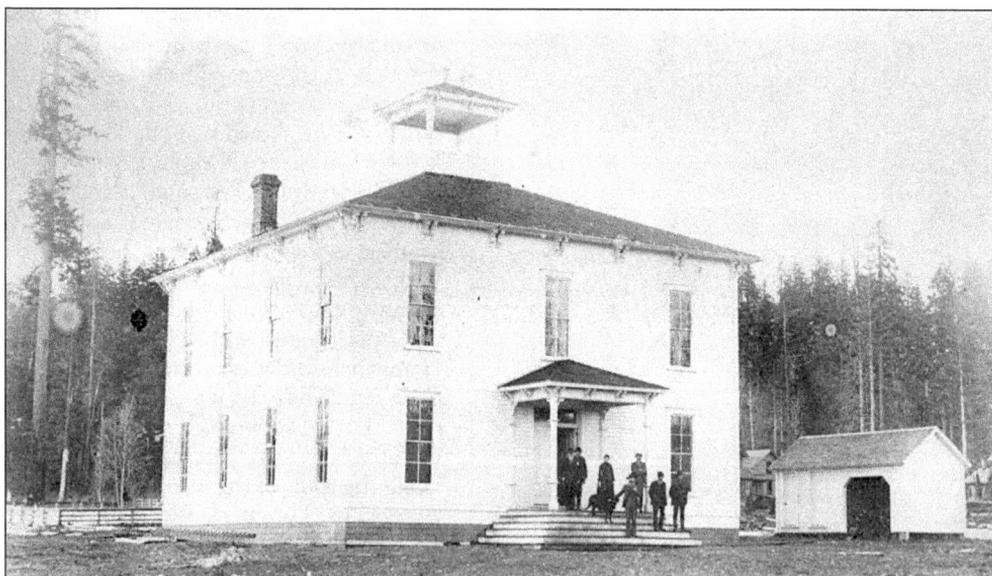

In an election on April 28, 1888, Shelton became the county seat of Mason County. Land for the Mason County Courthouse was donated by David Shelton, and this courthouse was built the same year. The building was adequate until 1904, when an addition was put on the east side of the building. David Shelton may be the man with the longer beard standing by the door. (Courtesy of MCHS.)

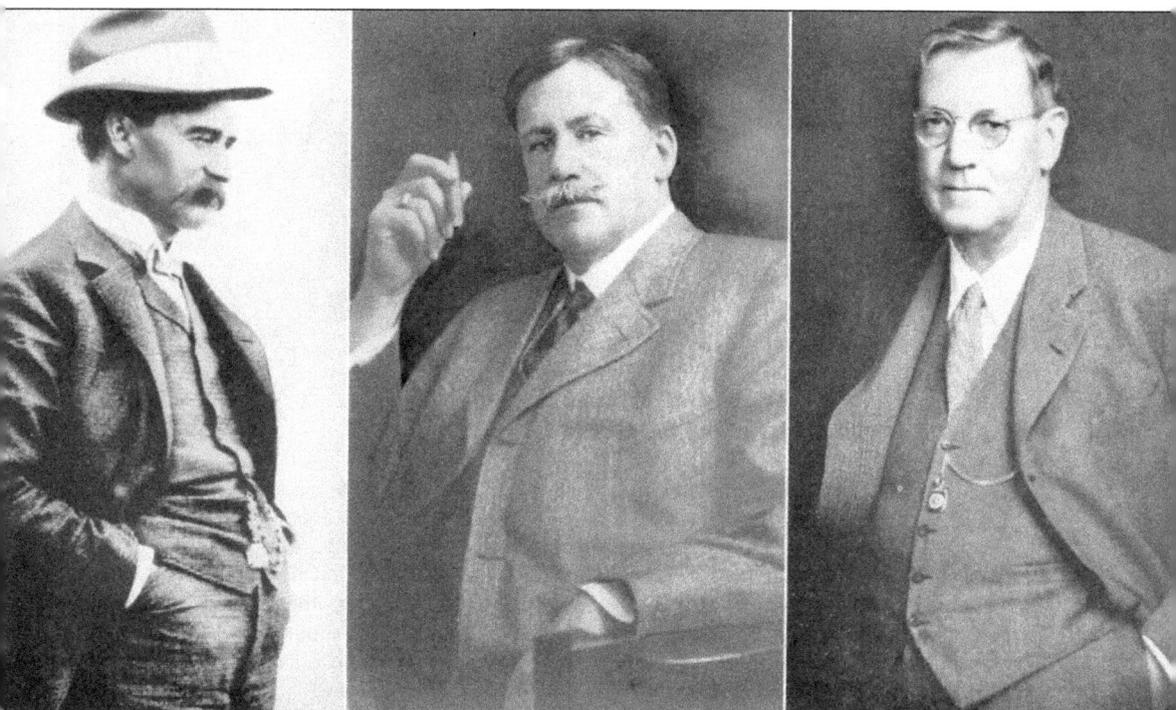

From left to right are Sol Simpson, A. H. Anderson, and Mark E. Reed. Each of these men came to Shelton to build the logging industry. Sol Simpson was from Quebec. In 1887, he came to Puget Sound to build a railroad at Kamilche for the Port Blakely Mill. He brought horses then the steam donkey to the logging operations. A. H. Anderson came from Wisconsin in 1889 with his wife, Agnes Healy, daughter of Benjamin B. Healy, who was a major stockholder in the Satsop Railroad. Anderson reorganized the railroad company and invested in numerous other businesses. Mark E. Reed arrived in Shelton in 1893. After failing in a small logging operation, he worked as a logger for other companies. With his background in law, the military, and logging, Simpson hired him in 1897 as foreman at Camp 1. Reed managed the Lumbermen's Mercantile and associated with Simpson and Anderson in a variety of business ventures. (Courtesy of Simpson Timber Company and Don Pauley.)

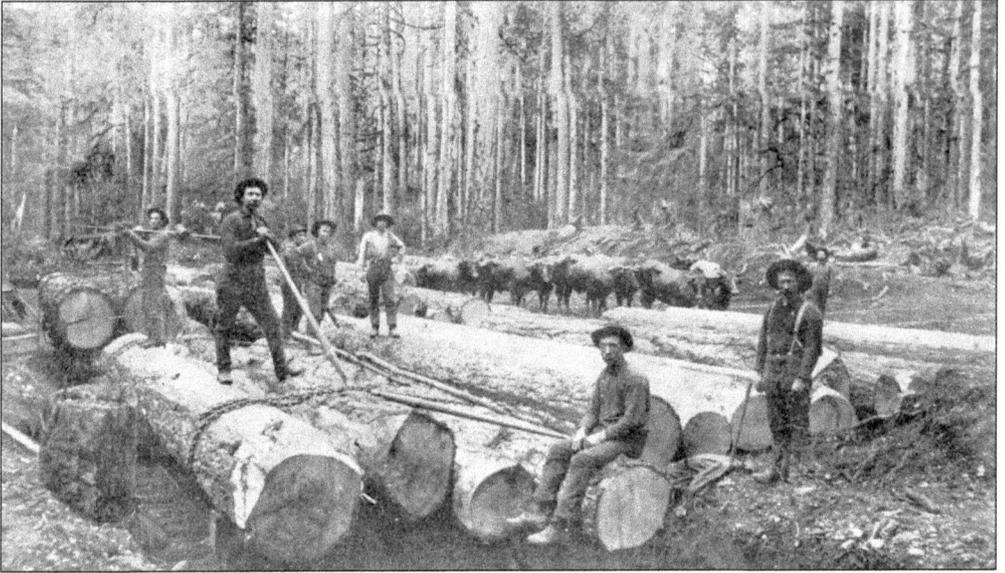

Men get a turn of logs ready to haul to the Satsop Railroad in 1890. Logs are chained together with the edges of one end of the logs cut off so they will slide over the skids more easily. A foreman at Camp 4, Bill Liggett, leans on his peavey. In the rear by the bull team is Ben Willey. Others are unidentified. (Courtesy of Simpson Timber Company and Don Pauley.)

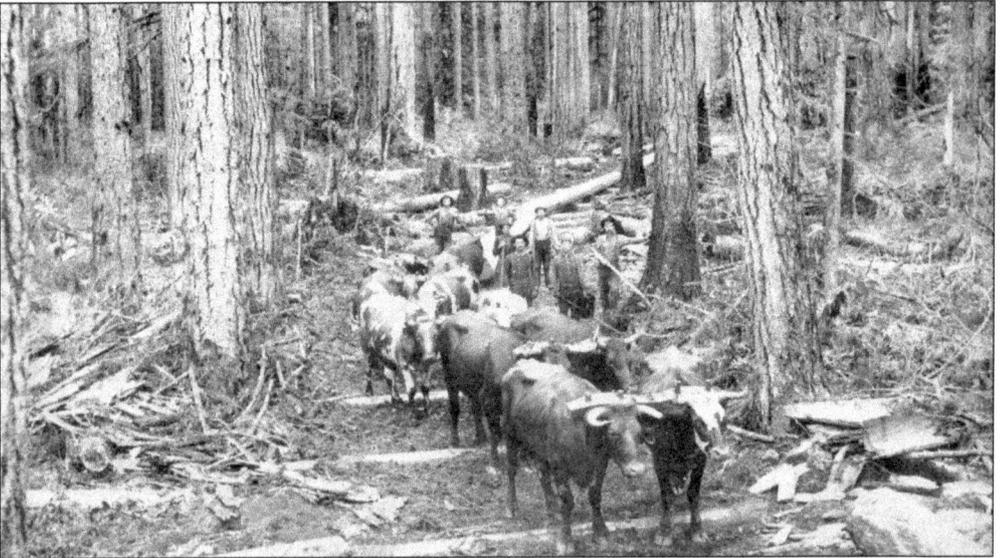

This team of oxen was used for the Port Blakely Mill operation in 1889. The man with the swab and grease can is Alex McLane, the skid greaser. The others are unidentified. Simpson thought oxen were slow and soon changed to horses for this work. (Courtesy of Simpson Timber Company and Don Pauley.)

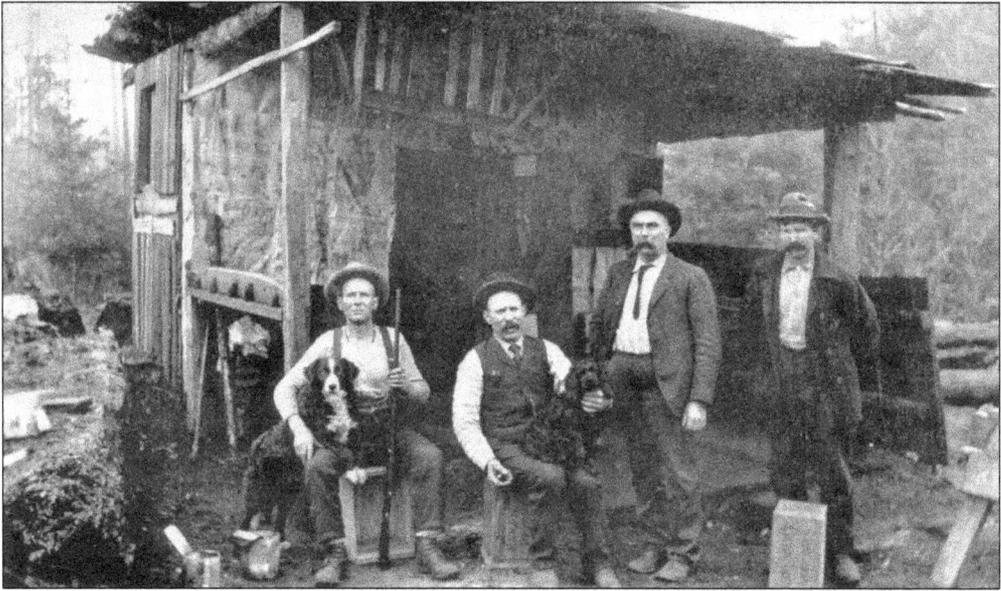

The Bordeaux brothers were early loggers in the Shelton area. Note the grease cans on the ground and strips of the *Seattle Times* on the wall. In 1888, at the Bordeaux brothers' Camp 6 are, from left to right, Joe Thibet, "Frenchy" (the cook), Joseph Bordeaux, and Gilbert Bordeaux. (Courtesy of Simpson Timber Company and Don Pauley.)

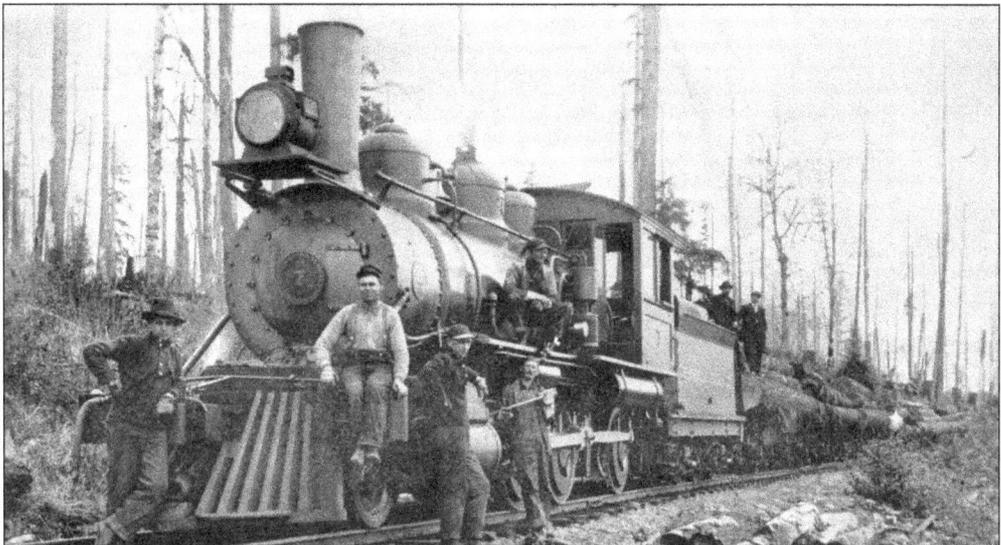

Engine No. 7 is loaded with logs from the Bordeaux operation on its way to Shelton. The owners of the Peninsular Railroad, which ran near the Bordeaux camp, were Sol G. Simpson and A. H. Anderson. Pictured are, from left to right, Dave Lytle, Clarence Huntley, Joe Forrest, and Frank Brown sitting above Bill Parker. The men on the logs at the right are unidentified. (Courtesy of Simpson Timber Company and Don Pauley.)

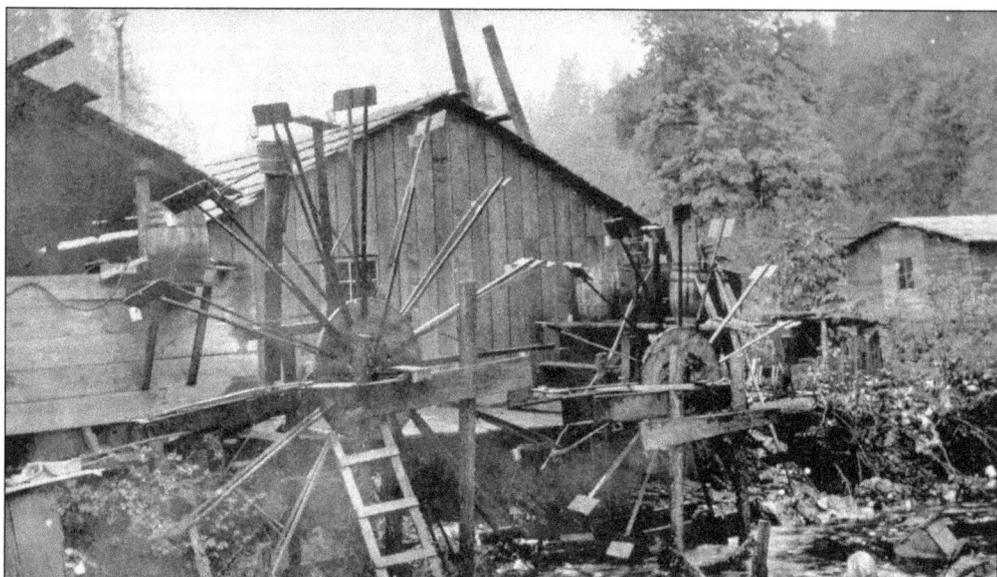

In 1890, this cookhouse was rigged with a waterwheel by the Chinese cook. The tin cans under the paddles dip water from Bingham Creek to be used by the cook. He fed the men of the camp and sold meals to passing peddlers. With those funds, he purchased a large dinner bell. (Courtesy of Simpson Timber Company and Don Pauley.)

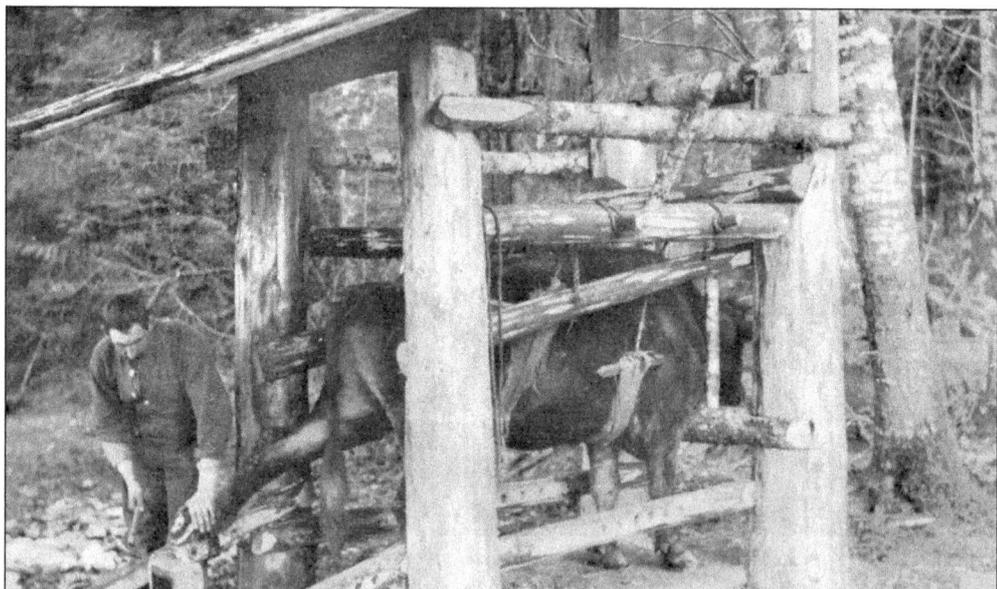

Even on a Sunday, there was work to be done, and keeping the tools in working order included shoeing the oxen. Here Orman Huntley puts new shoes on Blue Ox in 1890. (Courtesy of Simpson Timber Company and Don Pauley.)

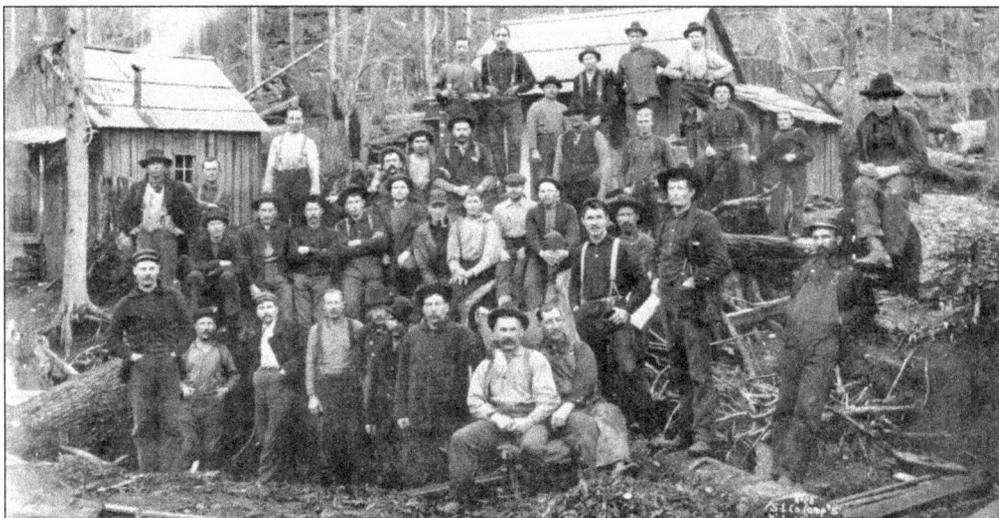

These men were employees of Simpson Logging Company in 1898. From left to right are (first row) Al Leroy, unidentified, George Grisdale, "Jack the Ripper" ?, two unidentified, Eric Odegard, Clarence Brainard, and Jim Forrest; (second row) unidentified, Bill Doty, two unidentified, Karl Weiks, unidentified, "Boomstick" ?, Frank Fieser, Ed Grout, Bill Grisdale, Dave Kelly, Jack Clark, George Cline, and two unidentified; (third row) Fred Anderson, Pete Rambo, Jack Ireland, Joe Stertz, "Old Ninety" ?, unidentified, Levi Cline, Plummer Cox, and Ed Cook; (fourth row) Cleve Anderson, ? Krise, Joe Zink, two unidentified, and Ted Callow. (Courtesy of Simpson Timber Company and Don Pauley.)

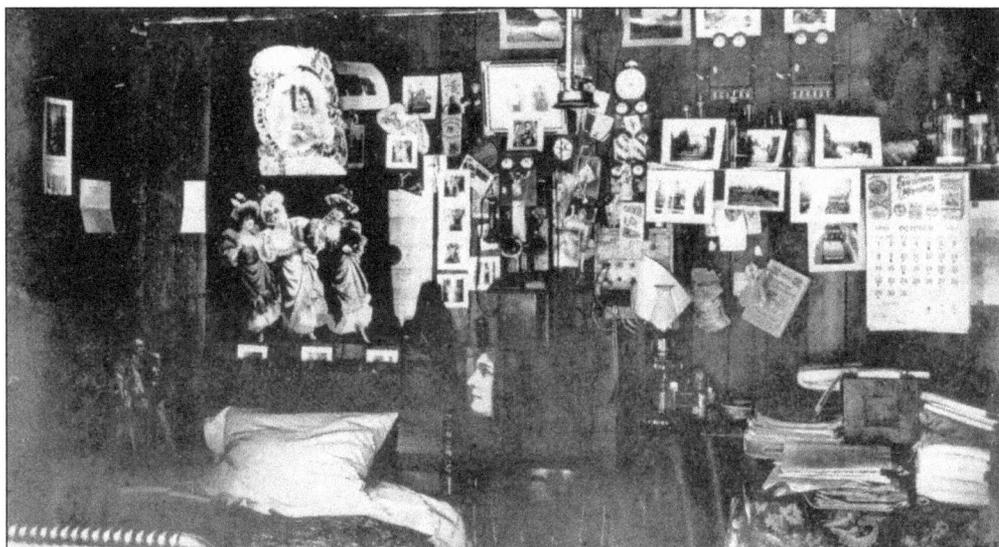

This is the Simpson Logging Company office in Matlock in 1899. The space includes all the manager needs. Time clocks and pictures of family and friends as well as pin-up girls and a sports team hang near the bed. There is a telephone on the back wall above the safe and plenty of light from the oil lamp on the table and the one hanging from the ceiling. No long conferences are held here with only one captain chair in the room. (Courtesy of Simpson Timber Company and Don Pauley.)

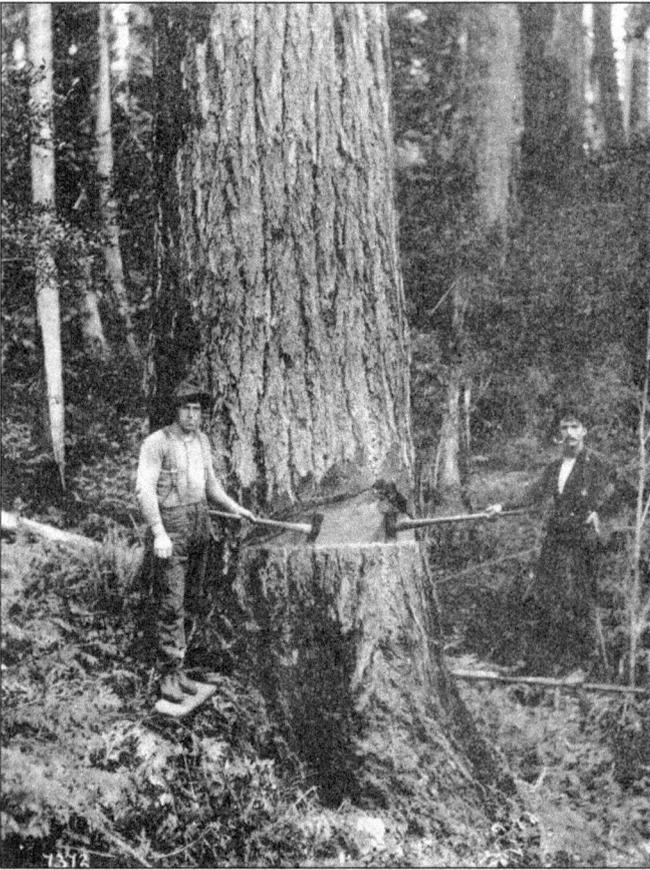

Standing on the spring boards allowed these fallers equal access to the girth of the tree. Cutting a Douglas fir around 1890 are an unidentified man (left) and Ed Hillier as young man. Hillier went on to become an official of the Simpson Timber Company. (Courtesy of Simpson Timber Company and Don Pauley.)

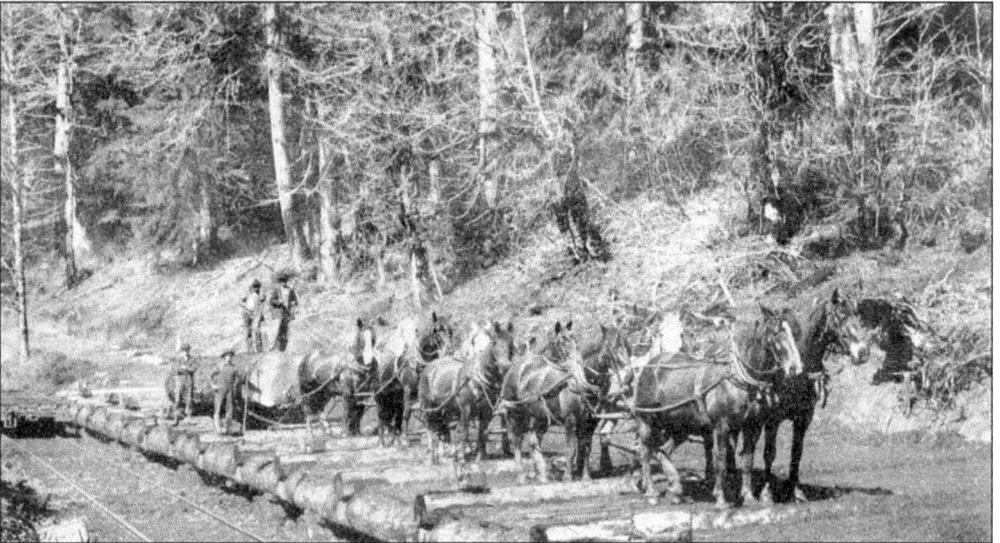

Sol Simpson was one of the first loggers to use horses in the woods instead of oxen. Here 10 horses haul a log out to the Blakely Railroad at the landing. Jack Cole was the foreman for this part of the Simpson Logging Company operation. It was Jack Cole's name that many Scandinavian immigrants knew before any other English. (Courtesy of Simpson Timber Company and Don Pauley.)

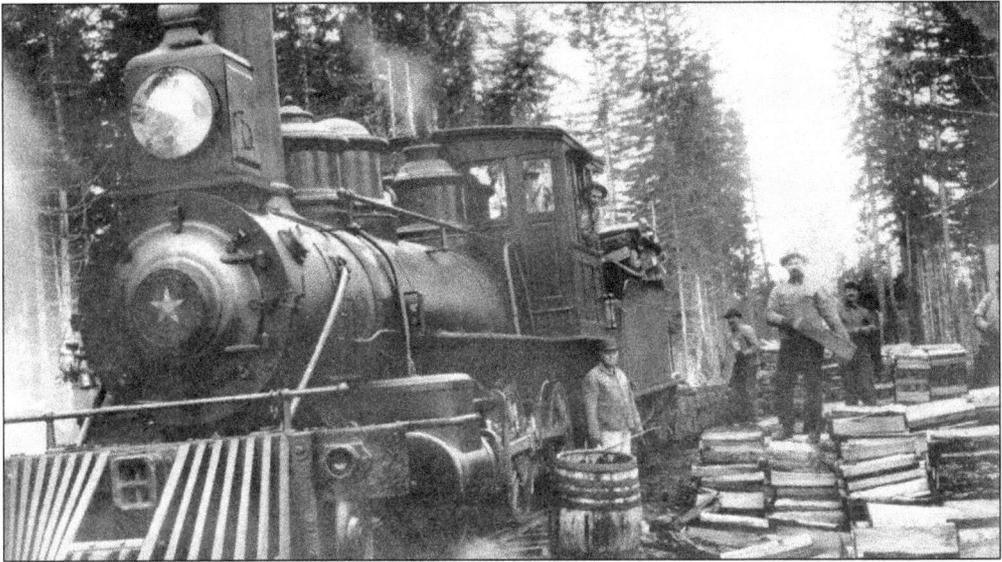

"The Blizzard" was the name for the Blakely Railroad Engine No. 1. She is pictured with her crew in 1901. Fireman Sophus Jacobson is in the cab, and engineer ? Zandt holds the tallow pot while standing beside the engine. Tom Hanlon loads wood while standing on the pile. Behind him on the left is Frank Fieser, and on the right is Arthur Elliott. (Courtesy of Simpson Timber Company and Don Pauley.)

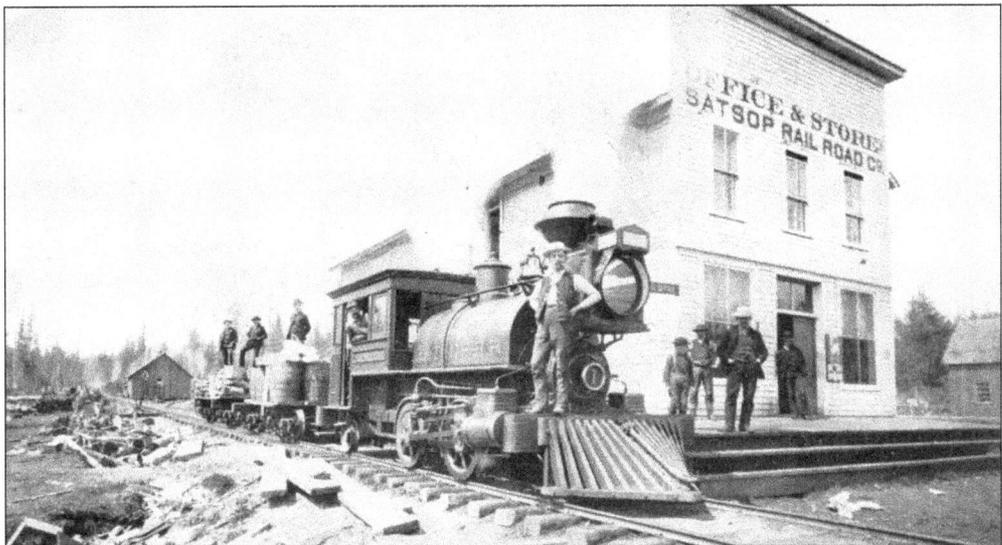

Shelton's first locomotive was Engine No. 1 of the Satsop Railroad. She sits in front of the company headquarters in downtown Shelton in 1889. Arthur Needham, the general superintendent of the line, stands on the cowcatcher, with the engineer, ? Crow, leaning out of the cab. On the flatcar behind the barrels is store clerk Emory White, and Joe Young stands on the store platform in the white hat. Others in the picture are unidentified. (Courtesy of Simpson Timber Company and Don Pauley.)

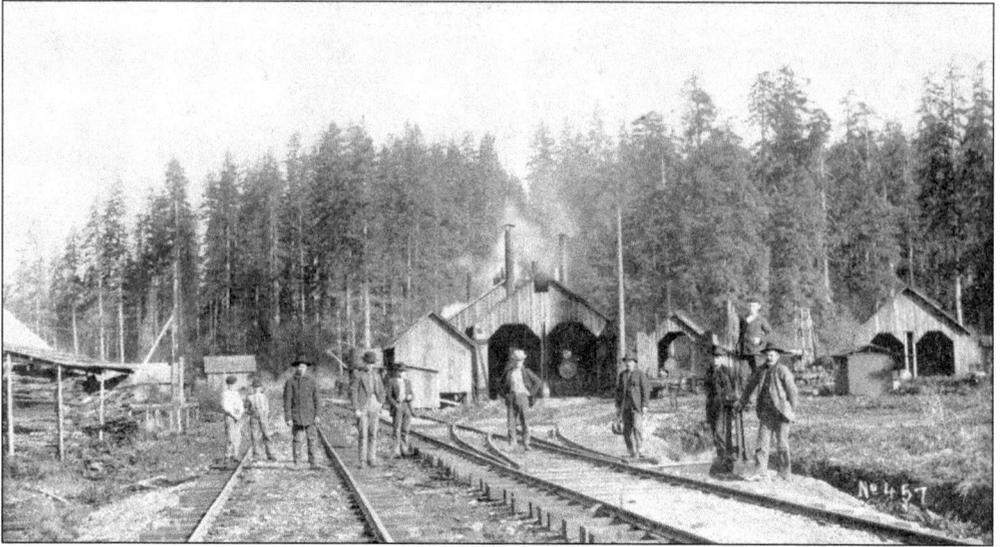

The roundhouse at Matlock was where engines were turned around and prepared for the trip back to Shelton. Repairs and maintenance were also done in the roundhouse. Pictured around 1890 are, from left to right, Ray and Jay Tew, Arthur Elliott, Sophus Jacobson, unidentified, Ed Elliott, Jim Shannon, Charlie Jacobson, Jack Hanlon standing on the switch, and Theodore Hines. (Courtesy of Simpson Timber Company and Don Pauley.)

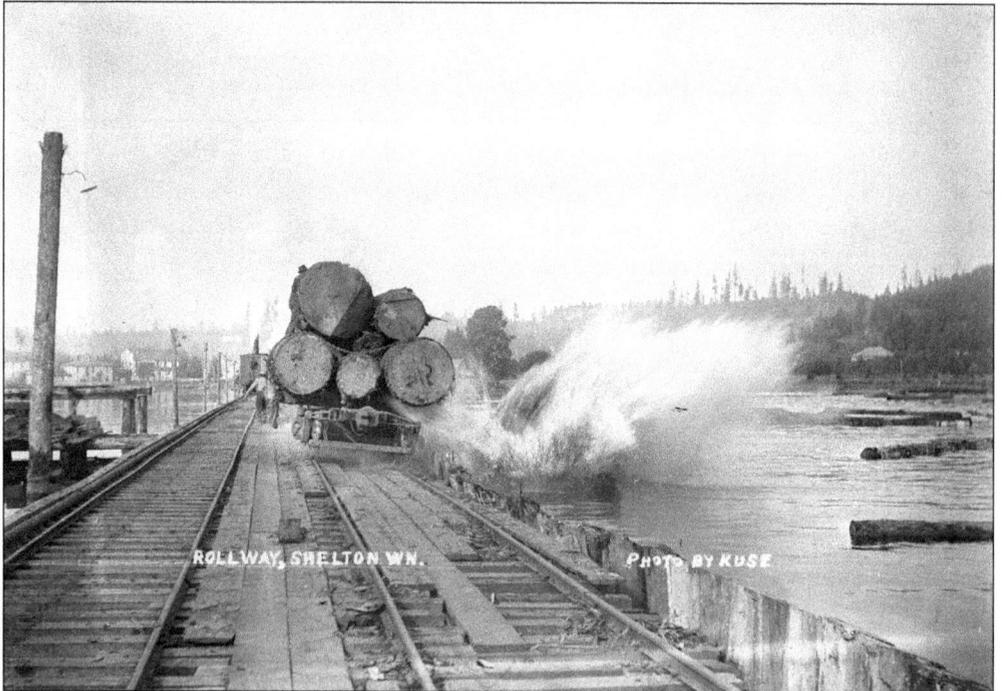

From the rollway, logs were dumped into the bay at Shelton. There they were sorted and rafted to mills in other locations, as Shelton did not have a sawmill until after the beginning of the 20th century. This rollway was on the Satsop Railroad line, which was principally owned by Seattle investors, including C. F. White, who became Shelton's first postmaster in 1885. (Courtesy of MCHS.)

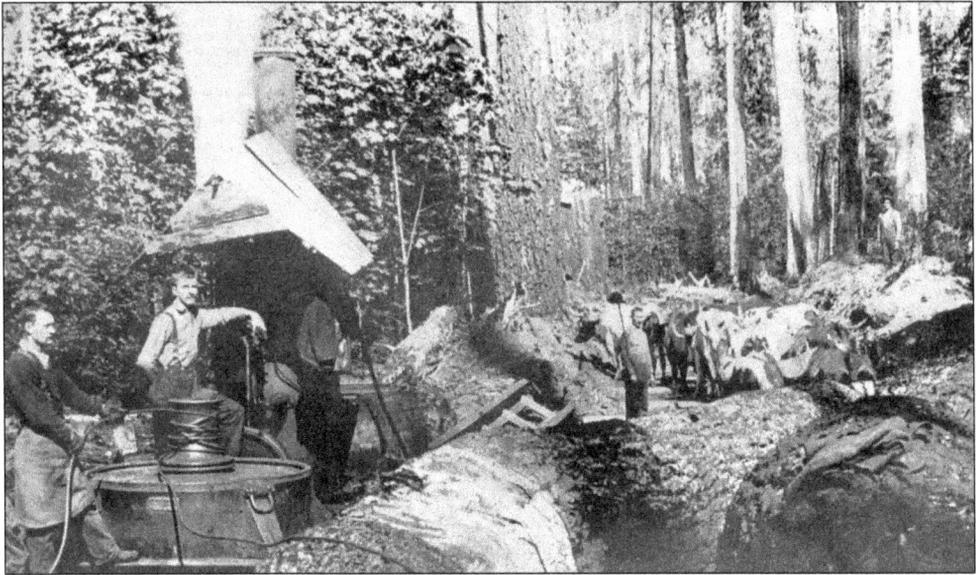

Yarding logs out of the woods in the early 1890s was the job of the first Dolbeer spool donkey purchased by Sol Simpson. From the donkey to the railhead, bulls or horses skidded the logs to be loaded on flatcars. George Grisdale is at the throttle. The other men are unidentified. (Courtesy of Simpson Timber Company and Don Pauley.)

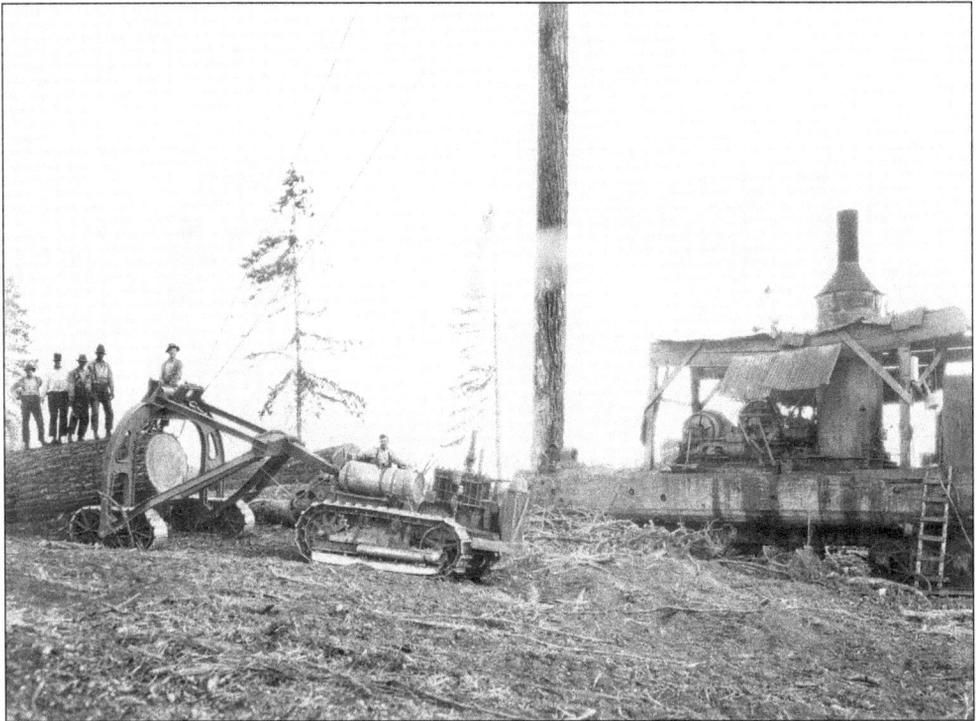

Sol Simpson brought this innovative method to logging around Shelton. Rigging was set in a high spar tree to drag logs up a steep grade where oxen or horses could not work. With a spool donkey and a spar tree, logs could be cut in terrain too rugged to be accessible by other means around 1900. (Courtesy of MCHS.)

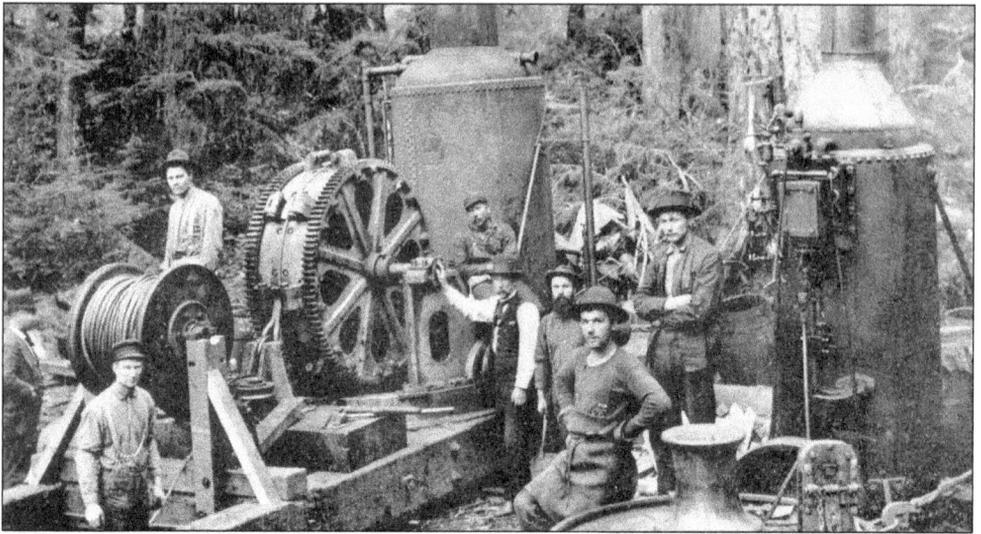

In 1898, the "Walking Dudley" was used in Simpson camps. Mounted on a railroad car and with the large drum in the middle, the whole thing could be moved on the rail bed, dragging logs between the rails. Pictured are, from left to right, two unidentified, Mr. Bird (the inventor of the device), Al Leroy, E. King, Jack Cameron, unidentified, and Frank Charles. (Courtesy of Simpson Timber Company and Don Pauley.)

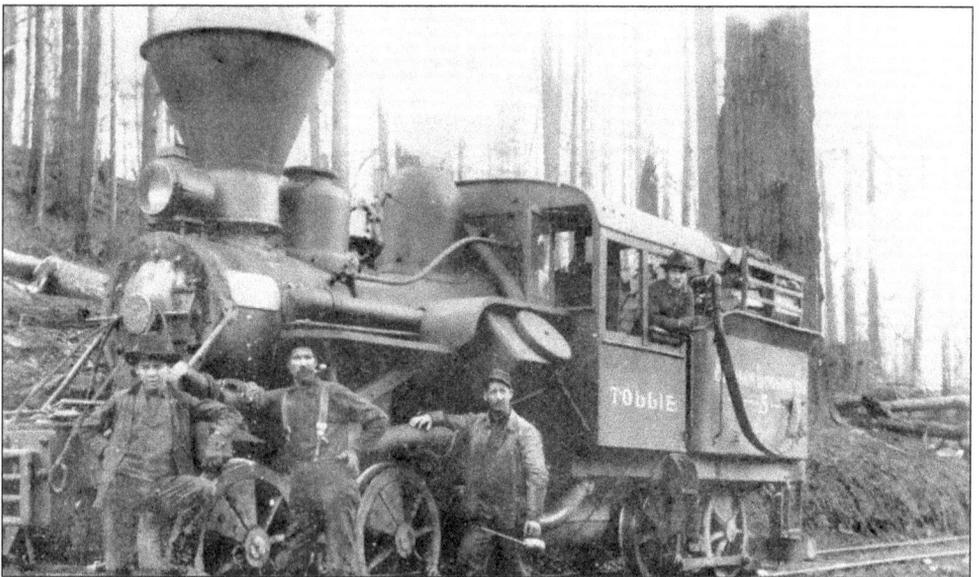

Geared locomotives replaced the Dudley. The "Tollie," named in honor of Mrs. Sol Simpson, was a geared Shay that could navigate the steep, curvy grades in hills around Shelton. The crew is, from left to right, Eddie Cook, David Kelley, Jim Forrest, and Will Grisdale c. 1924. (Courtesy of Simpson Timber Company and Don Pauley.)

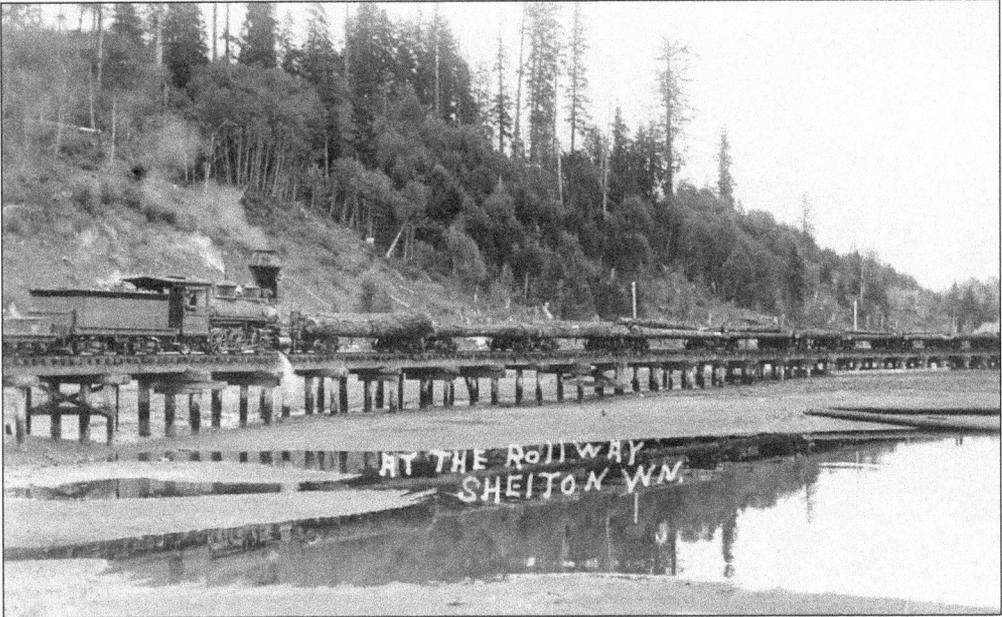

W. H. Kneeland built his own rollway along the northern edge of Big Skookum (also known as Oakland Bay) up to what is now known as Bay Shore. In this c. 1890 photograph, trains push railcars loaded with logs out to the bay, where the logs are dumped into the water. (Courtesy of MCHS.)

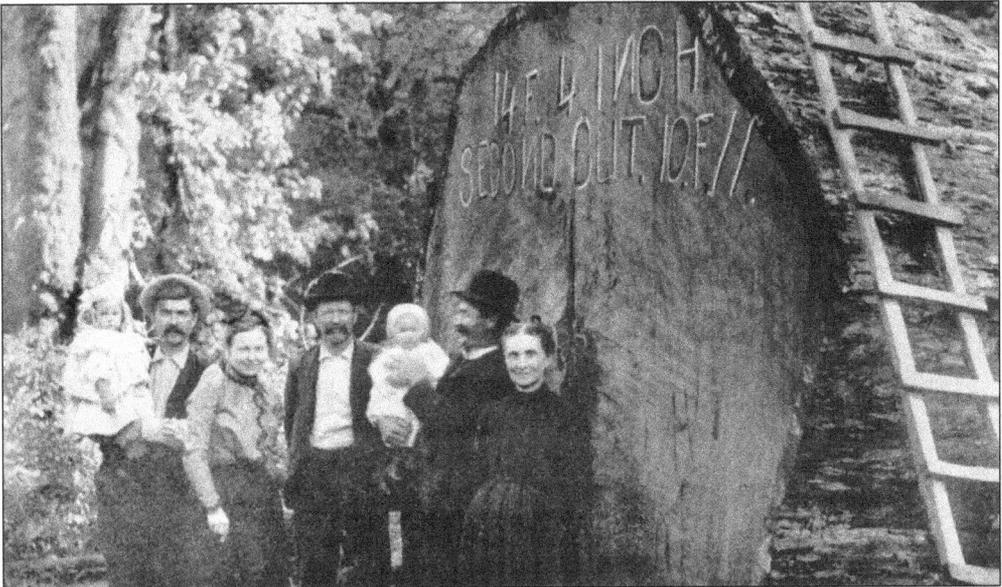

The biggest tree cut by the Simpson Logging Company was in 1900 at Camp 5. The butt end measured 14 feet, 4 inches. At the camp are, from left to right, Irene Grisdale, held by her father, George Grisdale, Mrs. George Grisdale (Bertha), Joe Simpson, Doris Grisdale (later Fortnum) held by her father, Albert Grisdale; and Elizabeth Simpson Grisdale. (Courtesy of Simpson Timber Company and Don Pauley.)

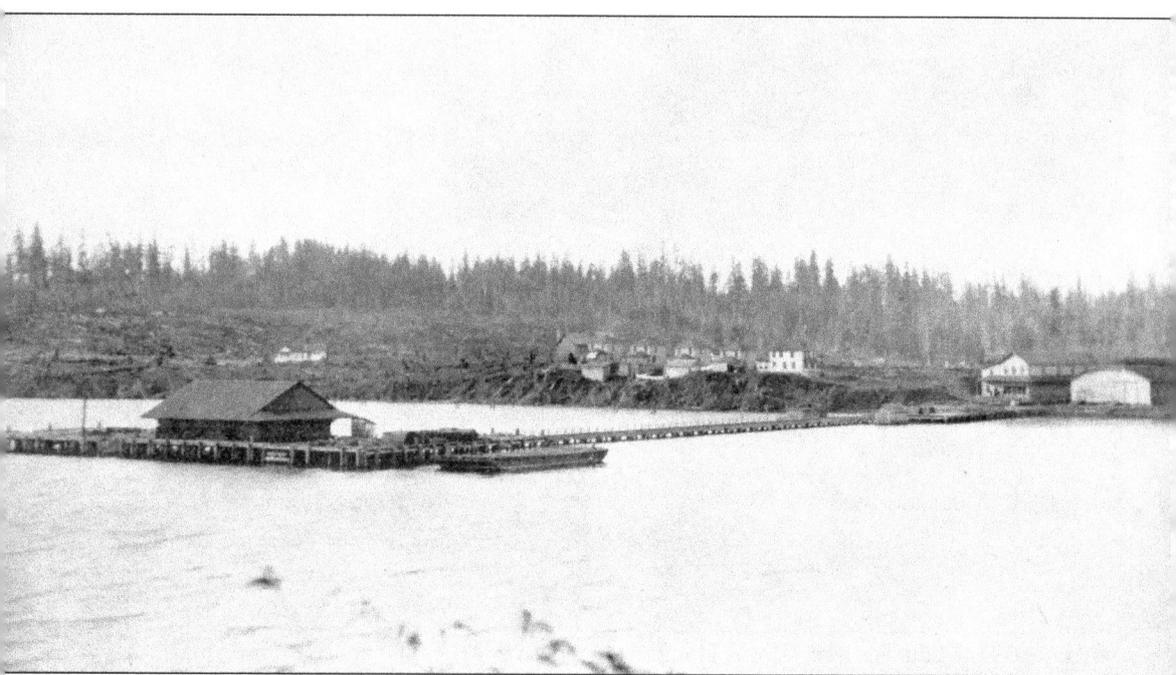

In 1890, Captain Renton and his San Francisco investors reorganized the Port Blakely Mill Company, and Sol Simpson, who had been hired by Captain Renton three years earlier to build the railroad at Kamilche, became the beneficiary. Simpson and Captain Renton's nephews, along with C. S. and Ed Holmes of San Francisco, became partners in S. G. Simpson and Company, which had the responsibility of getting as much timber out of the Kamilche area for the Port Blakely Mill Company as possible. Sol Simpson extended the railroad eastward from Kamilche Point to the eastern end of the old Blakely Railroad. He built a dock at the head of Little Skookum that extended far into the inlet. In this picture from 1893, the dock, which became known as New Kamilche, was the major shipping site for S. G. Simpson and Company. In another 10 years, Simpson's logging company would be the largest in the state of Washington. (Courtesy of Simpson Timber Company and Don Pauley.)

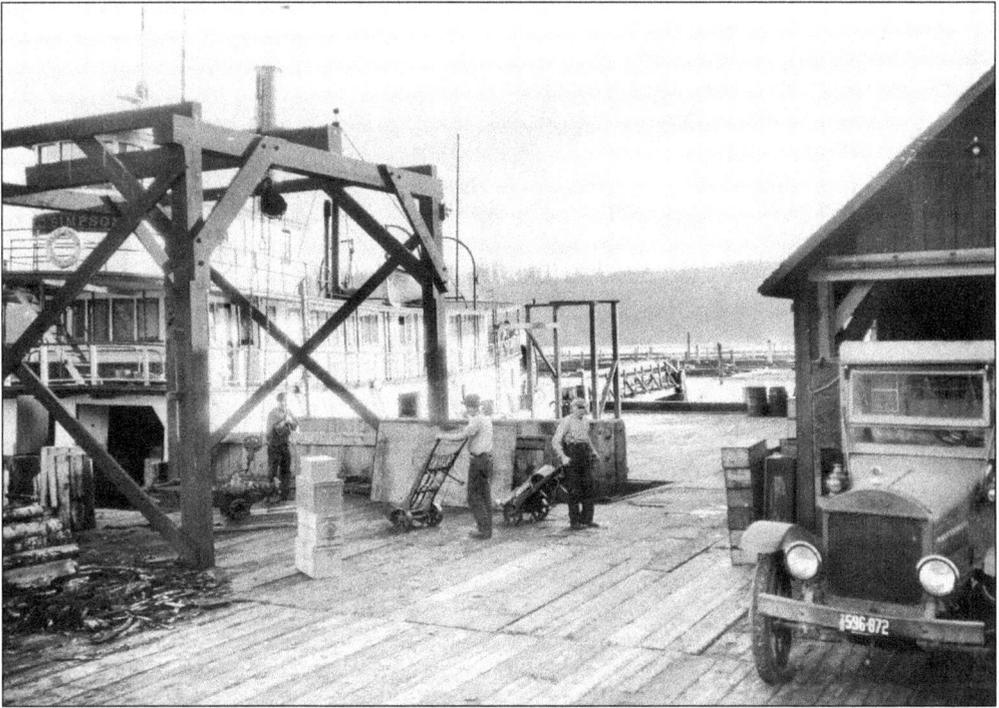

The SS *S. G. Simpson* was built by Crawford and Reed in Tacoma in 1907, a year after Sol Simpson died. It is seen at the wharf in Shelton being loaded for a trip to Olympia around 1910. (Courtesy of MCHS.)

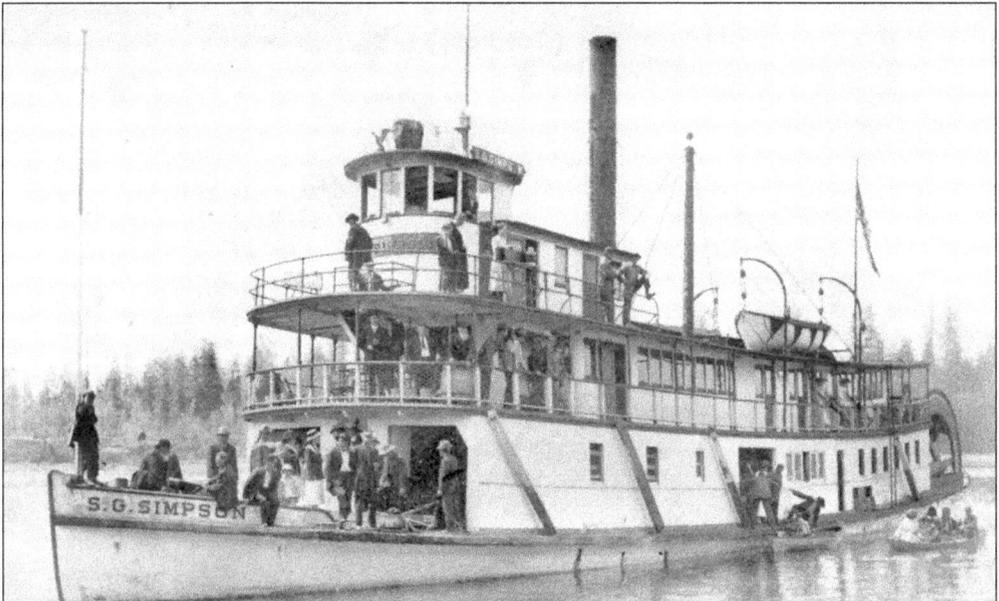

One of Sol Simpson's many enterprises was the Shelton Transportation Company, which owned a fleet of steamboats. The SS *S. G. Simpson* became the flagship for the fleet. Here, on July 4, 1911, passengers disembark into rowboats to attend a celebration on Harstine Island. (Courtesy of Simpson Timber Company and Don Pauley.)

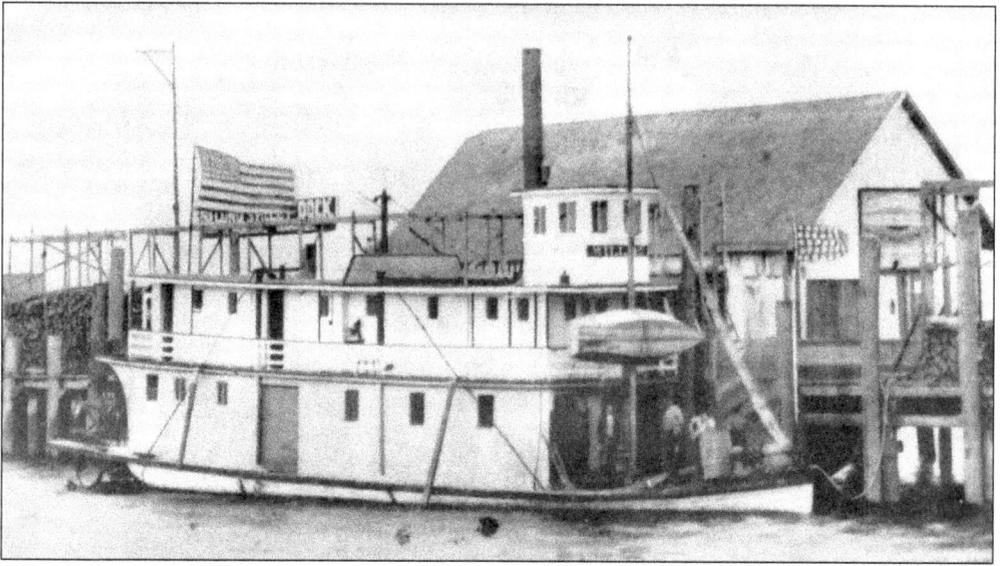

Another logger and sawmill owner also owned a fleet of paddle wheelers. Sam Willey's sons, Lan and Lafe Willey, operated the SS *Willey* between Shelton and Olympia from 1886 to 1900. The Willeys had started with a rowboat and the U.S. Mail contract years before. The SS *Willey* is docked in Olympia prior to a trip to Shelton in 1890. (Courtesy of Simpson Timber Company and Don Pauley.)

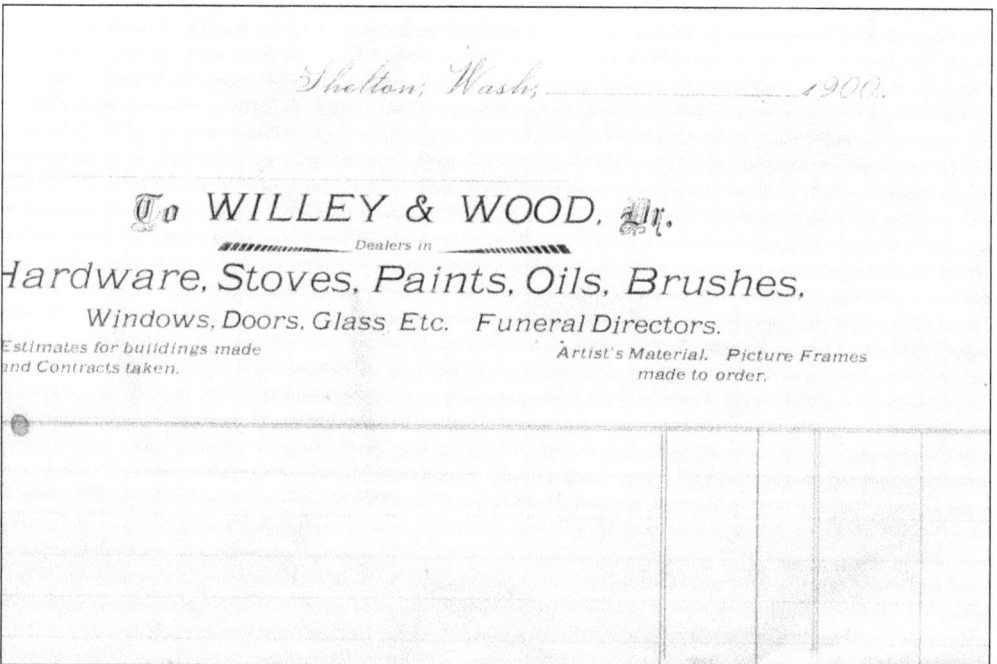

This Willey and Wood invoice from 1900 demonstrates the variety of work all the early settlers to Shelton were willing to do. Besides hardware and art supplies, the Willey family members were funeral directors. They could even build a casket as well. (Courtesy of MCHS.)

Born in Maine in 1849, W. H. Kneeland graduated from Lee Normal Academy in 1868. Teaching provided no challenge for him, and soon he went to the oil fields of Pennsylvania. In 1882, he arrived in Shelton with his brother, Frank, and $80,000 to buy 2,000 acres of land from David Shelton 3 miles from the water. He built a sawmill but soon was in debt. Selling the sawmill, he went to Tacoma, and having no luck there, he returned to Shelton in 1887. He bought his old sawmill back and began platting land for sale to new arrivals. In 1888, he began building the Shelton Southwestern Railroad after engaging several other investors in this endeavor. W. H. Kneeland was also a rancher, owning both beef cattle and Jersey cows on his 1,200-acre ranch. He built a theater, an electric company in 1904, and various other buildings in the town. He was mayor for one term and served in the legislature. He raised his family in Shelton and was a member of five fraternal organizations. (Courtesy of Susan Kneeland.)

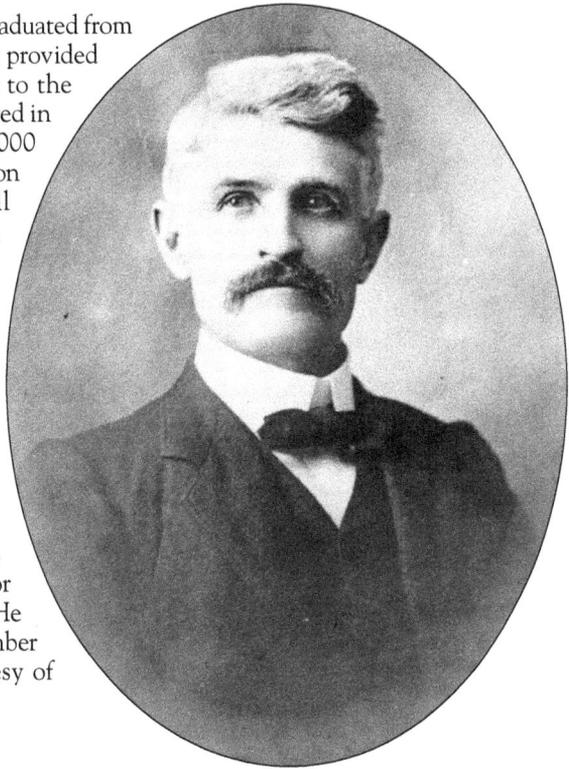

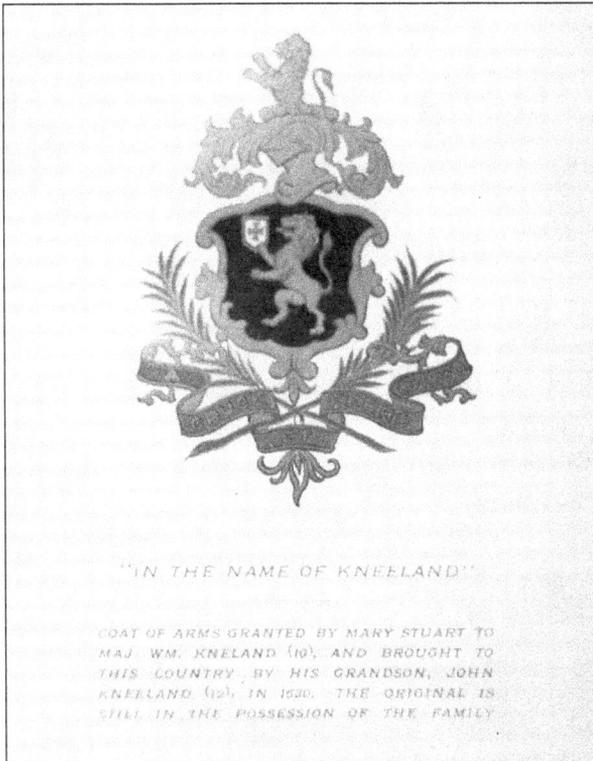

"IN THE NAME OF KNEELAND"

COAT OF ARMS GRANTED BY MARY STUART TO MAJ. WM. KNELAND (10), AND BROUGHT TO THIS COUNTRY BY HIS GRANDSON, JOHN KNEELAND (12), IN 1630. THE ORIGINAL IS STILL IN THE POSSESSION OF THE FAMILY

The Kneeland coat of arms dates back to Mary Stuart, Queen of Scots, in 1552. It was granted by her to Maj. William Kneeland and brought to North America in 1630 by John Kneeland, his grandson, who was the great-great-great-grandfather of W. H. Kneeland. The motto is Latin, meaning, "My heart and sword for light." (Courtesy of Susan Kneeland.)

27

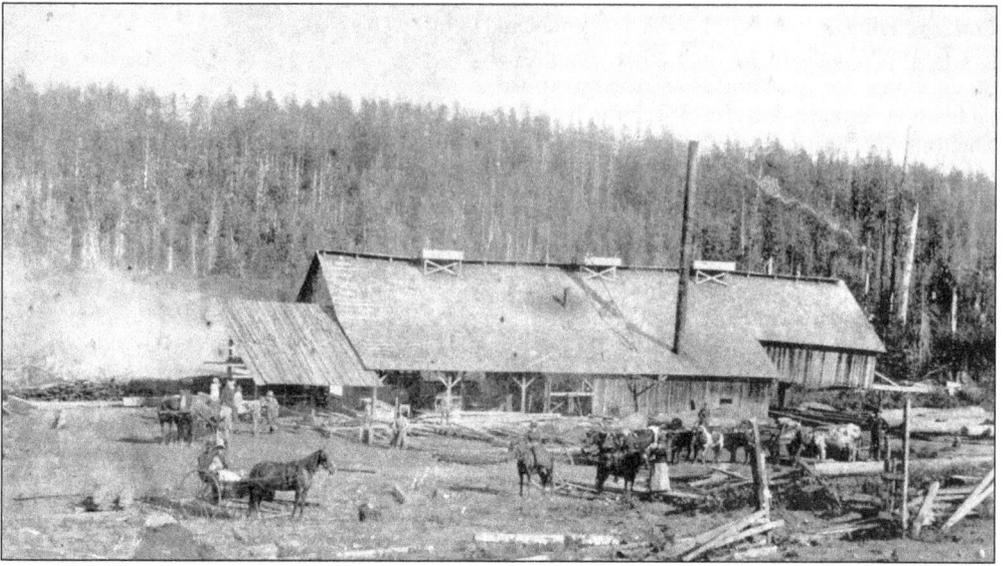

The W. H. Kneeland mill in the Shelton Valley is pictured here in 1890. The crew gathered for this photograph. W. H. Kneeland is in the buggy with his wife, Delia. Before building a railroad to haul lumber to the dock in Shelton, Kneeland had a flume system where lumber or logs were floated to the water on the bay. (Courtesy of Simpson Timber Company and Don Pauley.)

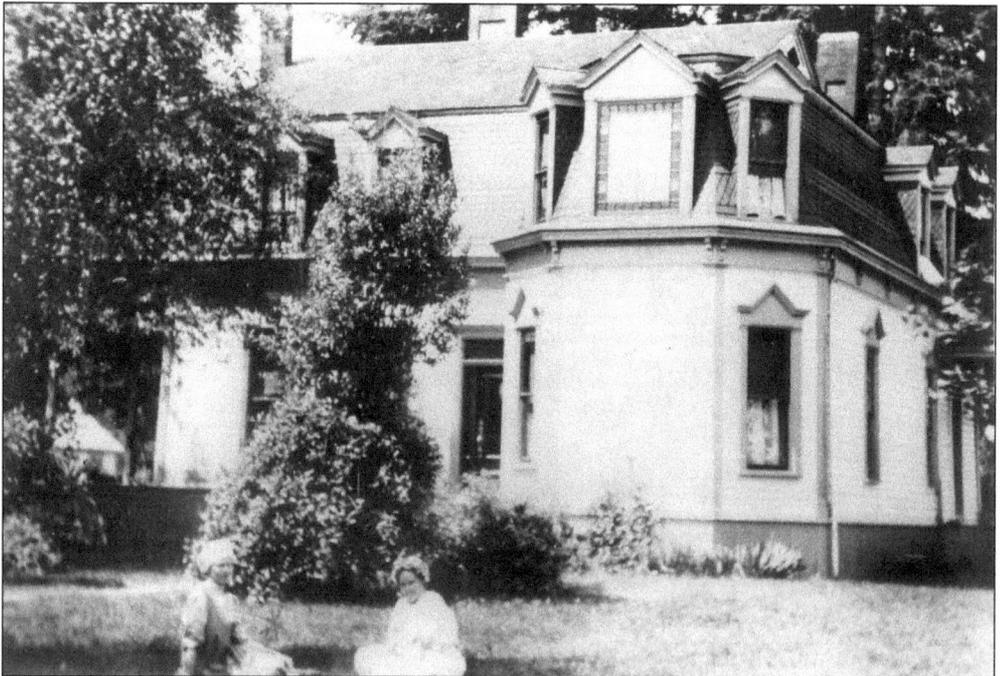

W. H. Kneeland's home in Shelton is pictured in 1910. Seated on the lawn are two Norwegian immigrants who worked as maids in the home. On the left is Inge Tolefson, and on the right is Signe Anderson. Both women married nephews of W. H. Kneeland. (Courtesy of MCHS.)

Two

THE COUNTY SEAT

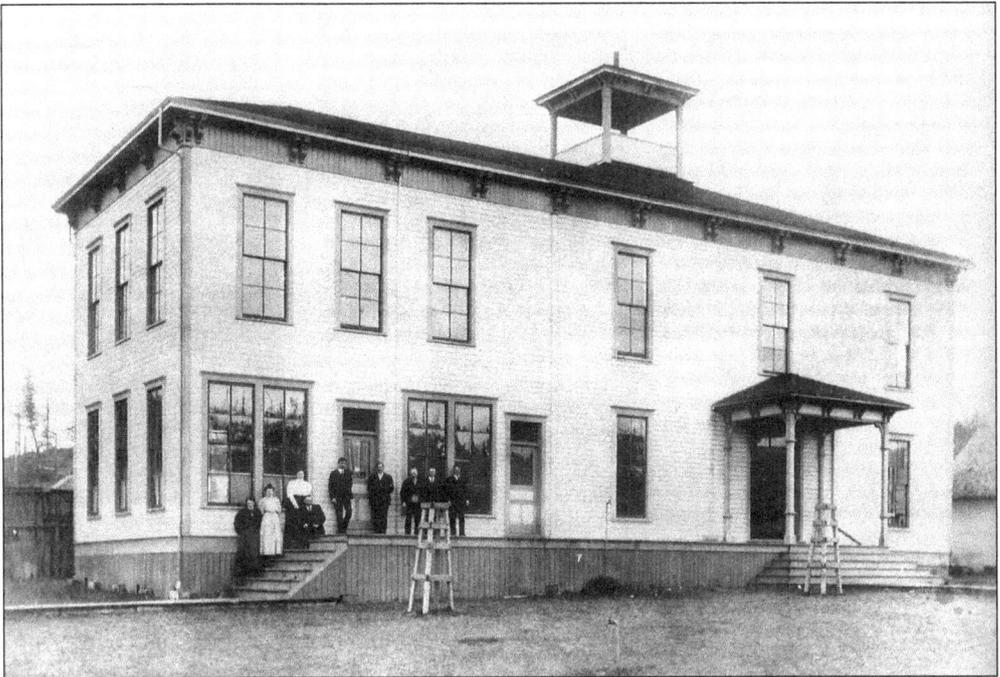

Shelton was voted the Mason County seat in 1888, and soon the courthouse was too small for the booming population and business ventures in the county. The staff and county commissioners gathered for this photograph of the new addition in 1904 are, from left to right, Susie Myers, Ella Chapman, Emma (McReavy) Huntly, Eli B. Robinson (seated), Will McDonald, Al J. Munson, Samuel L. Woods, A. L. Bell, and Dan Bannse. (Courtesy of MCHS.)

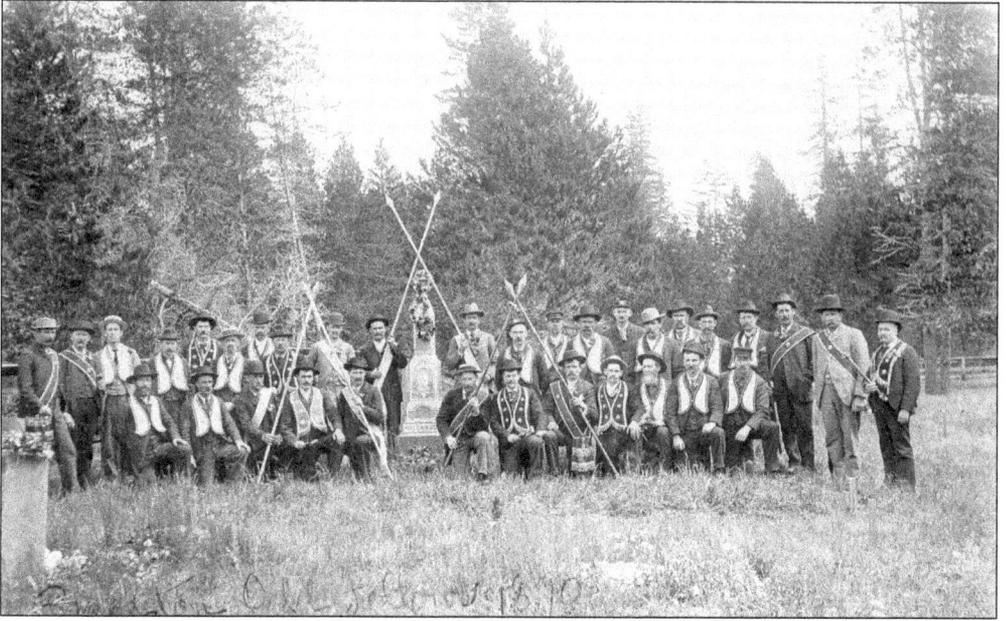

There were many fraternal organizations from Oakland to Kamilche. The Masons were prominent. Here the Odd Fellows gather in a field in 1890. Many men belonged to more that one group, building friendships and joining together in business ventures. There was usually a women's auxiliary group of each club. (Courtesy of MCHS.)

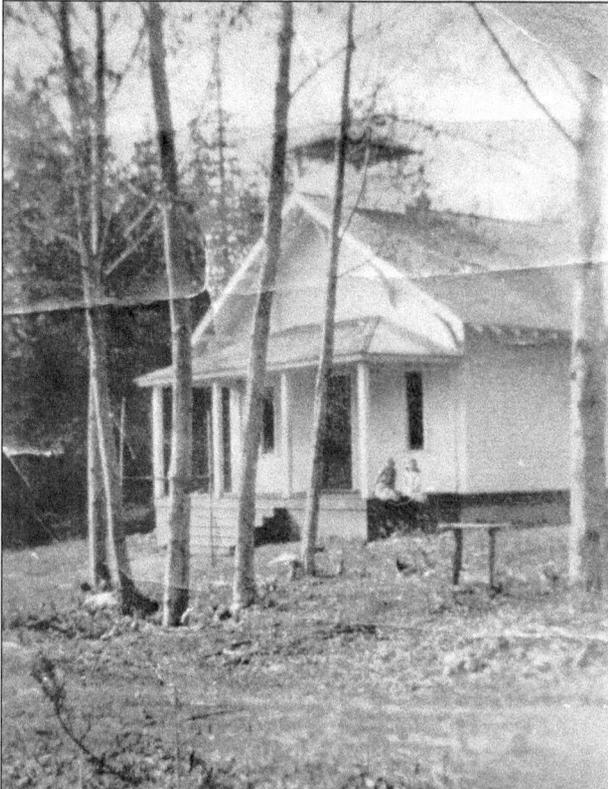

The schoolhouse at Arcadia (also known as Arkada), pictured around 1890, was one of many schools in Mason County. As with all the settlements, education was a vital part of the community. Often the school was the first noncommercial community building erected. Schools brought the local children together for learning and friendship. The two girls sitting on the porch are unidentified. (Courtesy of Virgil Fox.)

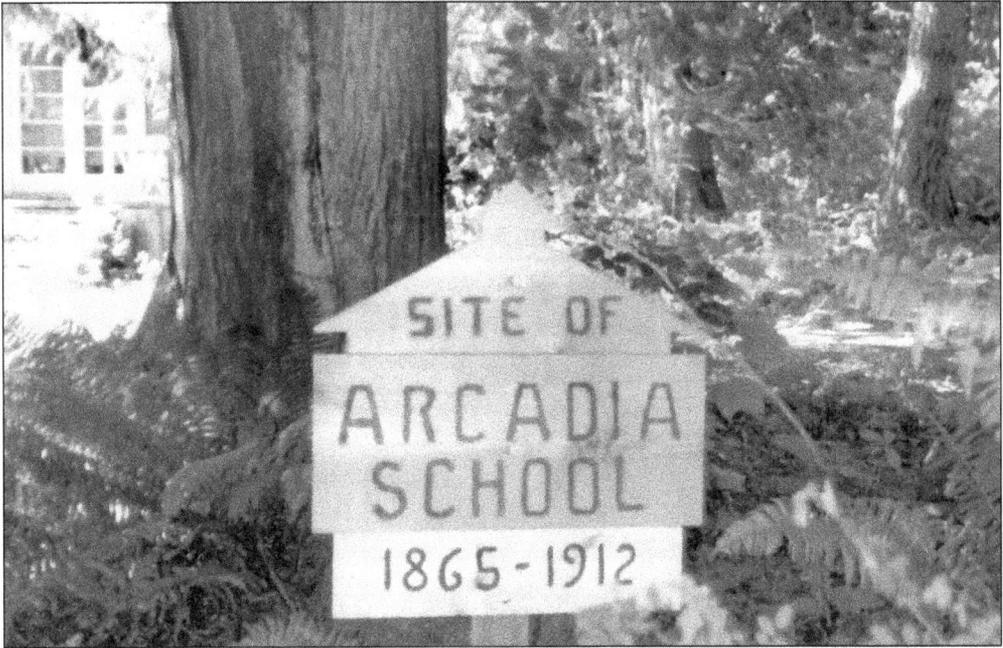

In 1987, this sign was erected by the Mason County Retired Teachers Association to mark the location of the Arcadia school. Many of these signs are placed around the county in an effort to maintain a connection with the historical significance of property currently used for other purposes. (Courtesy of Virgil Fox.)

The Forbes School at Kamilche was the first built there. The school was also referred to as the Kamilche School. It was torn down in 1957, necessitating another plaque to be erected at the site similar to the one at the Arcadia school location. These plaques can be found at numerous locations throughout the county. (Courtesy of MCHS.)

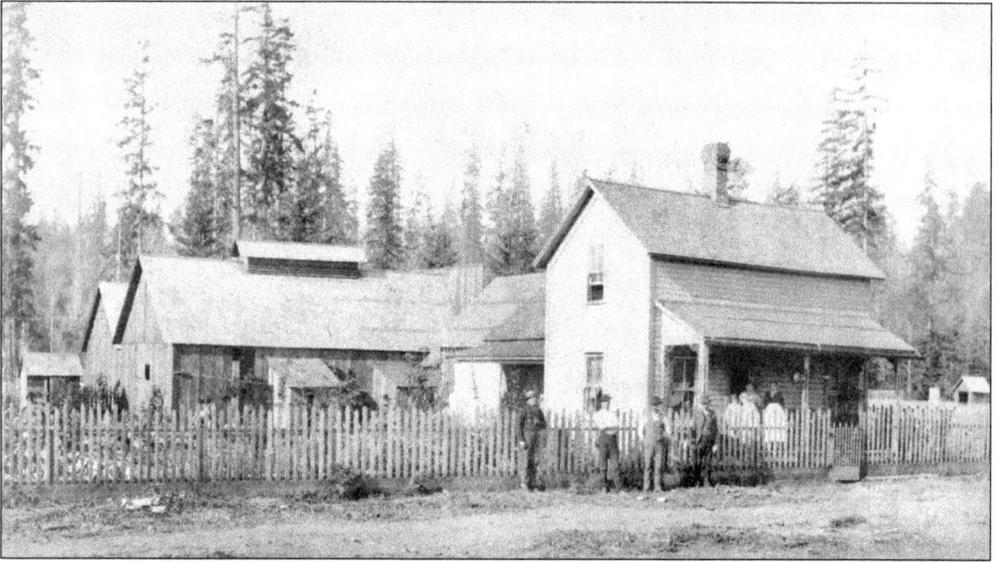

This home was built where the Govey Building is currently located at the corner of Fourth Street and Railroad Avenue. Standing at their home in 1889 is the Lemuel Graytroux family. Many French Canadians immigrated to Shelton from Quebec after Sol Simpson, and the *Mason County Journal* made it known that there was plenty of land and plenty of work. (Courtesy of Simpson Timber Company and Don Pauley.)

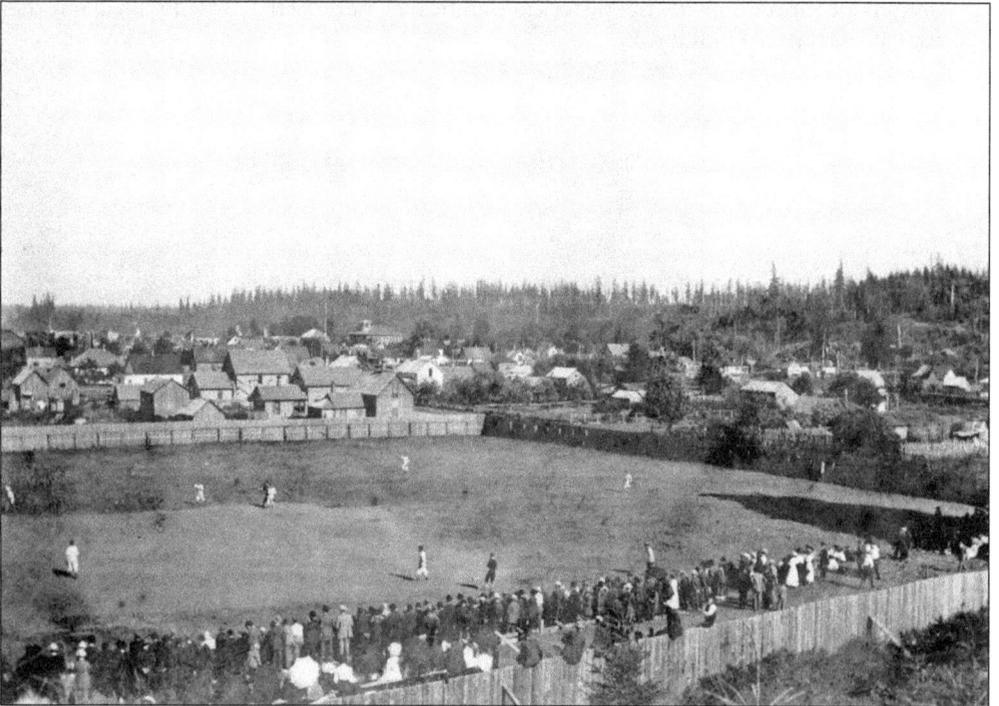

Loop Field was the place to be on a Sunday afternoon in the 1890s. Shelton had its own baseball team; others came from around the peninsula. A heavy hitter, Ham Hyatt left Shelton to play for Pittsburgh in the National League. Butch Byles played in the Pacific Coast League, and Alex Harper went on to play for the American Association. (Courtesy of MCHS.)

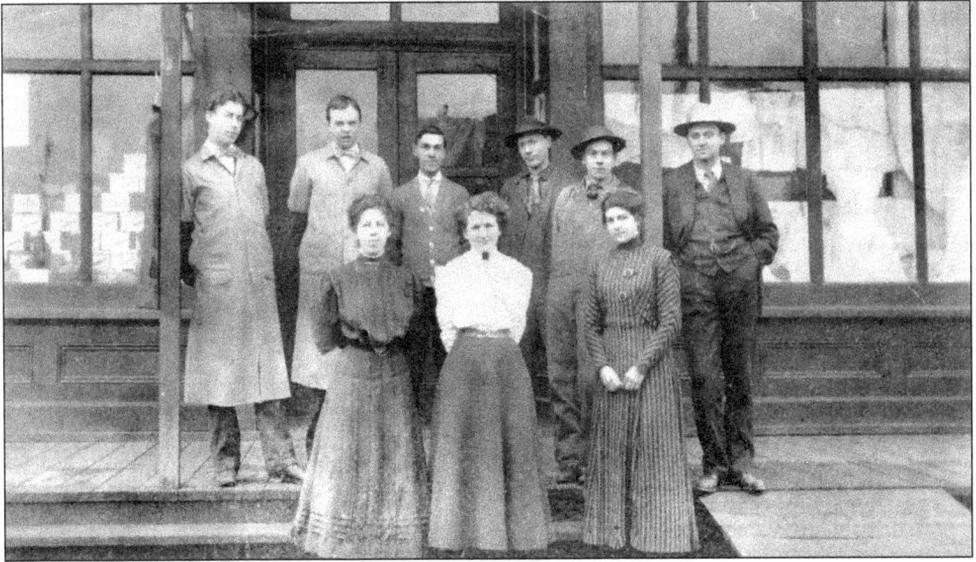

In 1895, several Shelton timber companies pooled their resources to open the Lumbermen's Mercantile Company. The motto of the store was "Everything from a Needle to a Locomotive." The staff of 1910 is, from left to right, (first row) Anna Olson Runacres, Carrie Callow Hurley, and Stella Crabb Kesterman; (second row) ? Smith, Herman Wyatt, Clarence Waddle, Phil Fredson, Lawrence Fredson, and C. S. McGee. (Courtesy of Simpson Timber Company and Don Pauley.)

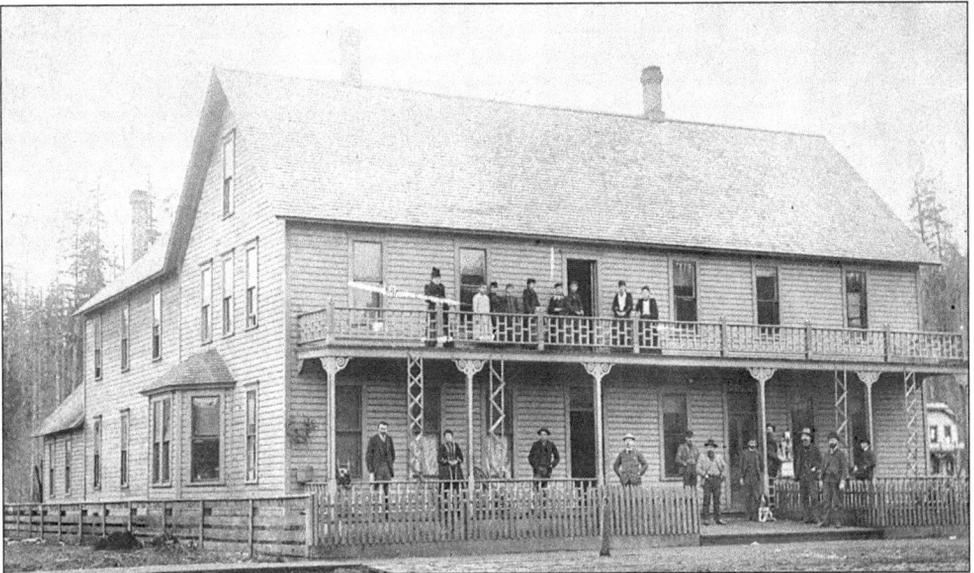

Guests line the balcony and porch at the Dipman Hotel in Shelton around 1898. Coming into town from the logging camp on Saturday to do some shopping, attend a ball game, or enjoy some other function was the highlight of the week for a logger's family. There was always need of a place to spend Saturday night and have a nice meal, then return with the train on Sunday. (Courtesy of MCHS.)

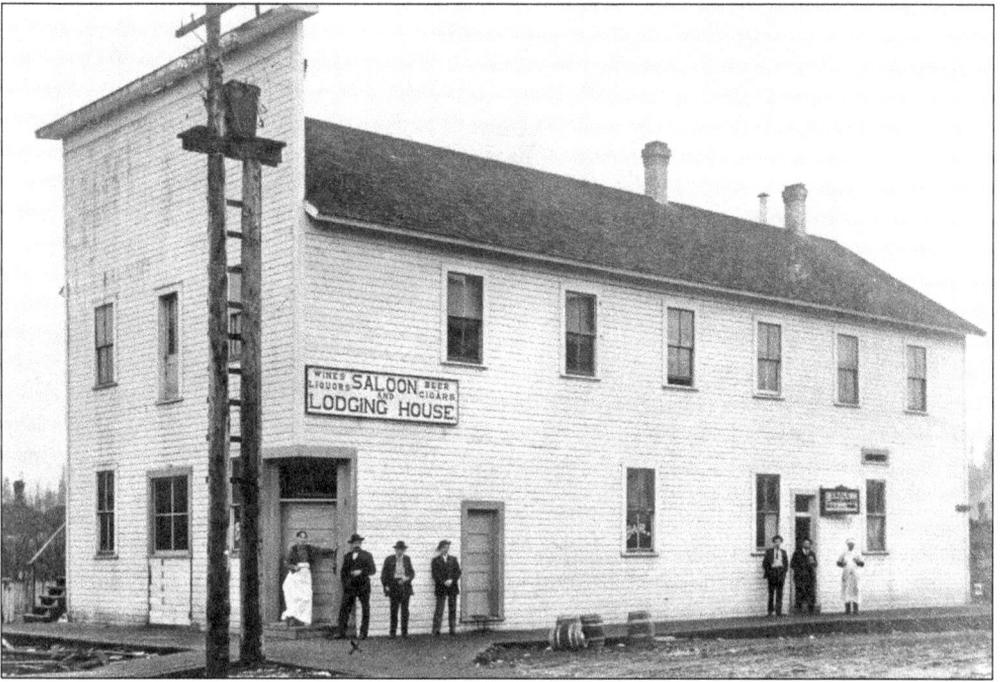

Paulson's Saloon and Lodging House provided additional space to stay for the hardworking logger when he ventured into Shelton on the weekend. Note the sloping walkway from the door to the street. No stairs here for an inebriated logger to fall down. (Courtesy of MCHS.)

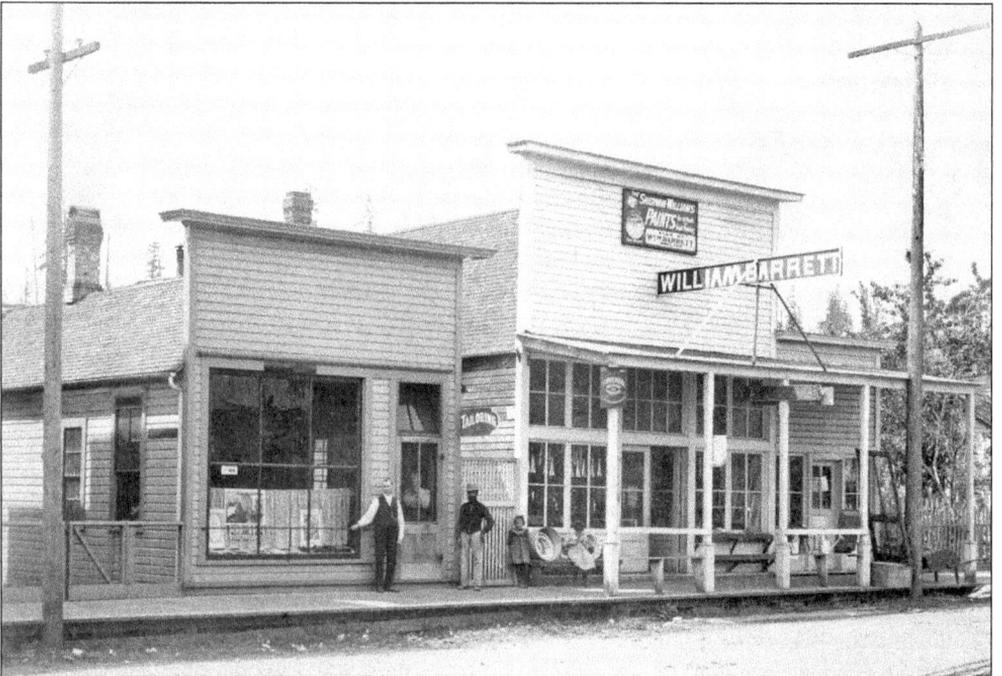

William Barnett's general store on Cota Street was another place for the people of Shelton and the surrounding logging camps to shop without going all the way to Olympia. With a tailor shop next door, any logger could dress in high style for the Saturday night dances. (Courtesy of MCHS.)

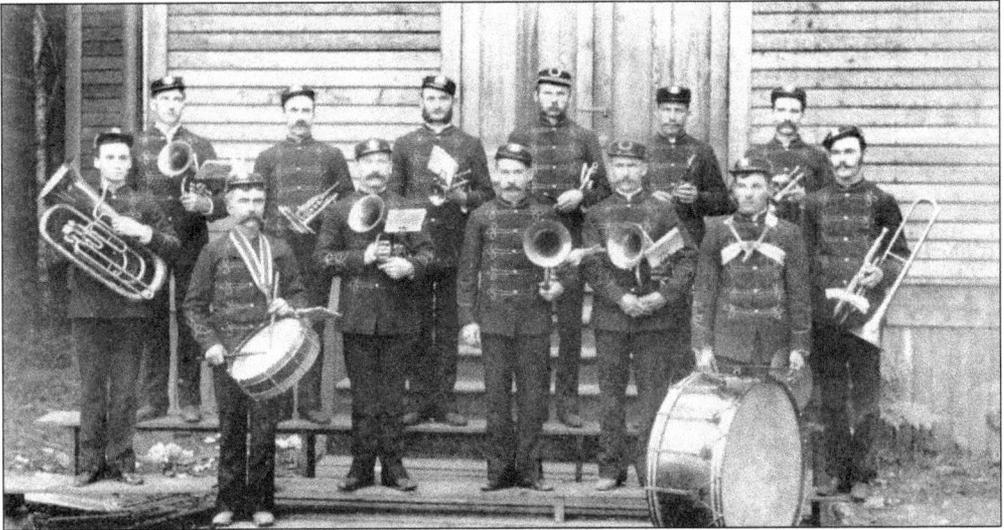

The 1892 Shelton Band brought culture to the rugged logging community. Members of the band are, from left to right, (first row) Prentice Dunbar, W. W. Smith, Charles Wiss, Billy Kennedy, W. L. Sargison, A. L. Saeger, and Grant Angle; (second row) Elias K. Carey, Charles Norton, Hiram Dunbar, William Asmus (director), ? Pugh, and Vader Dunbar. (Courtesy of Simpson Timber Company and Don Pauley.)

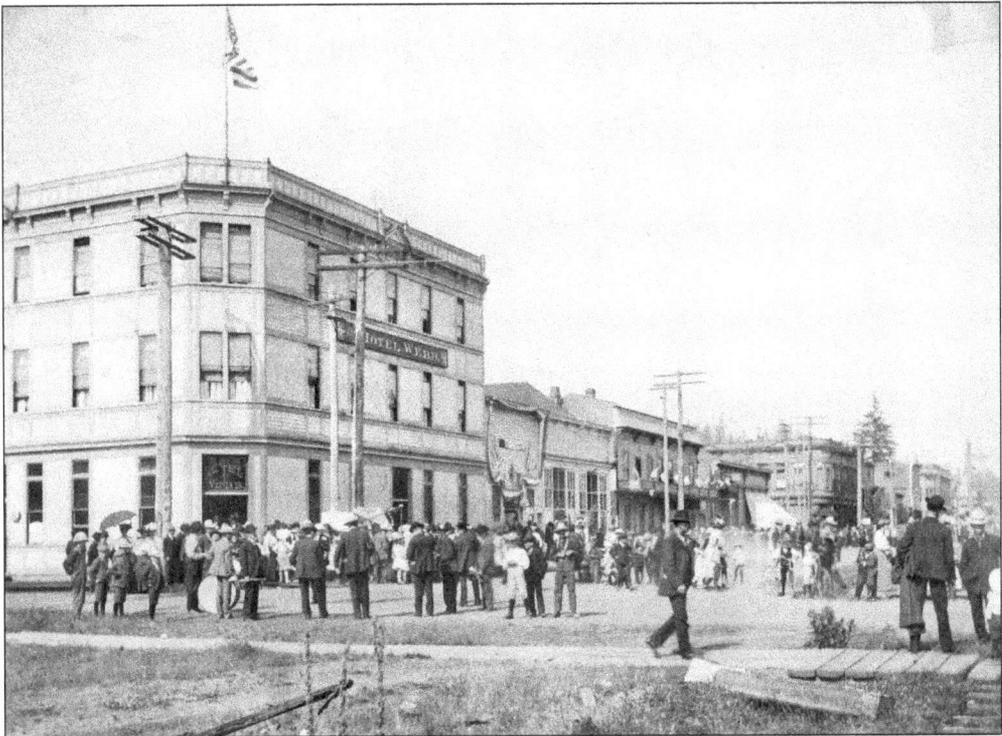

The Hotel Webb, on the corner of First Street and Railroad Avenue, was a perfect place to watch the July Fourth parade in 1904. The hotel caught fire on September 5, 1907. Eleven people lost their lives in the blaze, and 20 were injured. Henry Faubert, who owned the hotel, quickly began constructing a new hotel of tile block and called it the Hotel Shelton. (Courtesy of MCHS.)

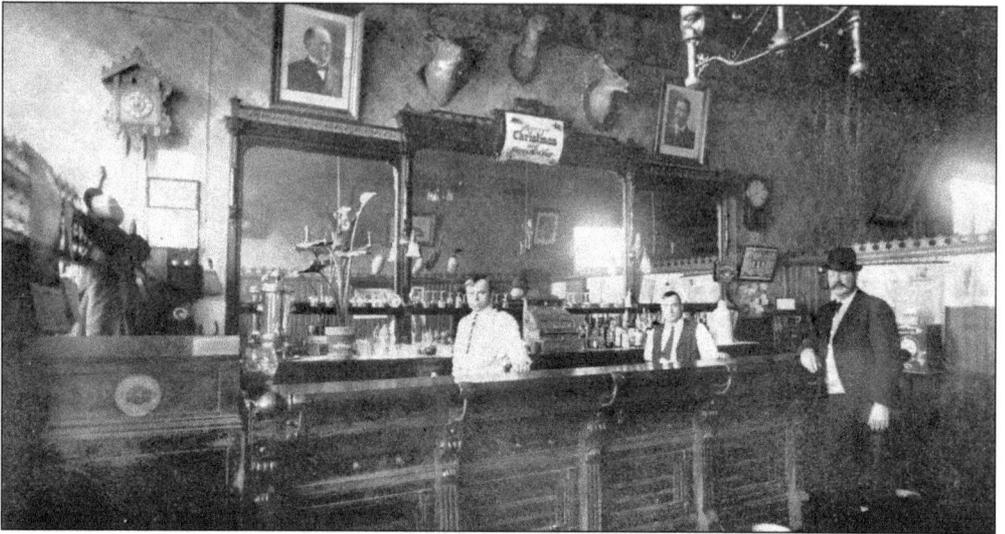

Billy Forbes left his job as bull whacker to own the Bear, "one of Shelton's better saloons," according to Stewart Holbrook. Enjoying Christmas at the Bear around 1900 are, from left to right, bartenders Billy Warren and Del Cheiner and Billy Forbes. (Courtesy of Simpson Timber Company and Don Pauley.)

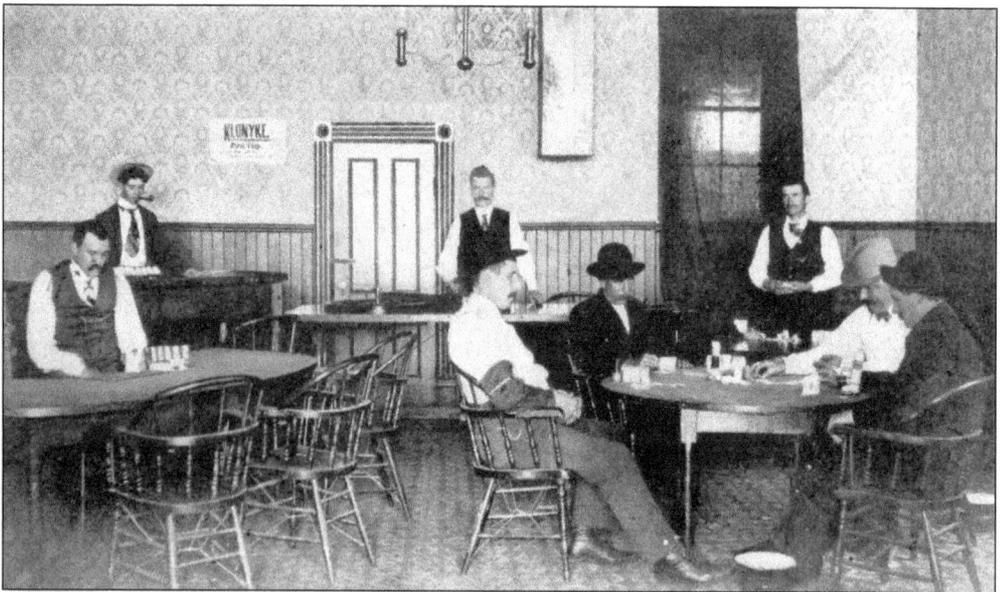

The Bear was set up for gambling in the back room. Games like klondike and poker were Saturday night entertainment for some. Dealers and players are, from left to right, Ben Williamson, Roy Simpson, Scotty Ironside, Orman Huntley, Miles Doyle, Harry Sprague, Billy Forbes, and Billy Daniels. (Courtesy of Simpson Timber Company and Don Pauley.)

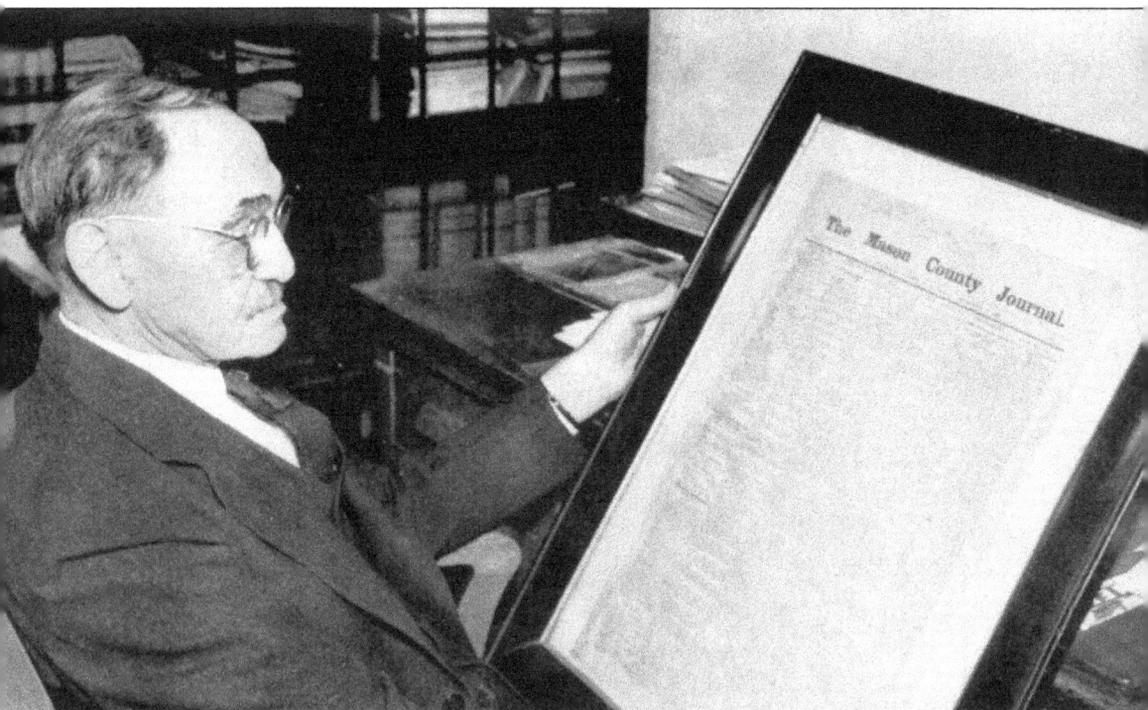

Grant C. Angle published the first issue of the *Mason County Journal* on December 31, 1886. He was in his early 20s, and he loved reporting the events of the young town of Shelton and advertising its needs to the world. Early on, he also recorded the histories of the pioneer settlers to Mason County, encouraging them to write their own stories, which he kept on file and later used for supplemental editions of the paper. He kept abreast of the times, ordering the latest equipment in the way of presses, and in 1904, he constructed his own building to house the paper and other offices. Grant C. Angle at various times was postmaster, state legislator, volunteer fireman, land developer, and baseball player. He also played in Shelton's band. In 1890, he married Hattie Thomas, and they had five children. He sold the paper in 1945 and died in 1951. He had always been Shelton's biggest promoter. (Courtesy of Simpson Timber Company and Don Pauley.)

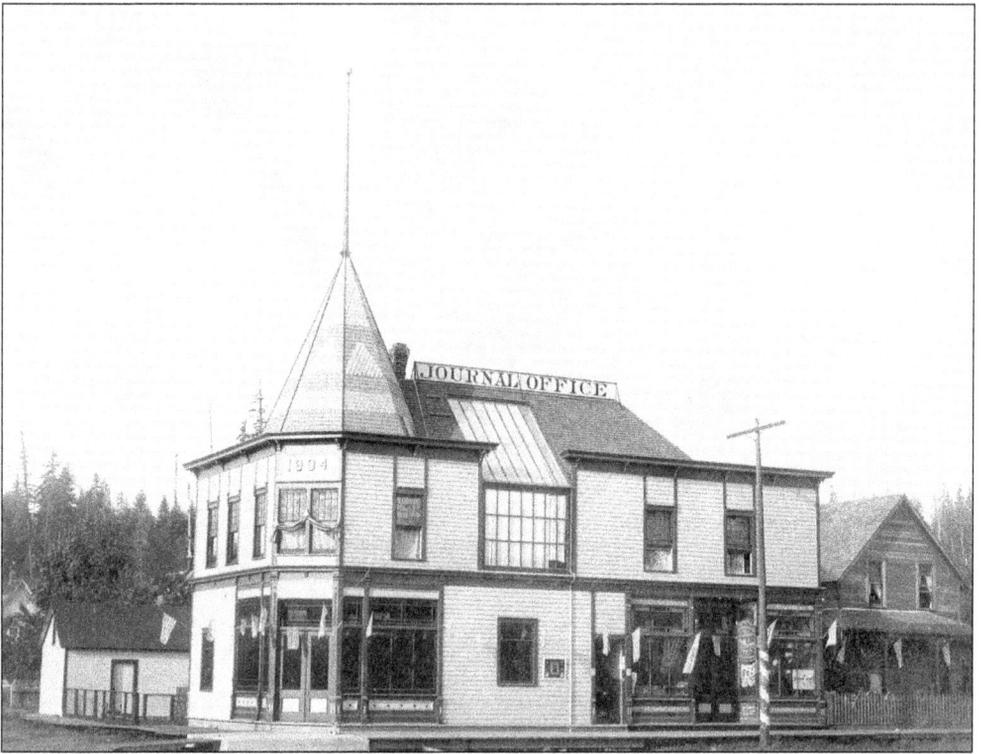

Grant C. Angle built this building in 1904 to house the printing presses of the *Mason County Journal*. The building also held the post office and photography studio. On the second floor were the editorial offices and a dentist office. There were other newspapers in Shelton, but none lasted like the *Journal*. (Courtesy of MCHS.)

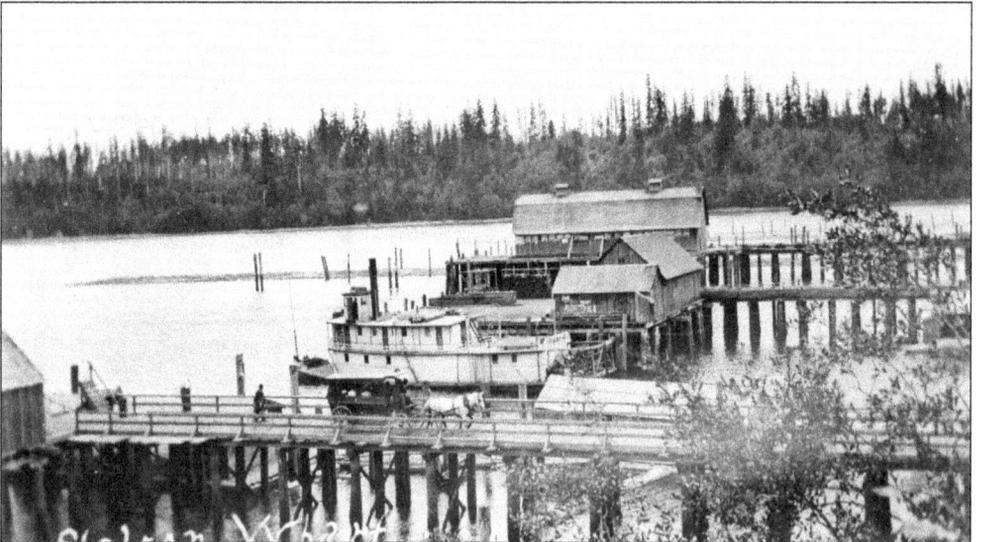

A 1900-era taxi carries passengers from the Shelton wharf into the town, where they can rent a hotel room, have dinner, play cards, or enjoy any of the other pleasures of the town. The stern-wheeler at the dock is the *Irene*, one of the boats in Simpson Transportation Company's fleet and named for his daughter. (Courtesy of MCHS.)

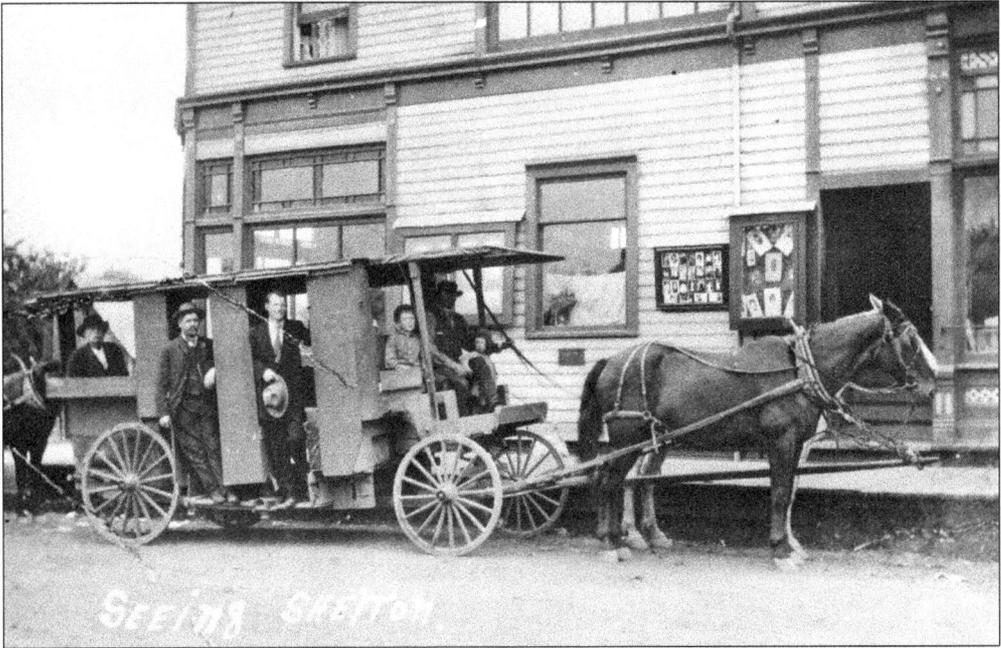

The taxi provides transportation for those who would rather avoid the muddy streets of Shelton while taking in the sights. Some hotels offered transportation to and from the dock as an incentive to guests to stay at their establishment. This taxi picks up fares by the *Journal* building around 1905. (Courtesy of MCHS.)

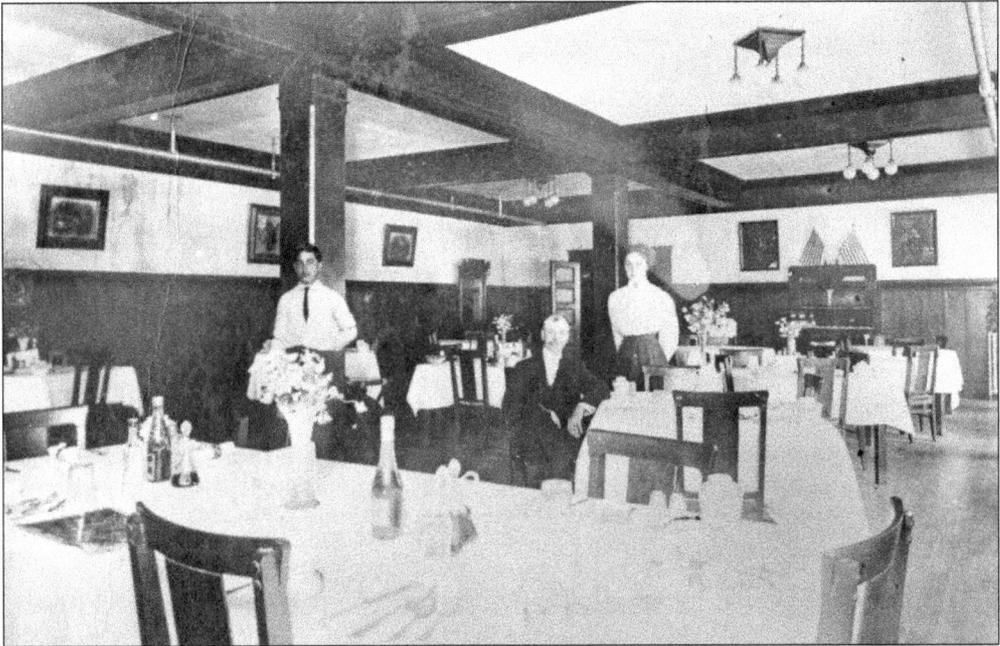

A. H. Anderson lived at the Webb Hotel in Room One. The dining room of the Webb Hotel, pictured around 1900, was an elegant dining experience. The day after this hotel burned down in 1907, owner Henry Faubert pitched a tent across the street for his customers and began plans to build a new and better hotel. (Courtesy of MCHS.)

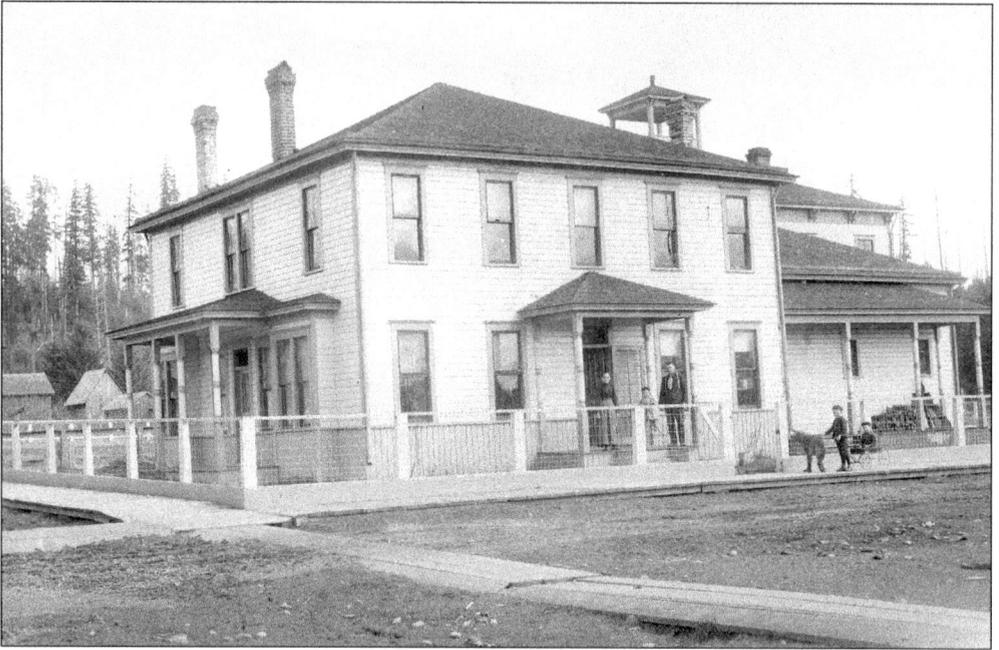

George Vogtlin and his family are pictured outside their home in 1888. Vogtlin was Mason County sheriff from 1889 to 1900. Planking on the streets helped keep the hems of women's long dresses a bit cleaner and mud off the shoes of everyone. The planks would not help, however when several inches of rain fell in one day. (Courtesy of MCHS.)

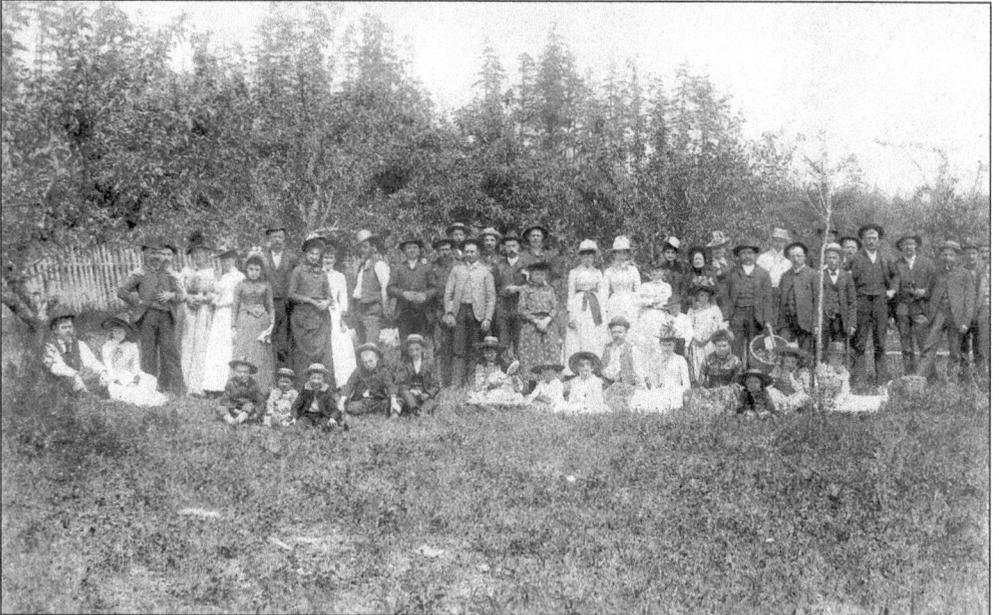

The families from the Kamilche rollway on the Blakely Railroad enjoy a summer outing on the farm of William Walter to pick cherries in 1890. Walter was the first teacher in Mason County and the first school superintendent. He married Catherine Collins, a widow at Collins Point, in 1870, after he returned to Puget Sound from fighting in the Civil War with a regiment from Indiana. (Courtesy of MCHS.)

Three

FARMING AND CHURCHES

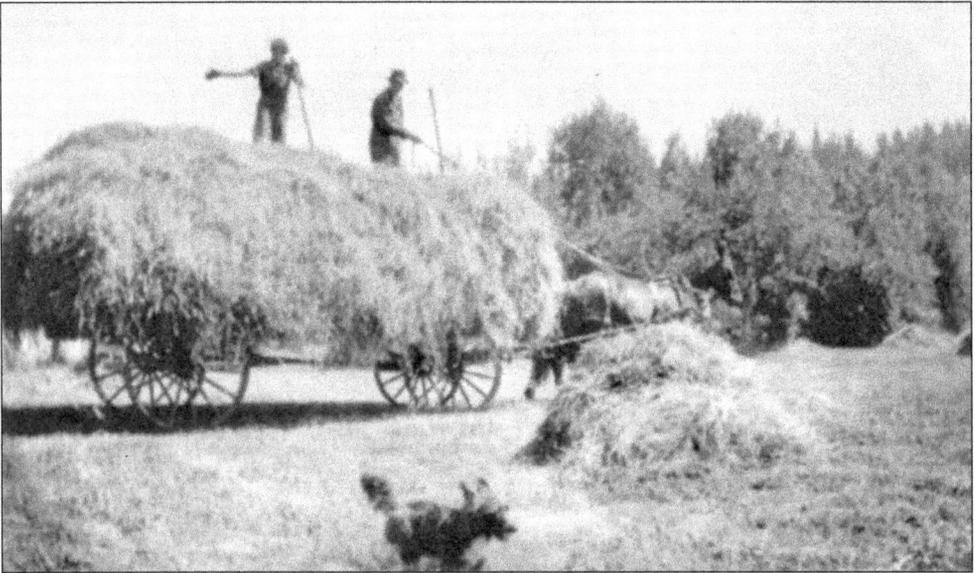

William Walter sold his claim of 146 acres on Little Skookum to Jeremiah Lynch in 1883. The land had been cleared and was ready to farm, except for the stumps, which were burned before a crop was planted and pastureland created. Haying on the Lynch farm was no easy task, even in 1935. (Courtesy of Frank Bishop.)

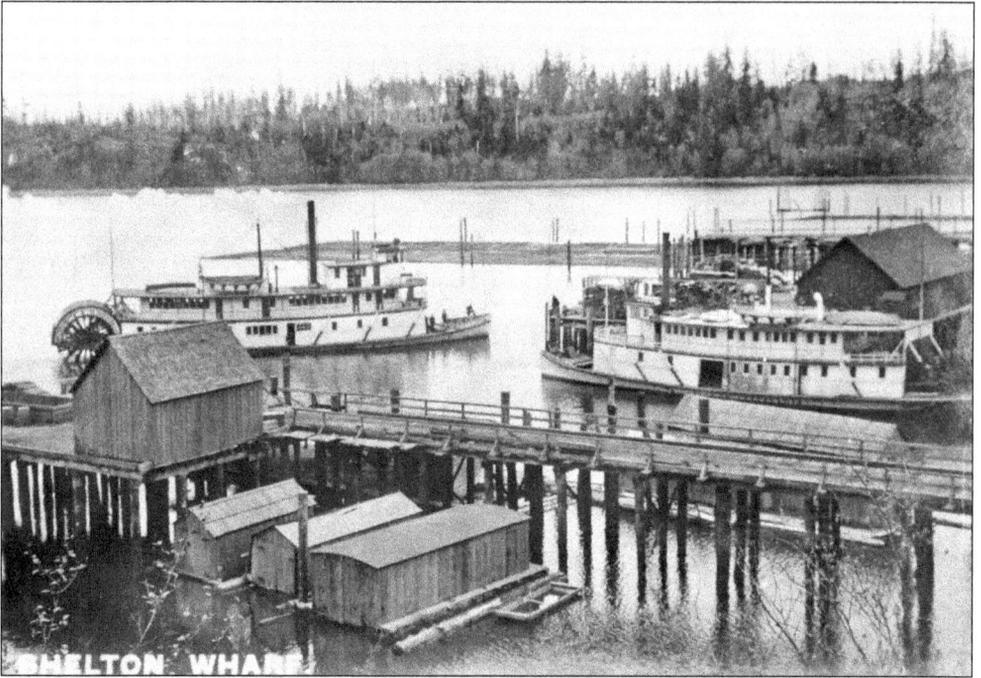

The Shelton wharf had increased traffic in the early 1900s. Here the SS *S. G. Simpson* and the *City of Shelton* come and go from the dock. There were two boats a day going from Shelton to Olympia. Note the rafts of logs at the middle of the picture. (Courtesy of MCHS.)

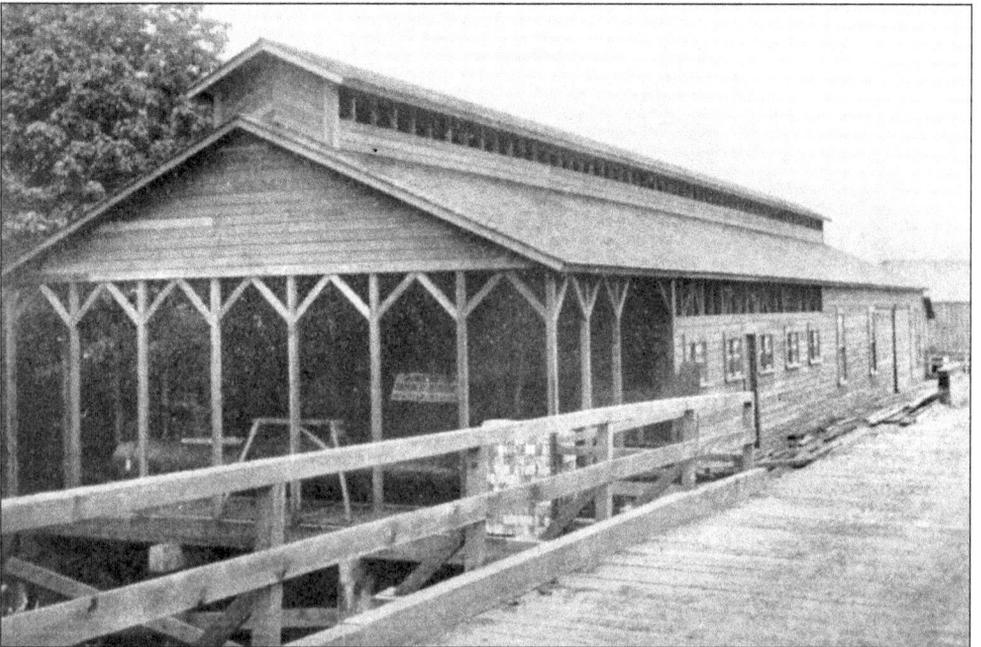

By 1909, the local farms and dairies supplied enough produce to support a cannery and creamery on the wharf. This made the importation of canned goods almost unnecessary. Although the building appears empty, this first cannery and creamery was a busy place in the early 1900s. (Courtesy of MCHS.)

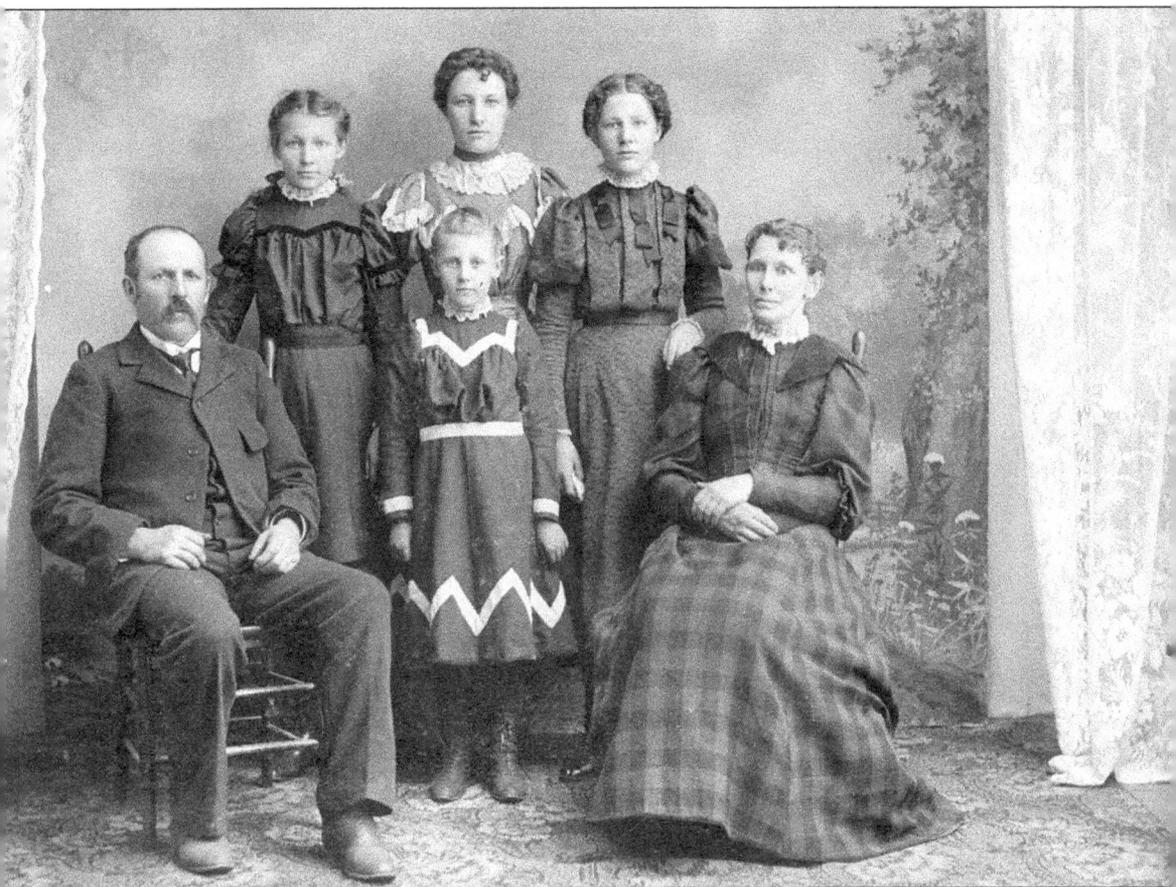

Minnie Belle Ridings was born at Porter in the Washington Territory in 1864. In 1882, she taught for four months at a school started by Capt. Ed Miller on Skookum Bay, where she earned $20 a month. It was at Captain Miller's home where she and Daniel Myers met. Myers worked as a logger for Captain Miller, but his trade was carpentry. Myers purchased 160 acres of farmland from David Shelton 3 miles up the Shelton Valley on which he built a small log cabin. Minnie Ridings and Daniel Myers were married in 1883. In this anniversary portrait taken on April 10, 1899, are, from left to right, (first row) Daniel Myers, Lelia Myers, and Minnie Bell Myers; (second row) Susie Estelle Myers, Ada Myers, and Eva Jane Myers. The youngest Myers daughter, Dorcas, was born in 1901. (Courtesy of John Tegtmeyer.)

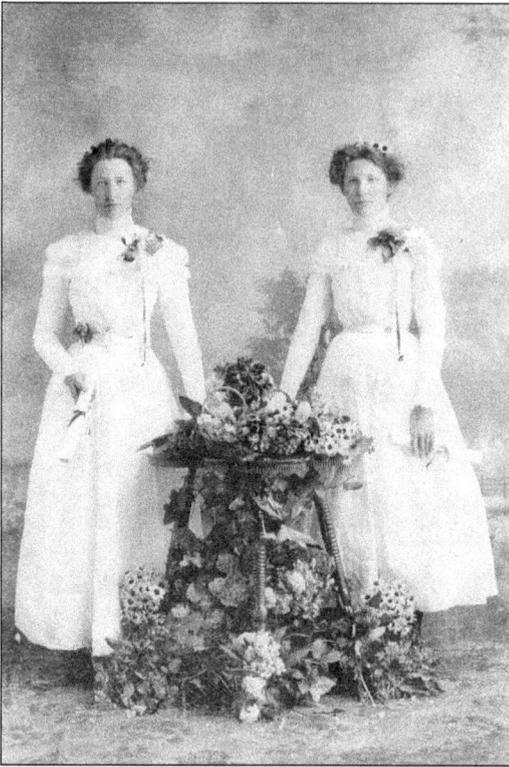

Graduation day for the two oldest Myers girls was captured in the portrait of 1900. Ada Myers (left) graduated from ninth grade and Eva Jane Myers from eighth grade at the Shelton school 3 miles from their farm. Education was important in this family of five girls. (Courtesy of John Tegtmeyer.)

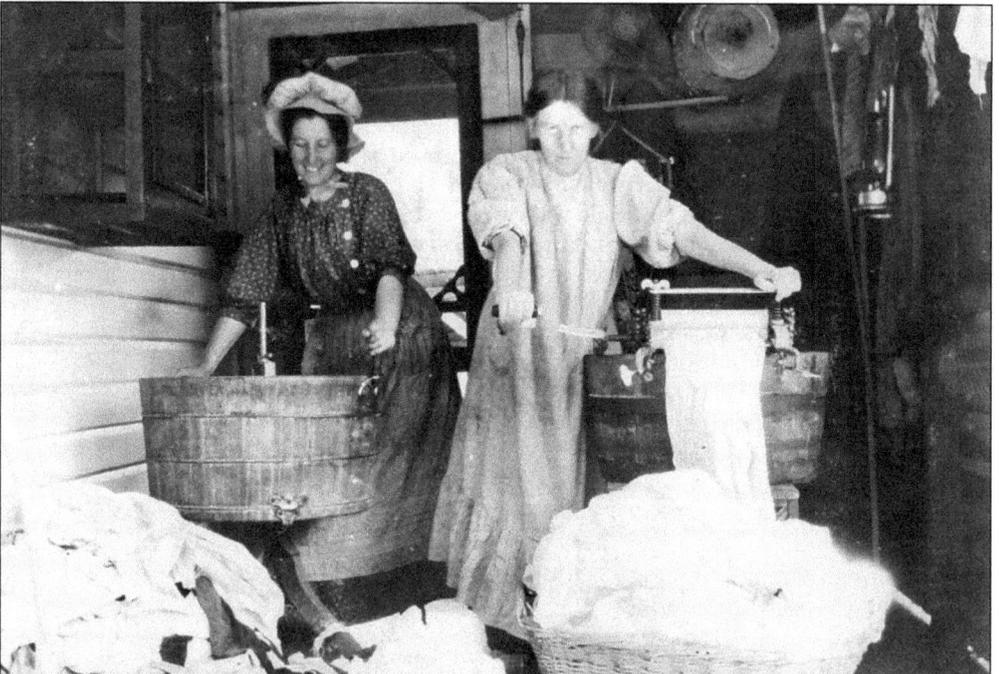

Life was not all posing for the camera for the Myers girls. Ada (left) and Eva Jane (right) face a big wash day in this candid 1902 picture. This chore occurred every week on the Myers farm. (Courtesy of John Tegtmeyer.)

Eva Jane Myers carries milk buckets in from the barn at her parents' farm outside the town of Shelton in 1902. "Where there are no boys, the girls do all the work," Minnie Bell Myers would say. The Myers farm provided produce and milk for the new cannery and creamery in Shelton. (Courtesy of John Tegtmeyer.)

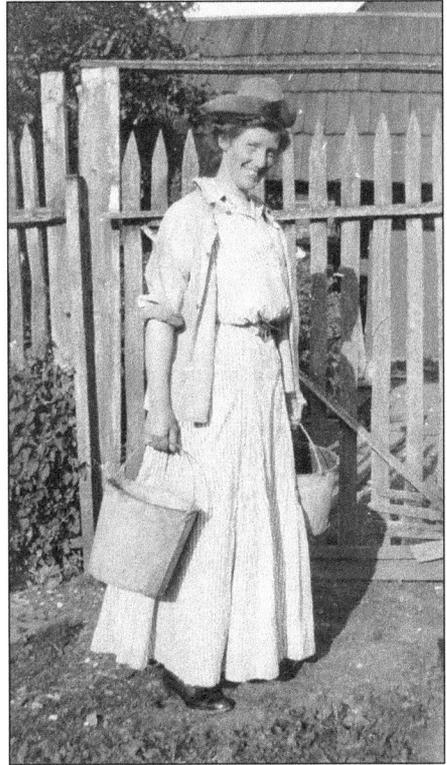

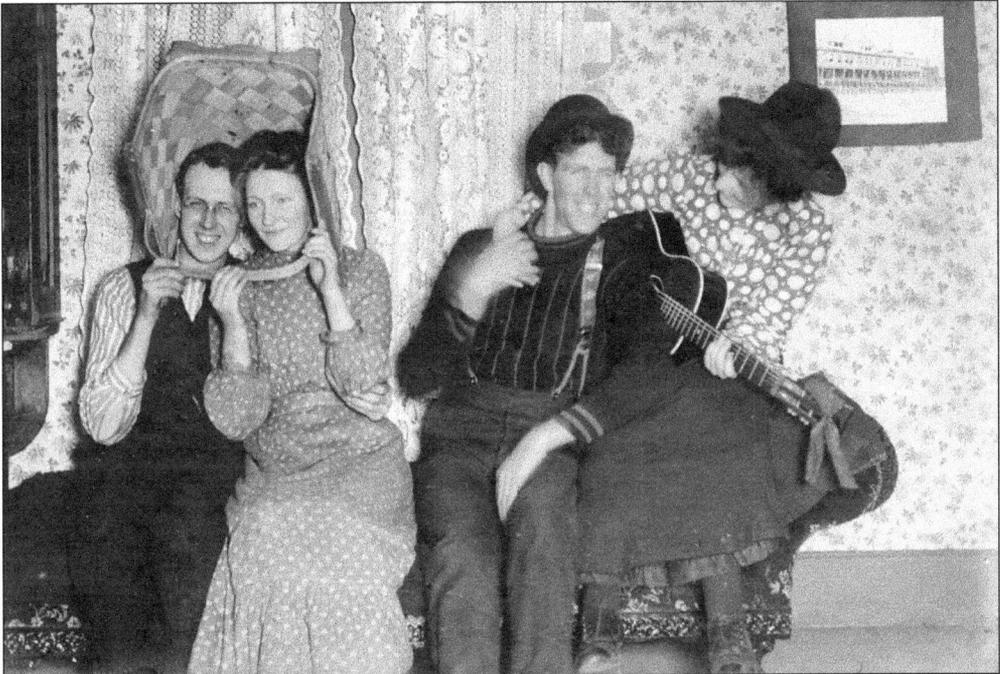

On the Myers farm, when the cousins visited, silliness ensued and the camera came out. Having fun and enjoying some music in the parlor in 1904 are, from left to right, Paul Ridings, Susie Myers, Howard Ridings, and Eva Jane Myers. (Courtesy of John Tegtmeyer.)

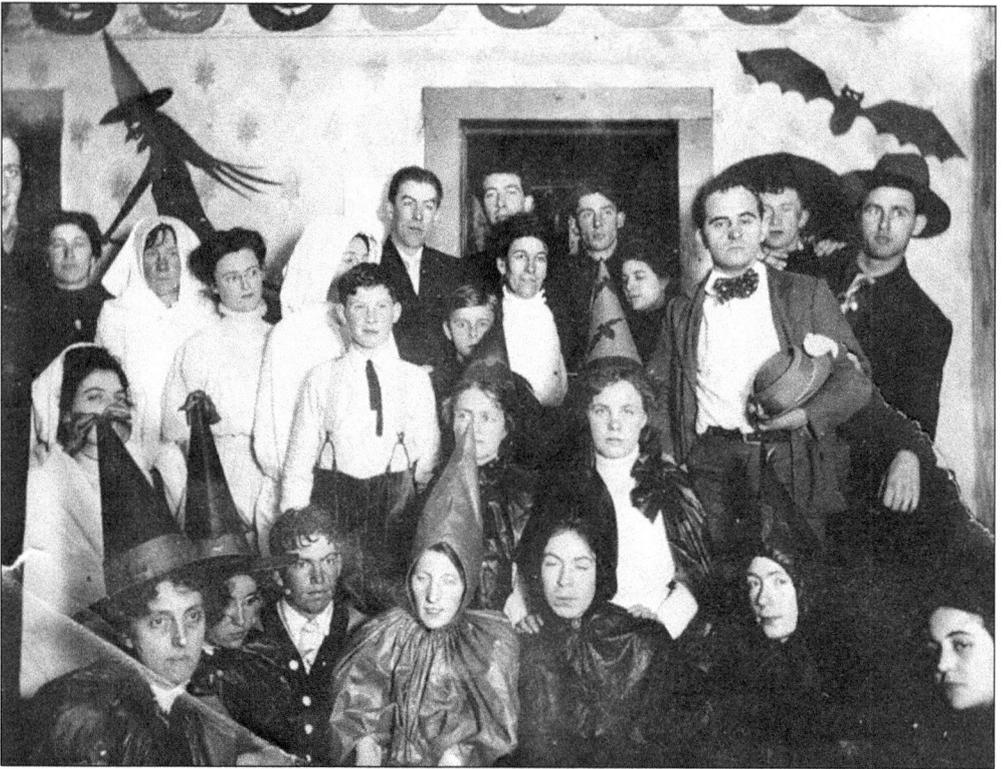

Putting on plays and musical entertainments were common events for a farming family in the early 1900s. Here the Myers girls enjoy putting on costumes for a Halloween party with friends and relatives from Shelton and Porter, Washington. (Courtesy of John Tegtmeyer.)

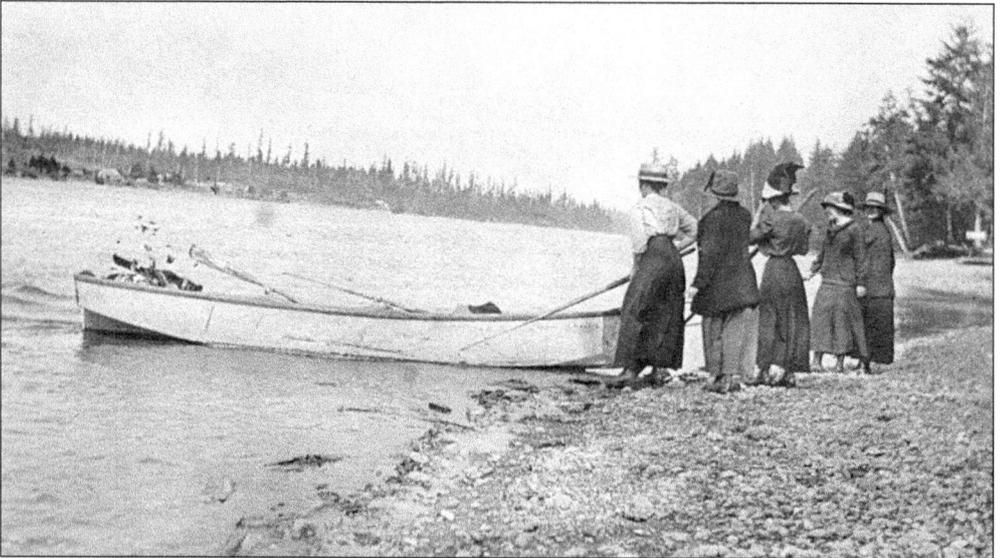

All dressed up for a visit with someone at Arcadia, the Myers girls forgot to check the tide, and their boat got stuck on the mud flats along Hammersley Inlet. It probably would not be the last time they were in this dilemma. If they could not push it off with an oar, someone would have to wade for it. (Courtesy of John Tegtmeyer.)

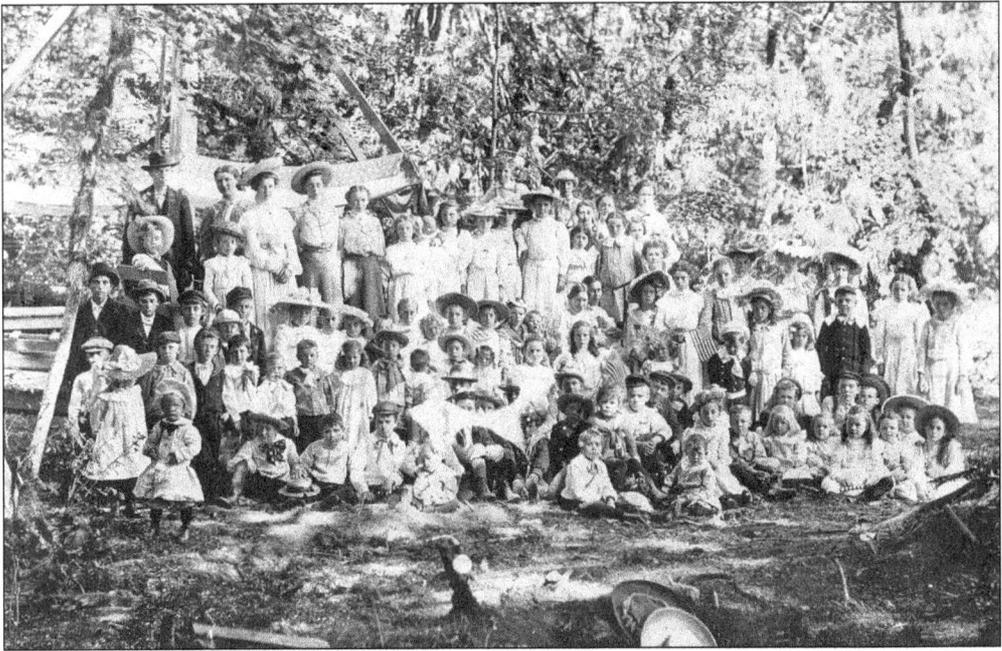

July 4, 1906, was a grand celebration for the children in Shelton and the surrounding camps. July Fourth in Shelton often began with whistles blowing from the steamboats in the bay and the locomotives on the tracks, followed by a parade and a picnic. Firecrackers popped all day, and everyone gathered to watch fireworks when the sun went down. (Courtesy of MCHS.)

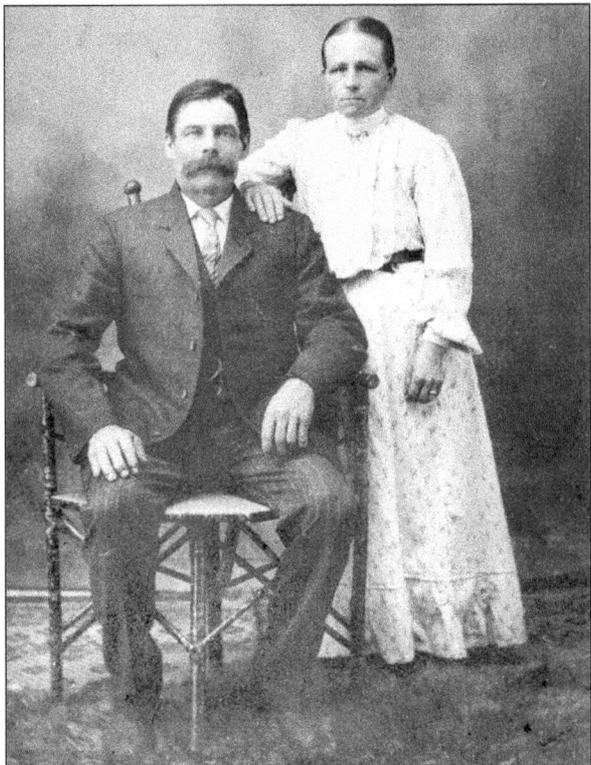

Emigrants from the Scandinavian countries arrived in Shelton at the beginning of the 20th century. Many of the newcomers knew the name of Jack Cole, a foreman for Simpson Timber Company. A number on their jackets indicated which camp they were sent to work as loggers. Some emigrants decided to farm. This couple from Finland, Sophia and Charles Prost, settled along Hammersley Inlet to farm in 1906. (Courtesy of Sylvia Nelson.)

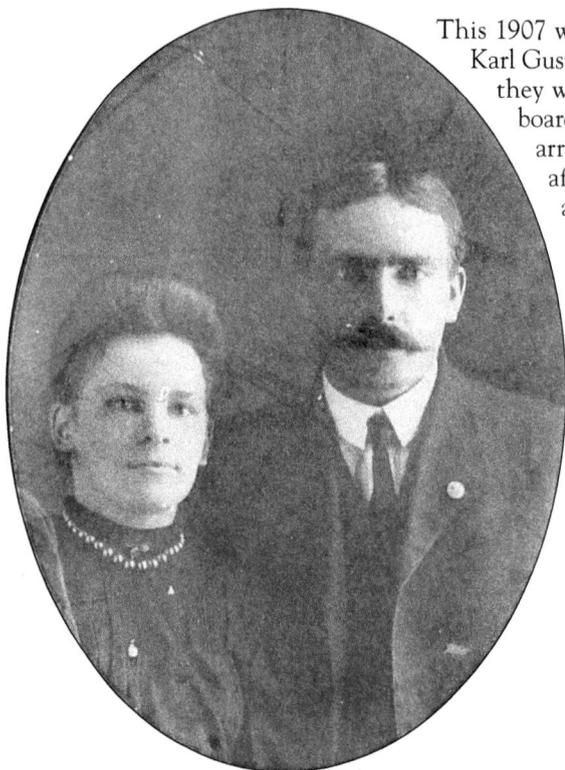

This 1907 wedding portrait of Amanda (Prost) and Karl Gustav Osterberg was taken in Seattle, where they were married. Amanda was working in a boardinghouse when Osterberg's whaling ship arrived. He jumped ship to marry her. Soon after, they followed her parents to Shelton and bought the adjoining farm on the Inlet. (Courtesy of Sylvia Nelson.)

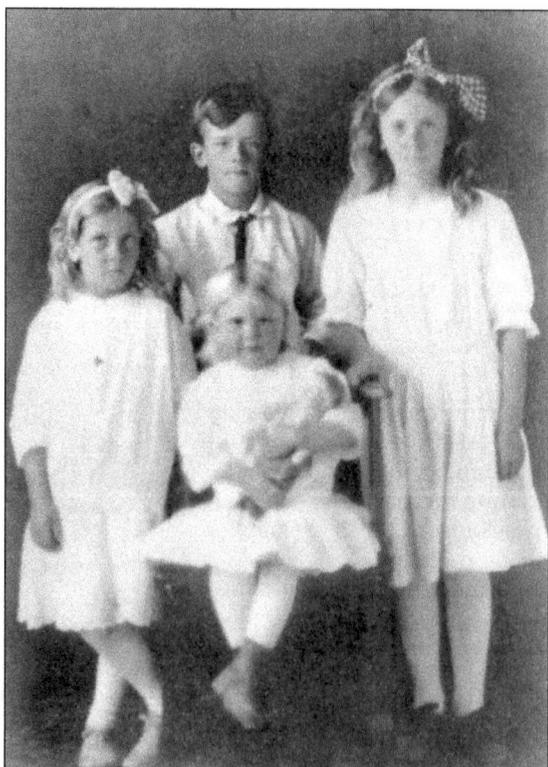

In 1916, the first four Osterberg children sat for this portrait. They are, from left to right, (first row) Gertrude, Inez, and Fanny; (second row) Edgar. The children attended the Southside School, between Shelton and Arcadia. Inez later wrote, "When it rained on our way to school we took off our shoes and socks, put them under our coat so they wouldn't get muddy." (Courtesy of Sylvia Nelson.)

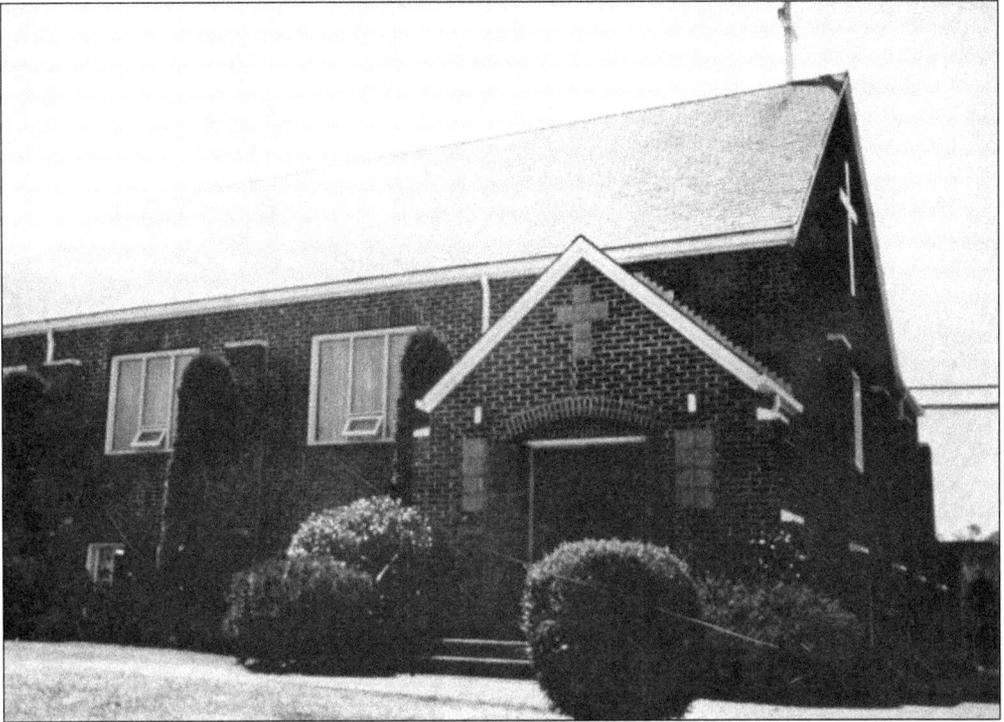

Despite a growing Scandinavian population, a Lutheran church was not part of Shelton until 1949. In 1952, Faith Lutheran Church was built on Franklin Street in downtown Shelton. The brick building with the cross inserted in the front is still standing next to the armory. (Courtesy of MCHS.)

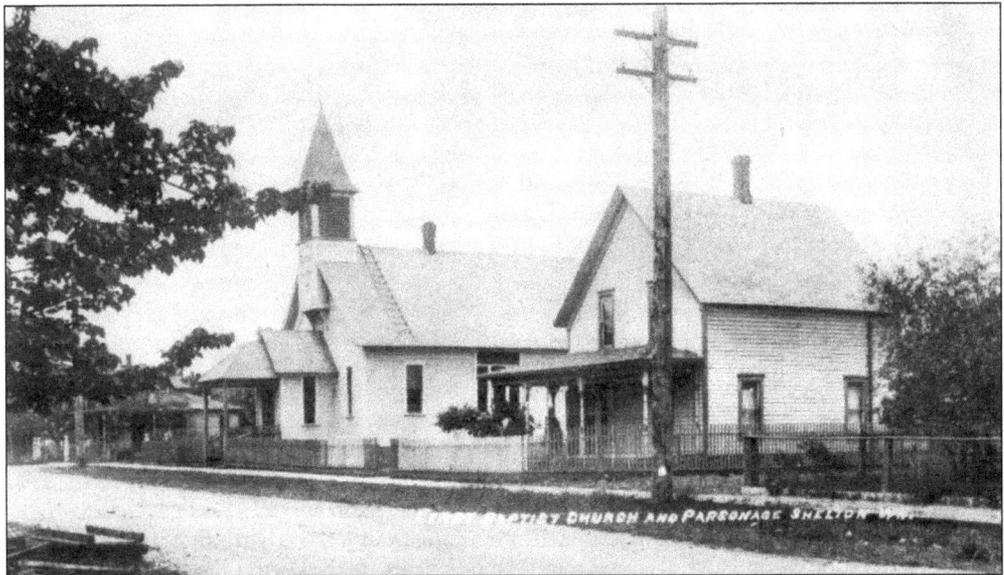

The First Baptist Church and parsonage were built at Fifth and Cota Streets. This was one of five churches built in Shelton on land donated by David Shelton for that purpose. Although he was a Methodist by upbringing, he seemed to feel that any Christian church was good for the town. (Courtesy of MCHS.)

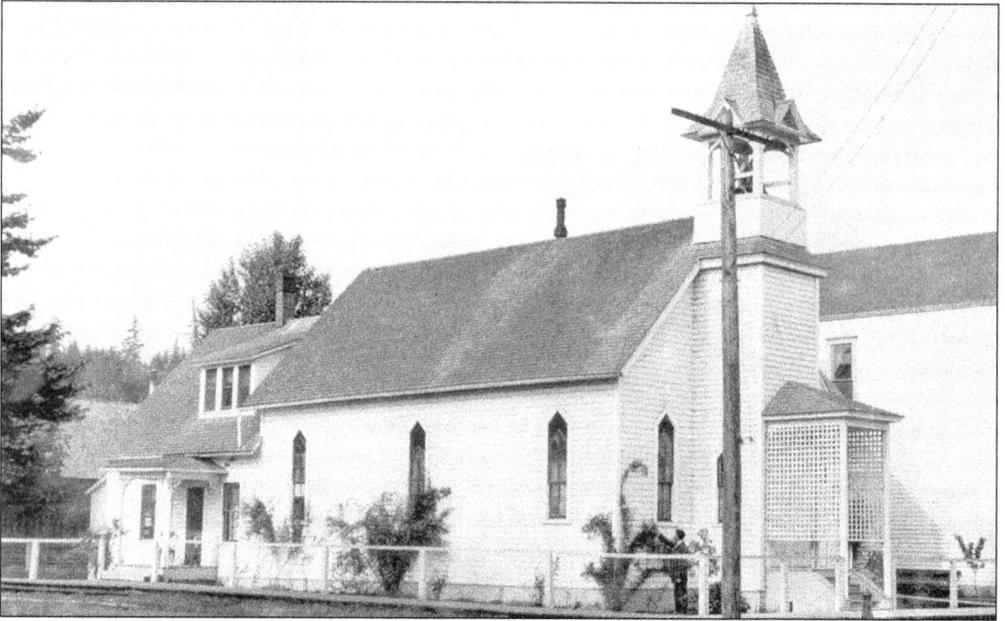

The Methodist Episcopal church was built in 1889 at Second and Cota Streets. In 1907, the church bought property at Fourth and Pine Streets as a number of saloons began being built on Cota Street. However, a new church was not built on that land until this church burned in 1923. The new church was dedicated June 8, 1924. (Courtesy of John Tegtmeyer.)

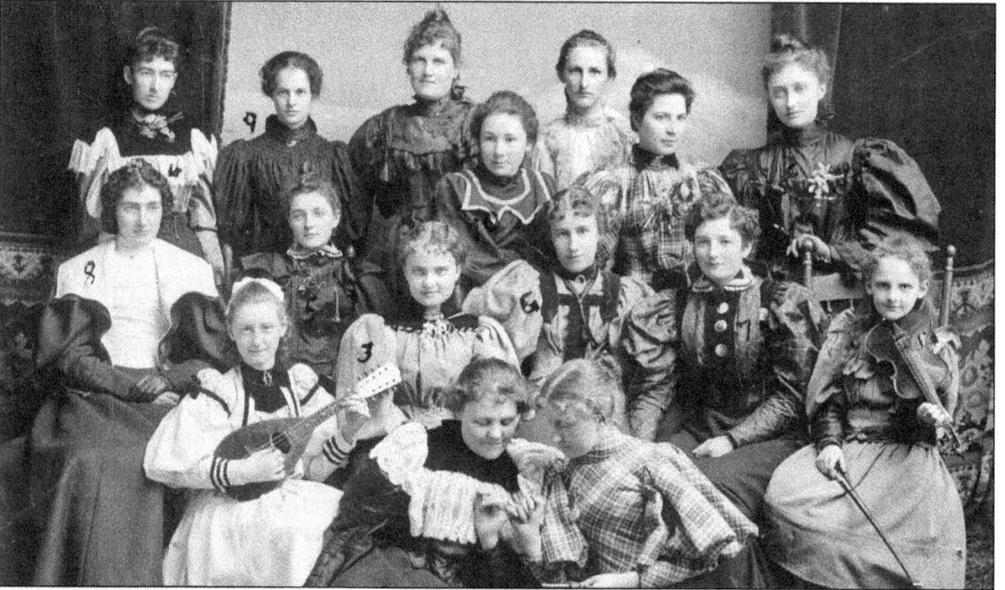

Saint Cecilia's Choir sang for the Methodist Episcopal church services and gave concerts to raise money for a new church. Members of the choir are, from left to right, (first row) Jean Todd Fredson and Dora Webb Hoyt; (second row) Maude Saeger Tuell, Bertha Robinson Lee, Helen Tremper Lane, Essie Webb Bordeaux, and Myrtle Saeger; (third row) Winnie Snider Kneeland, Joyce Shelton Tellus, Luella Shelton, Cecelia Dunbar Fredson, and Mabel Germaine; (fourth row) Mollie Snider, Edith Kneeland, Mrs. Emmer Tremper, and Fannie Colville Webb. (Courtesy of MCHS.)

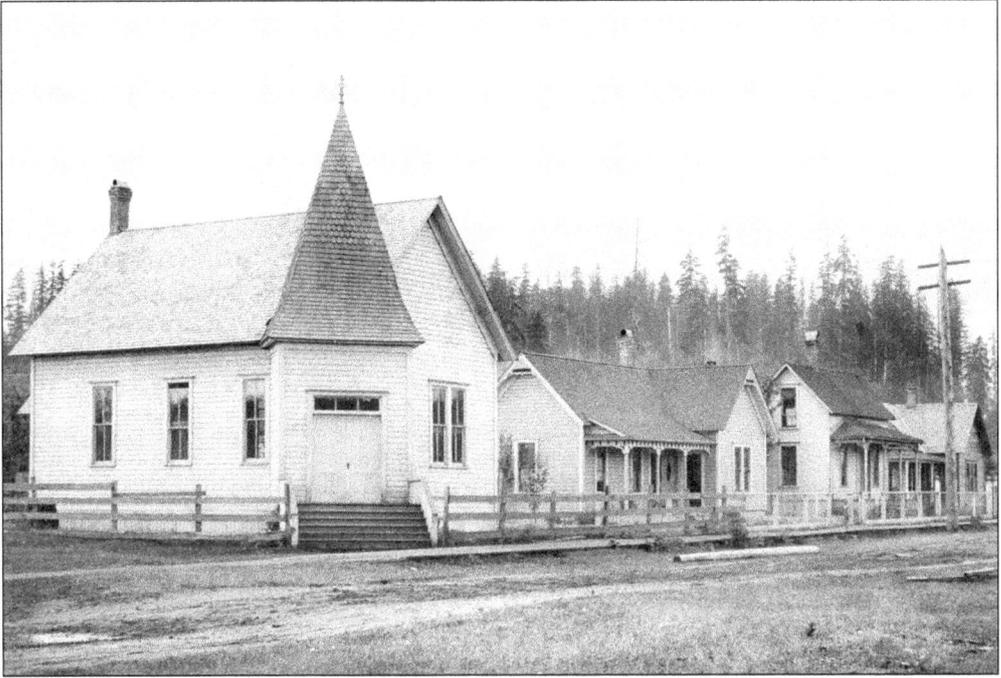

The Adventist church was another church that provided the rapidly growing community a place to worship. Built at Sixth Street and Railroad Avenue, the building depicts the common architecture of the early 1900s seen in several structures in Shelton. (Courtesy of MCHS.)

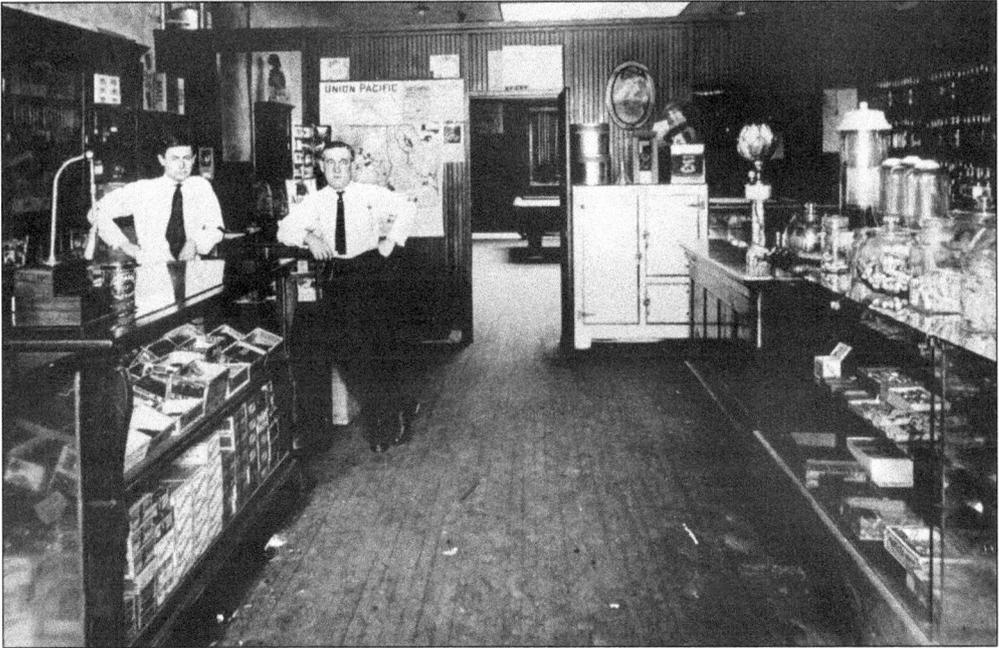

Inside the Garfield Store, an unidentified clerk poses with customer Guy Kneeland (right) around 1910. Note the number of cigars for sale in the case at the left. In 1909, a local cigar factory in Shelton made a 5¢ cigar called the Shelton Belle, a favorite "cheap stogie" of the time. (Courtesy of MCHS.)

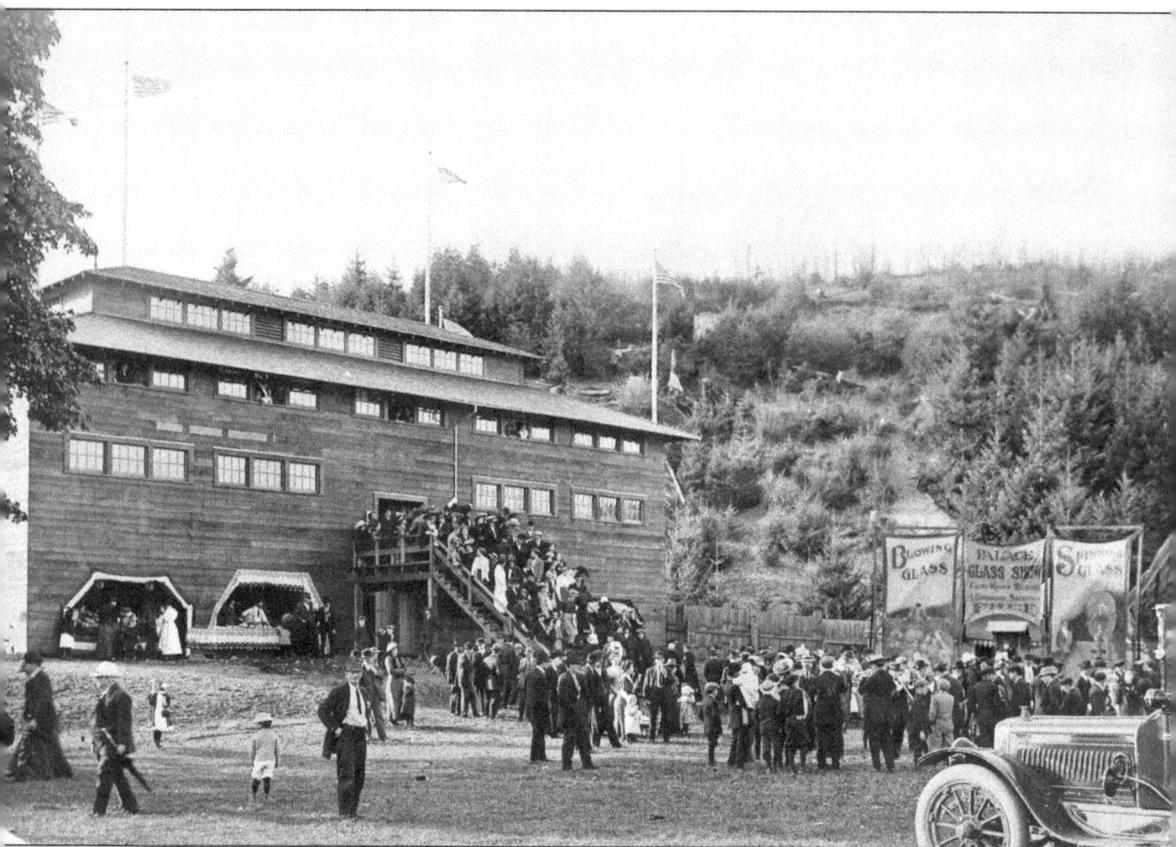

The first Mason County Fair, pictured here, was held in 1908; it soon became an annual event. The Shelton Commercial Club, which was the primary sponsor, called it the "Mason County Fruit Fair." Exhibits included only fruits and vegetables to compete for prizes. However, in 1912, the location was moved to Loop Field, and a new building was constructed in which to show sewing and grange items, with an area on the field to exhibit livestock. In 1926, forty acres on Scott's Prairie were donated by Mrs. Winlock W. Miller and her son. An additional 29 acres were purchased by the county commissioners. The fair was moved to this location. There it remained until World War II, during which time the participants were mostly 4-H members and the location was the Lincoln School Gymnasium. In 1949, the fair relocated again, this time to the Shelton Valley. In 1963, it moved to the present location on 67 acres near the Shelton Airport. It is now the Mason County Fair and Rodeo. (Courtesy of MCHS.)

Four

SCHOOLS, SPORTS, AND FIRE

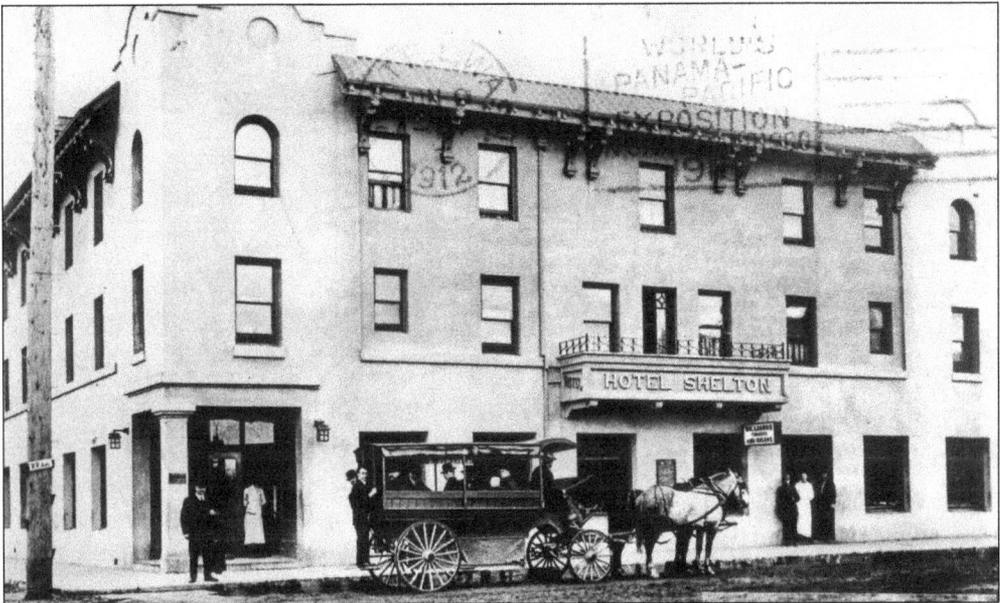

After the fire of 1907, Henry Faubert built a new hotel to replace the Webb at the same location on First Street and Railroad Avenue. The new hotel was called Hotel Shelton and included taxi service to and from the wharf for the boat ride to Olympia, Arcadia, or New Kamilche. (Courtesy of MCHS.)

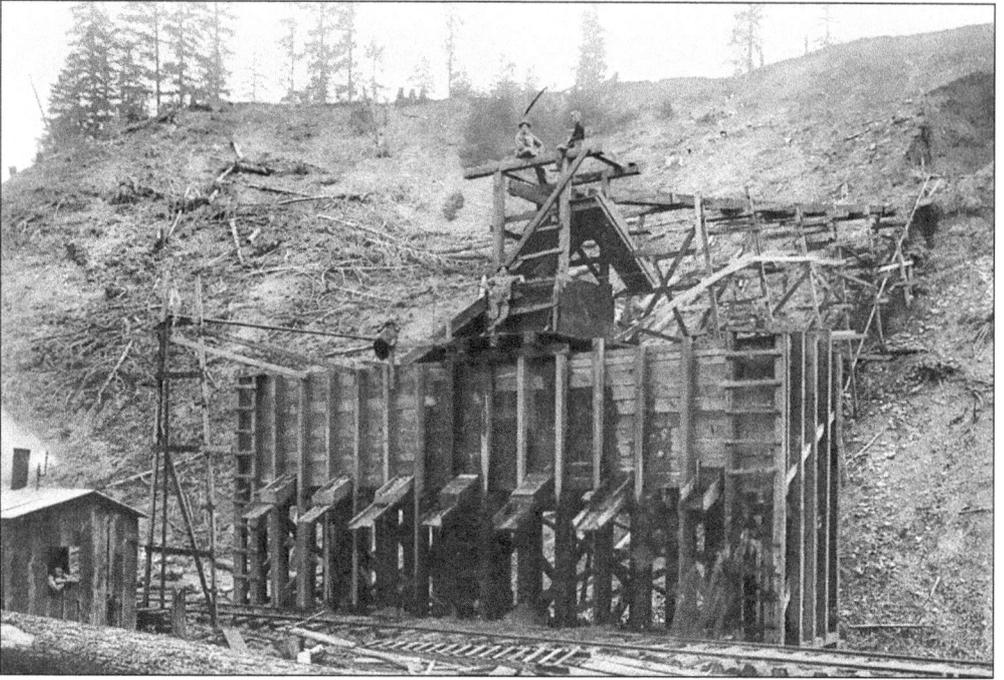

Gravel was a necessary commodity for railroad building, road beds, and concrete production. J. Lee Pauley saw an opportunity and developed this gravel pit in 1912. Little did he know that an even bigger need for gravel was just around the corner. With the automobile came the need for better roads. (Courtesy of Don Pauley.)

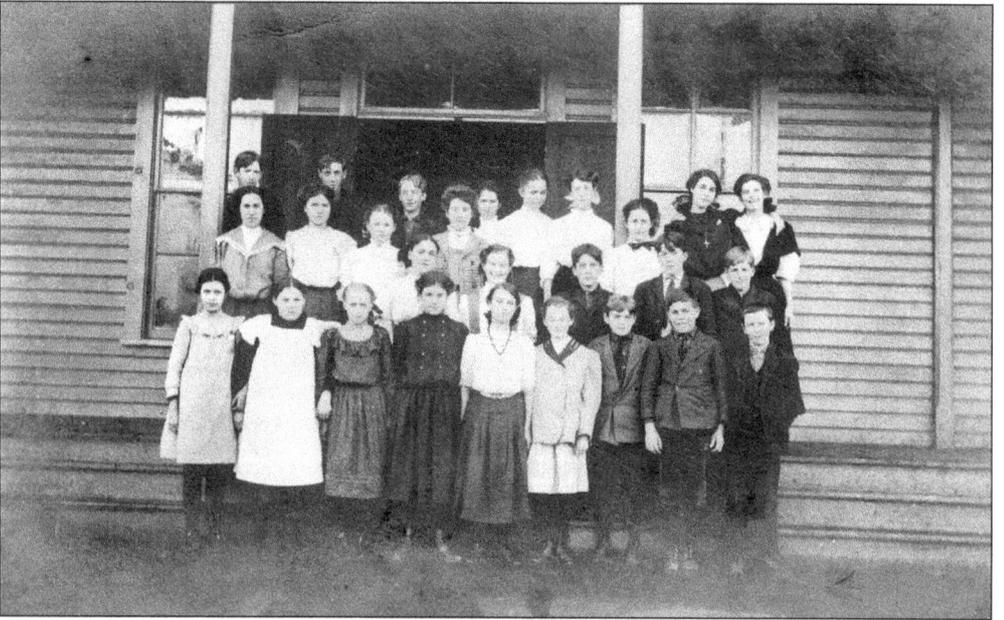

Finishing the eighth grade was the goal of many students in the early 1900s. The Shelton School graduating class of 1908 is shown in this picture. In her plaid jacket, the teacher, Ada Myers, stands on the steps with her proud students. Others in the picture are unidentified. (Courtesy of Lillian Hanscom.)

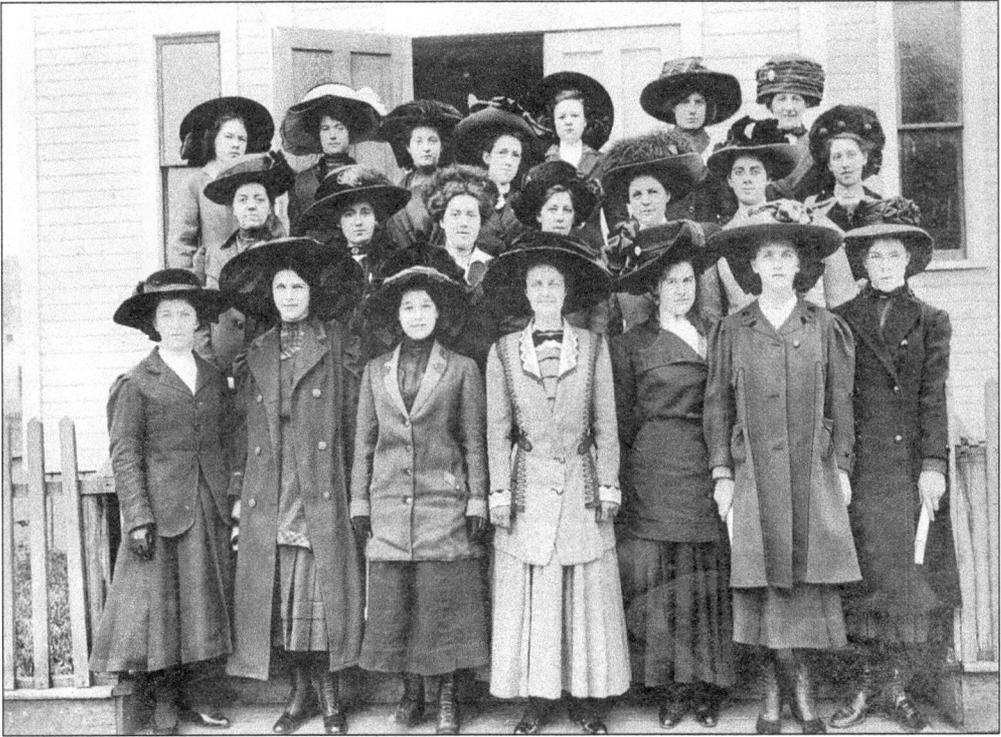

Philathea Shelton School graduates of the class of 1910 are shown here with teacher Ada Myers (in the back row on the right). Others are unidentified. Philathea is a Greek word meaning "Lover of Truth" and was the name of Sunday schools of the World Wide Philathea Union of the early 1900s. The union was a group organized for women to study the Bible and social issues of the day. (Courtesy of Lillian Hanscom.)

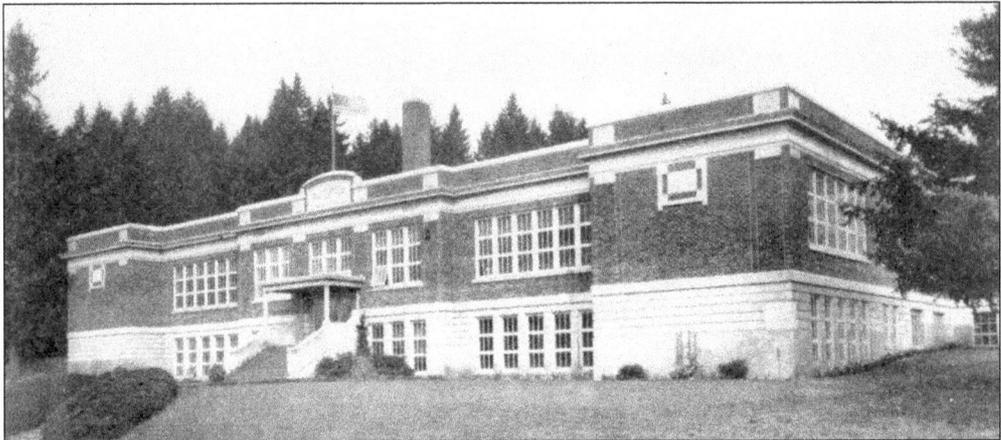

Irene S. Reed High School was dedicated in 1924. It was a gift to the community of Mark E. Reed and provided a means for Shelton students to strive for education beyond the eighth grade. The school was named in honor of the daughter of Sol Simpson and wife of Mark E. Reed. She spent many years as superintendent of schools for Mason County. (Courtesy of Simpson Timber Company and Don Pauley.)

SHELTON PUBLIC SCHOOLS

Report of *Myers, Dorcas, Eighth* Grade, 191*5-16*

Month in Gr.	Reading	Spelling	Writing	Arithmetic	Language	Geography	Civics	History	Physiology	Music	Drawing	Agriculture	Dom. Science	Deportment	Days Present	Days Absent	Times Tardy	PARENT'S SIGNATURE
1	88	91	95	85	86			57	65					E	16	1	0	M. B. Myers.
2	70	85	95	75	89			84	91				92	E	18	0	0	M. B. Myers
3	90	83	95	70	83			60	90			79	94	E	17½	½	0	M B Myers
4	91	85	96	86	88			80	90			80	94	E	19	1	0	M B Myers
5	91	96	95	85	89			90	91				92	E	20	0	0	M B Myers
6	92	78	96	90	88	100		90	93				93	E	19	1	0	M B Myers
7	93	81	97	90	90	95		90	91				93	E	20	0	0	M B Myers
8	94	83	97	85	90	95		85	92				93	E	20	0	0	M B Myers
9	94	84	97	90	90	95		85	93				94	E	20	0	0	
Term Av.																		REMARKS
1st Ex.																		
2nd Ex.																		
Ex. Av																		

The eighth grade report card of Dorcas Myers, youngest of the Myers daughters, is an example of grade cards issued to students in the 1915–1916 school year. Notice the columns for Deportment and Tardy. By the time Dorcas Myers was in school, the Myers family had moved from their farm in the Shelton Valley to a house on Fourth and Laurel Streets that still stands. (Courtesy of Susan Kneeland.)

TO PARENT OR GUARDIAN

This report indicates the fidelity and standing of the pupil in school work. It will be sent to you for inspection at the end of each school month.

A grade of 100 is excellent, 90 is good, 80 is fair, 70 is poor.

Grades below 70 are not satisfactory, and marked improvement must be made before promotion to the next grade.

Please sign each month's report on line following last entry.

Your co-operation is most earnestly desired.

H. ENZO LOOP, Superintendent.

Helen Oldfield Teacher

The back of Dorcas Myers's card of 1915–1916 has the name of Herbert Enzo Loop, for whom Loop Field was named. "Prof" Loop, as he was called, came to Washington from Pennsylvania in 1899 and to Shelton in 1909. He was a teacher and later superintendent of schools. He also served a four-year term as commissioner of public works. (Courtesy of Susan Kneeland.)

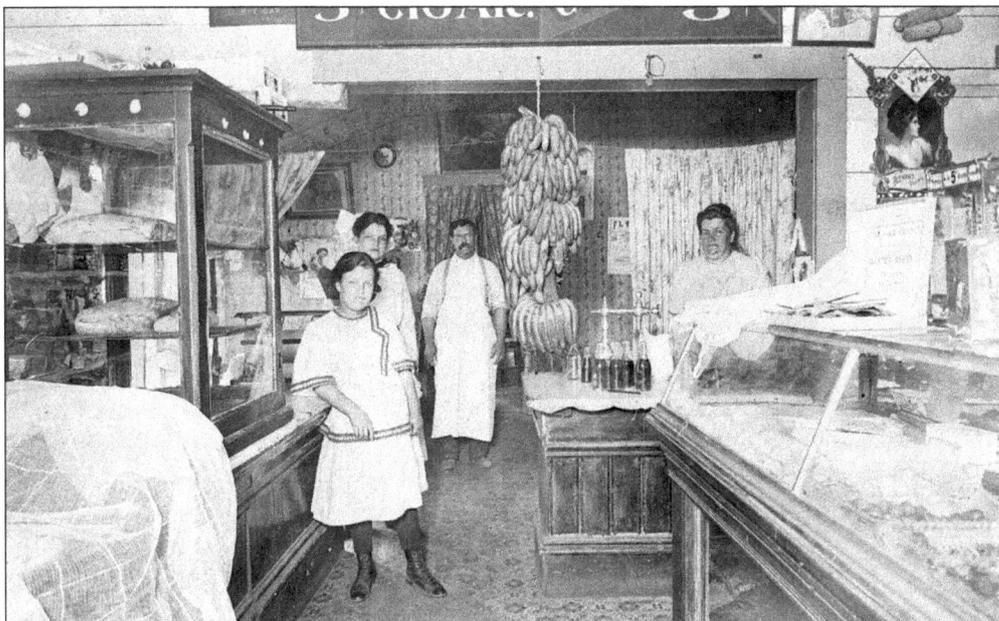

The inside of the store and bakery at Second Street and Railroad Avenue was the place where the fire of 1914 began that destroyed most of downtown Shelton. Fortunately, some buildings used a block material in construction that stopped the fire from destroying the whole town. Pictured here in 1910 are, from left to right, Ruth Pauley, Naomi Pauley, John Pauley, and Susannah (Leisure) Pauley. (Courtesy of Susan Kneeland.)

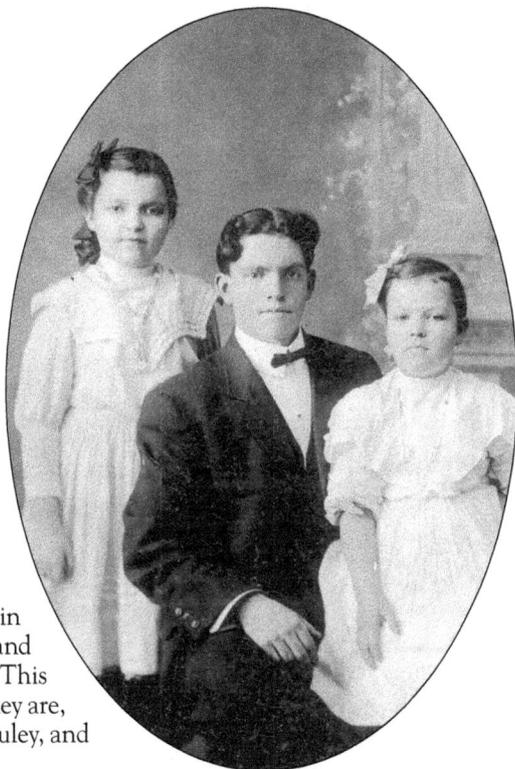

John Pauley arrived in Shelton from Michigan in the late 1800s. He married Susannah Leisure and came to Shelton to establish a store and bakery. This portrait of their children was taken in 1905. They are, from left to right, Naomi Pauley, Joseph Lee Pauley, and Ruth Pauley. (Courtesy of Sylvia Nelson.)

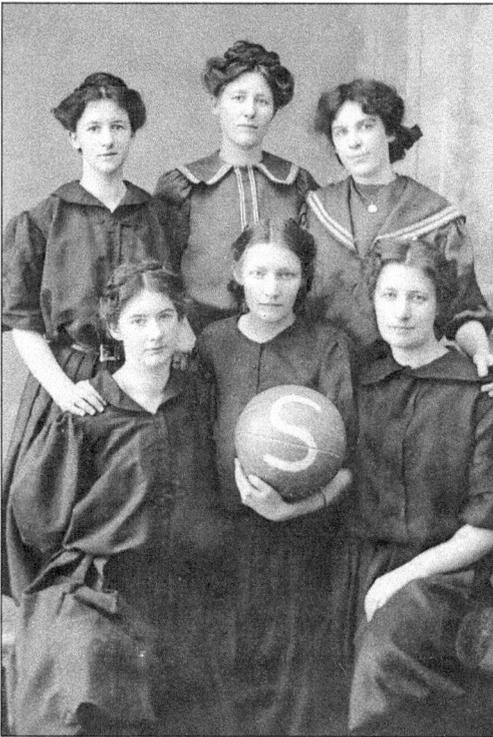

Due to their "delicate nature," girls played a half-court basketball, which allowed all players to run from the center line over their designated half of the court. In 1907, the Shelton team members are, from left to right, (first row) unidentified, Susie Myers, and Ada Myers; (second row) all unidentified. (Courtesy of Susan Kneeland.)

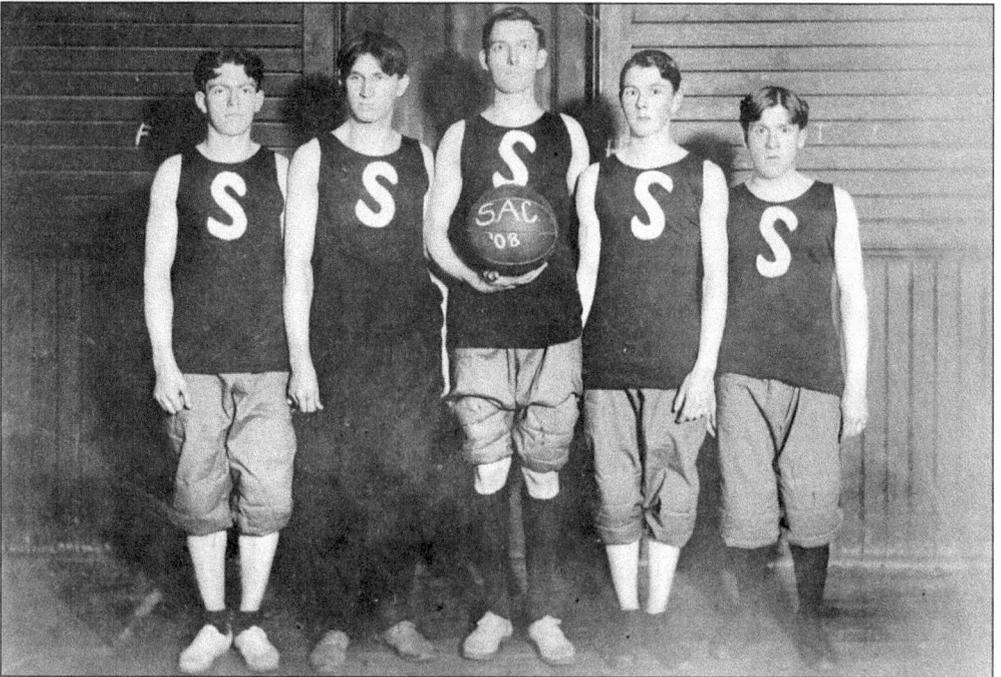

The Shelton Athletic Club sponsored the high school teams. They played in the Old Doyle Hall. Unlike the girls team, the boys played the full court as all teams do today. Pictured in 1908, members of the team are, from left to right, J. Lee Pauley, M. Johnson, Pete Downs, Daniel O'Neill, and Billy Huntley. (Courtesy of Susan Kneeland.)

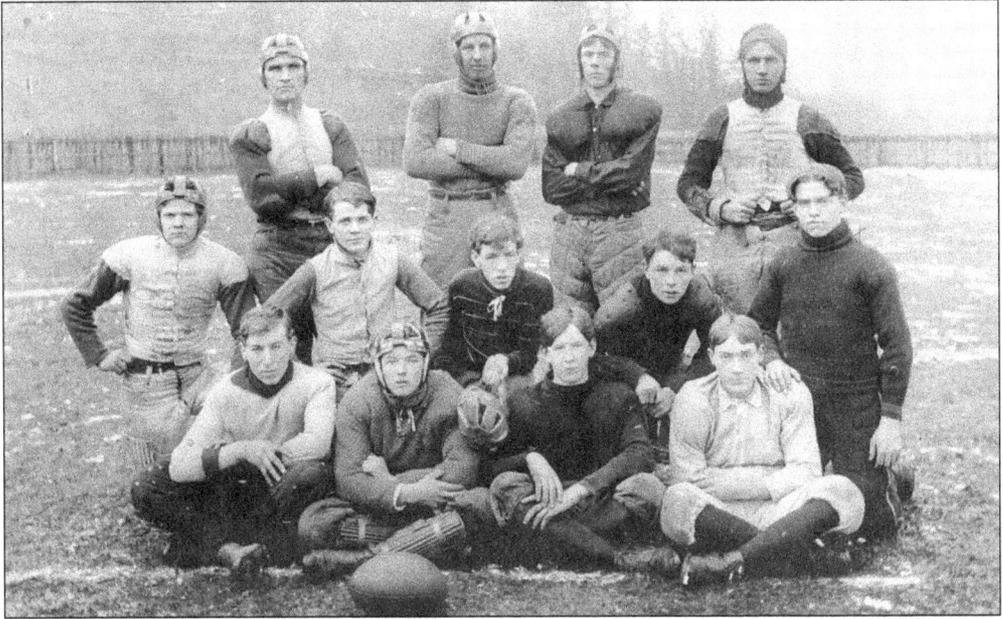

The 1908 high school football team beat Olympia in a tight game on New Year's Day. The score was 3-0. Team members are, from left to right, (first row) Max Stewart, Sag Munson, Allie McPhail, and Clarence Latham; (second row) Dave Adams, Billy Gilbert, Lockie McPhail, Don O'Neil, and J. Lee Pauley; (third row) Merritt Johnson, Lloyd Bunnell, Fred Tegtmeyer, and Morris Johnson. (Courtesy of Susan Kneeland.)

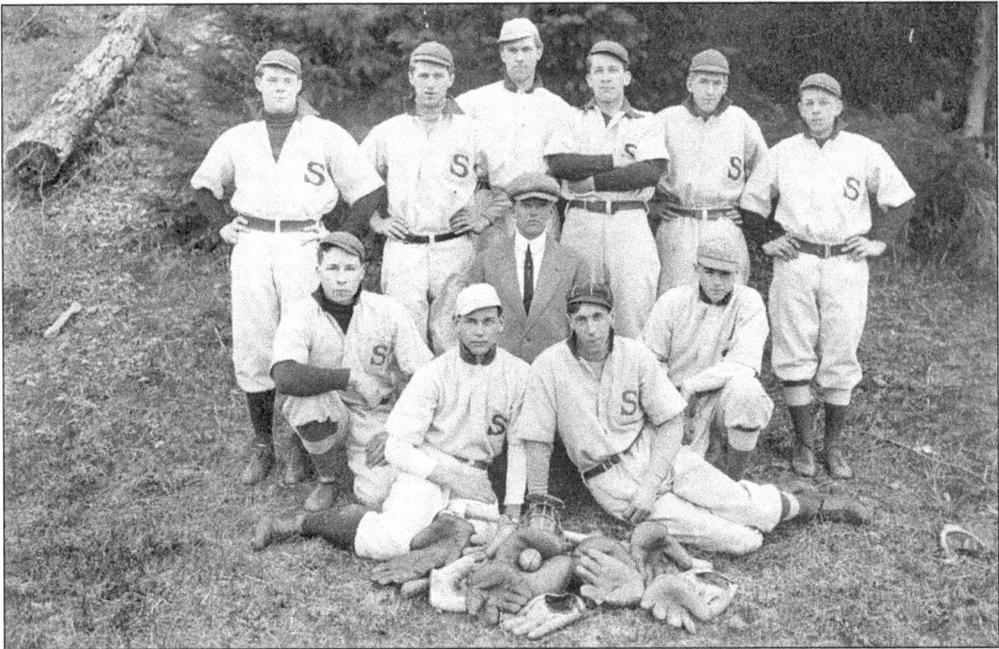

Simpson Timber Company's baseball team is pictured around 1910. Team members are, from left to right, (first row) Warren Earl and Pete Carlson; (second row) Clifford Cole, Sag Munson, and Frankie Fredson; (third row) Harold Brown, Chet Bordeaux, Mervin Wivell, Lawson (Woody) Sanderson, Babe Munson, and Angus O'Neill. (Courtesy of MCHS.)

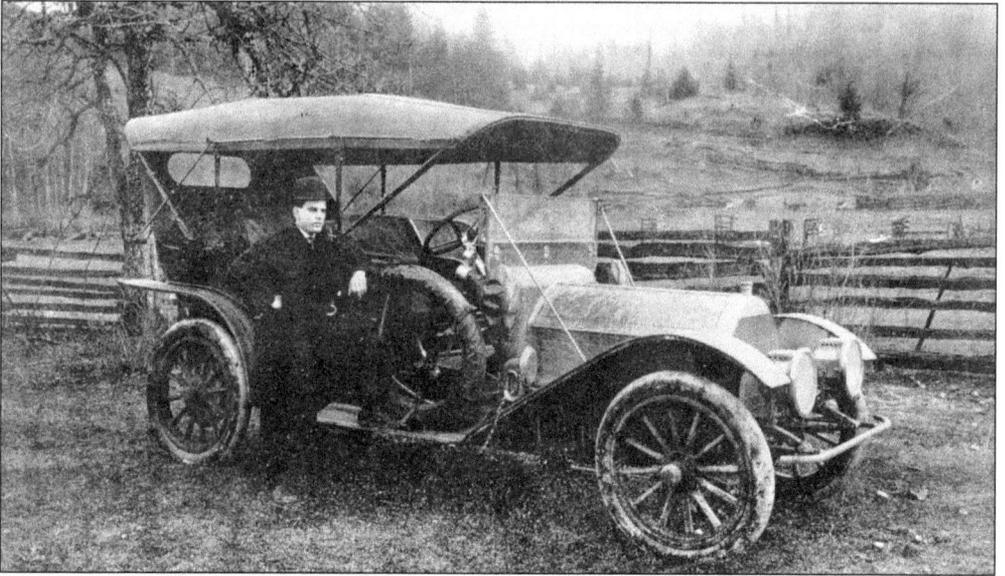

Born in Seattle in 1890, Joe Thomas drove in the Indianapolis races of 1920, 1921, and 1922. He finished in the top 10 in two races. In the 1921 race, he crashed after 25 laps. He is pictured here in 1909 with his Pierce Arrow, which he frequently drove on the dirt roads around Shelton. (Courtesy of Simpson Timber Company and Don Pauley.)

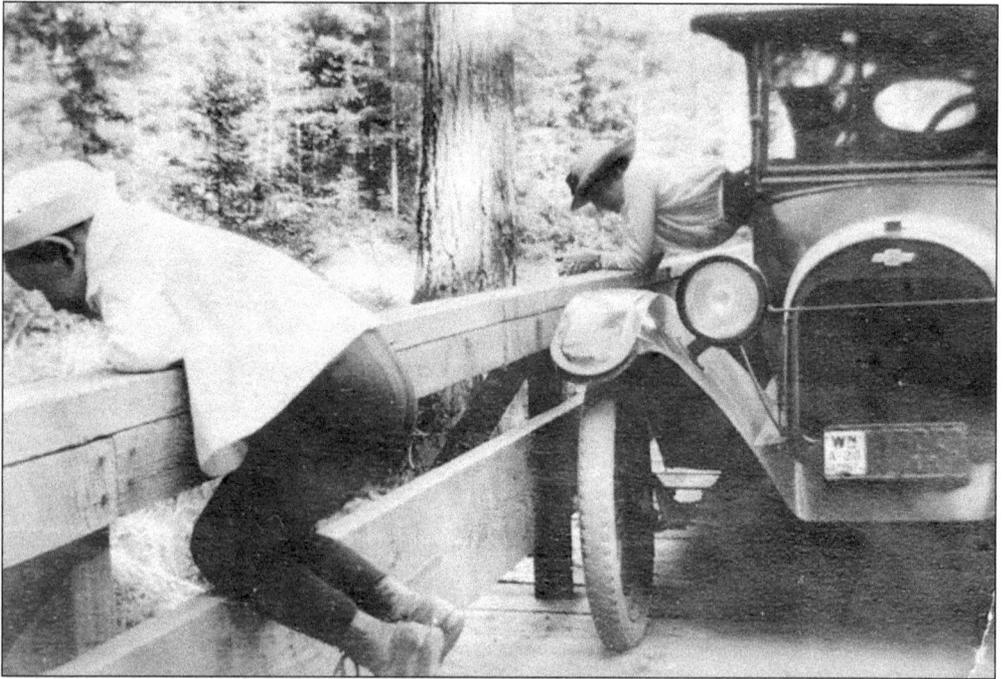

The first automobile in Shelton arrived in 1906. It belonged to Frank Willey, the postmaster. Soon W. H. Kneeland, Dr. Charles Wells, and others owned cars. A new business, Johnson's Garage, started at Fifth Street and Railroad Avenue to repair cars. Out for a Sunday drive, this car stops on the Skokomish River bridge so the occupants can look for fish. (Courtesy of John Tegtmeyer.)

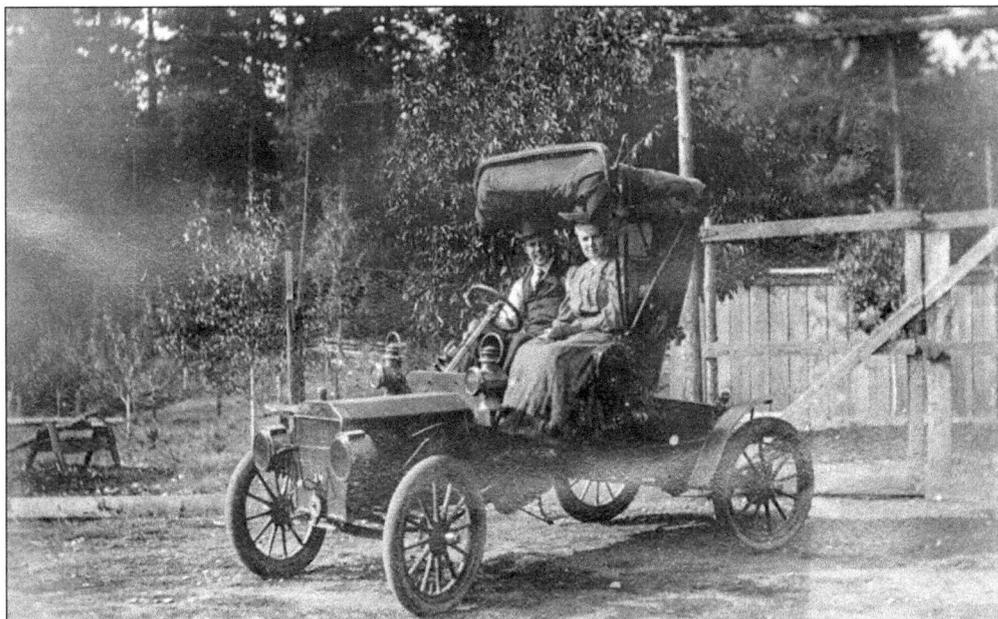

Paul Ridings and his mother, Dorcas, out for a spin from Porter, Washington, drove to visit the Myers farm in 1909. The first road in Mason County was petitioned as early as 1858 and followed a Native American trail from Hood Canal to Oyster Bay. Roads were not much improved before the car entered the scene, and they followed the same routes. (Courtesy of John Tegtmeyer.)

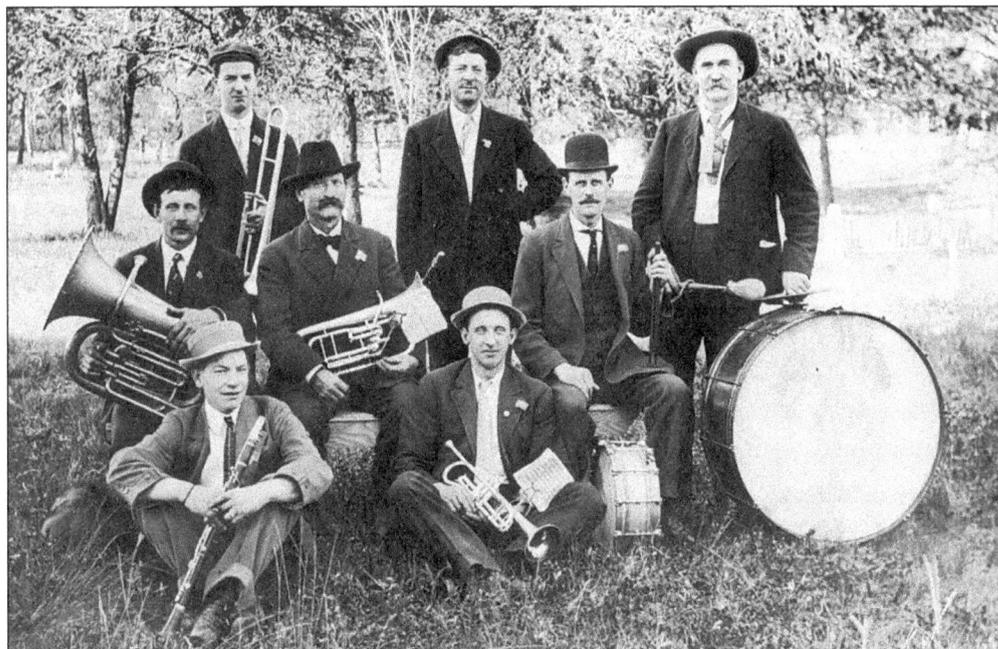

Music was important entertainment at the beginning of the 20th century, and nearly everyone played an instrument, usually with a group. The members of this unidentified band around 1910 are, from left to right, (first row) "Hick" Laurence Fredson and unidentified; (second row) Mr. Dunbar, Nonie Shoemacher, and Ben Shoemacher; (third row) Milt Adams, Dan Bangey, and Charles Wiss. (Courtesy of MCHS.)

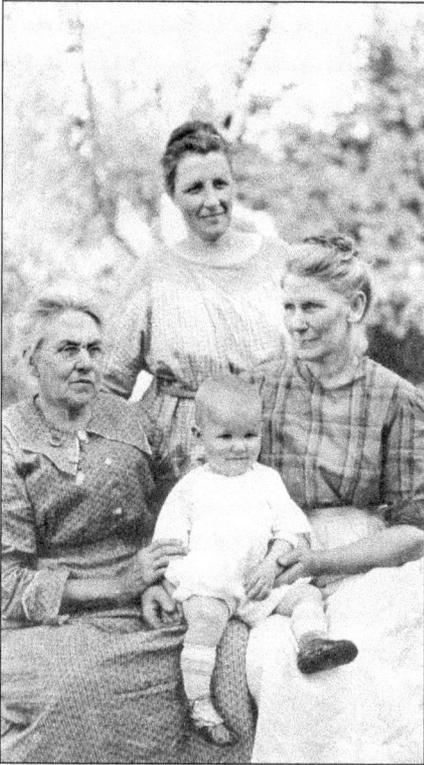

A portrait of four generations of Washingtonians was rare in 1920. The next generation of Washingtonians is entering the scene, and the Myerses are there to capture the moment. They are, from left to right, (first row) Dorcas Ridings Holbrook, Herbert D. Hanscom, and Minnie Bell Ridings Myers; (second row) Ada Myers Hanscom. (Courtesy of Lillian Hanscom.)

Susie E. Myers married J. Lee Pauley in September 1910. She had worked for the county assessor since 1904, and after having a family, she returned to work at the courthouse. She ran for the county auditor position, which she won. She continued in the office until her retirement in 1960. (Courtesy of Sandra Pauley.)

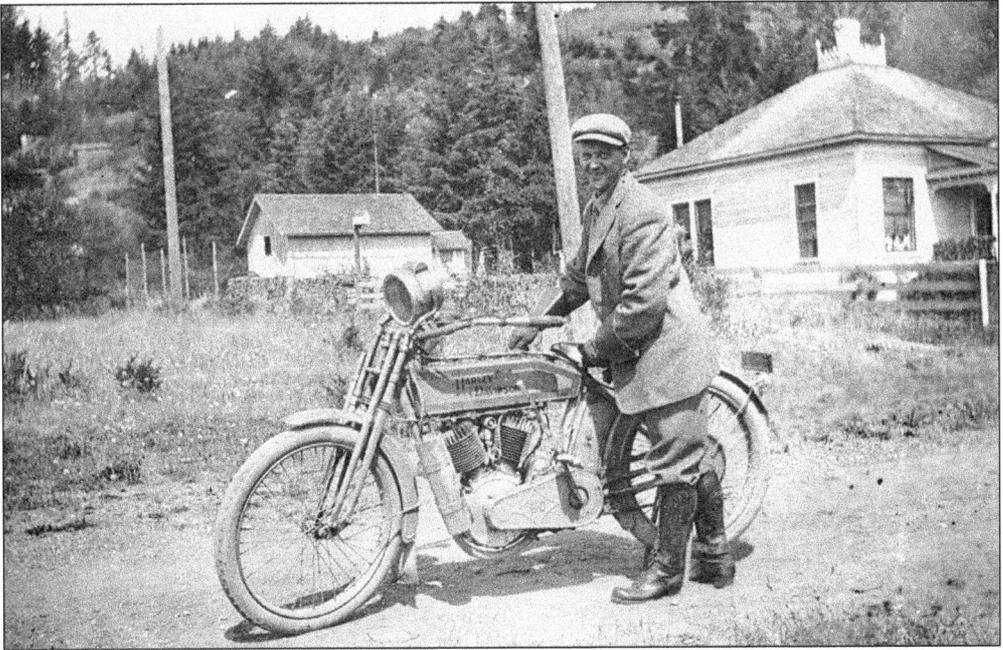

Another motorized vehicle made its arrival in Shelton soon after the automobile. In 1912, Nat Wheeler shows off his new Harley Davidson motorcycle before leaving on the winding dirt road to Olympia. Produced in Minnesota, the Harley Davidson motorcycle continues to be popular among biking enthusiasts. (Courtesy of John Tegtmeyer.)

Frank Wallace Bishop owned a bakery in Seattle and does not figure into the story of Shelton until he divorced Emily, shown with him here in 1914, to marry Marguerite Lynch in 1919. Marguerite was the niece of Jeremiah Lynch of New Kamilche. That same year, Frank Wallace Bishop sold the bakery and moved to Ohio with Marguerite. (Courtesy of Frank Bishop.)

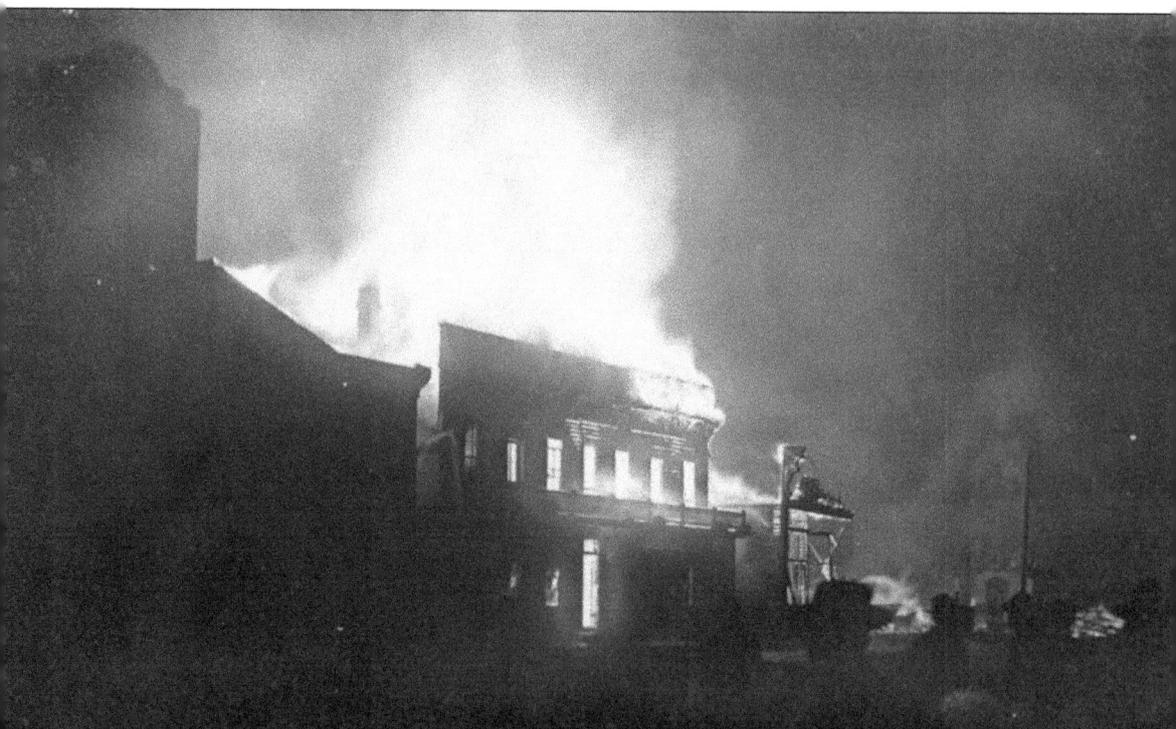

SHELTON FIRE 3 A.M. AUG. 27, 1914. Photo by Kus

Fire was a fear for Shelton residents. After the big fire in 1907 that destroyed the Webb Hotel, some buildings were built of block or brick rather than wood, and Mark E. Reed tried to get the town businesses all built of a less flammable material, but his words went unheeded until this fire in 1914. The fire began in the early morning at the bakery of Joseph Lee Pauley on Second Street and Railroad Avenue on August 24, 1914. It quickly spread to the rest of the downtown area. Only the Shelton Hotel, which was built of block after the 1907 fire, kept the flames from spreading across First Street. A total of 20 buildings were destroyed. Only the safe at the bank remained. Some buildings on Cota Street were damaged, but the Methodist Episcopal church was saved. Unlike the fire of 1907, no lives were lost. The rebuilding effort changed the look of Railroad Avenue forever. It was decided that, since the town would always be in danger of fire, buildings would be constructed of brick or block at least in the business district. (Courtesy of MCHS.)

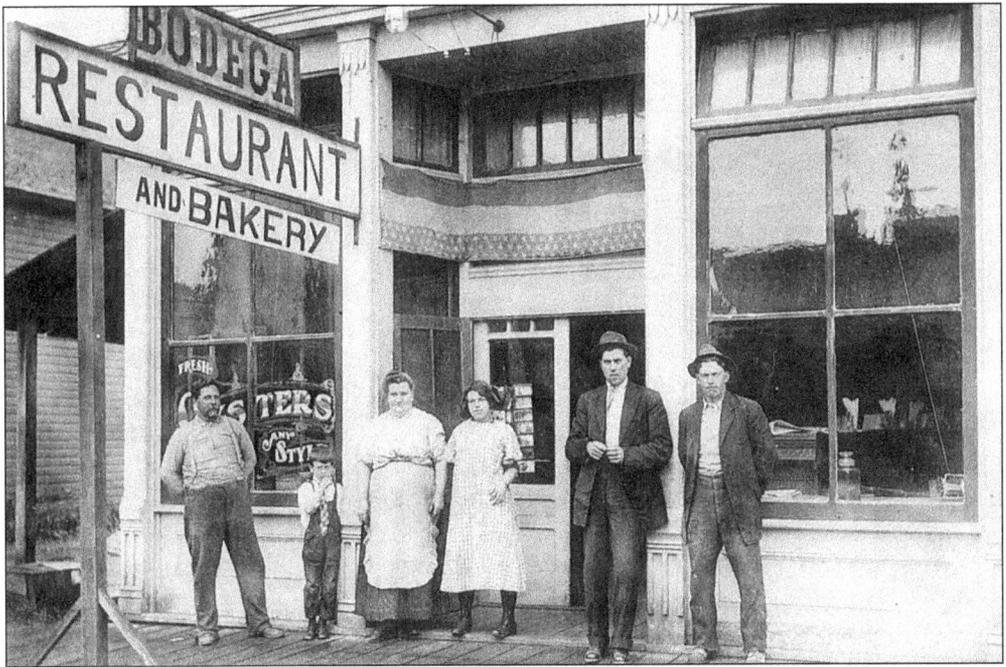

After the 1914 fire, John Pauley went into the car business before constructing a new building for another Bodega Restaurant and the *Shelton Independent* newspaper, rival to the *Mason County Journal*. Family members here are, from left to right, John Courtney Pauley, Joseph Courtney Pauley, Susannah (Leisure) Pauley, Naomi Pauley McNeill, Rosy McNeill, and Joseph Lee Pauley. (Courtesy of Sylvia Nelson.)

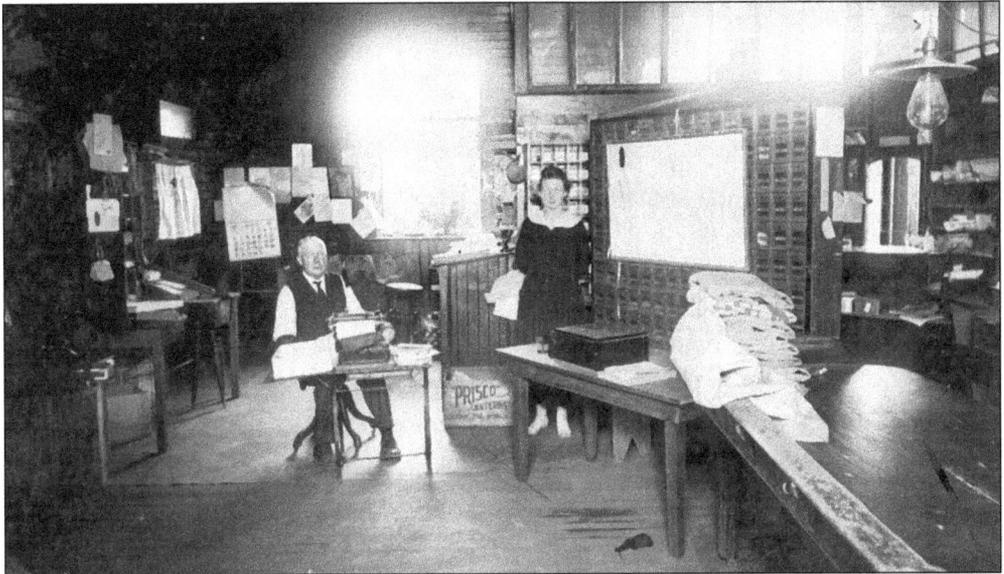

Frank Willey and Dorcas Myers are pictured at the Shelton Post Office around 1920. Frank Willey later was elected a county commissioner. Dorcas Myers decided to follow her heart rather than her mother's advice and went to Seattle to train as a nurse at the Swedish Hospital. She returned to Shelton upon completion of her studies and worked at Mason County Hospital. (Courtesy of MCHS.)

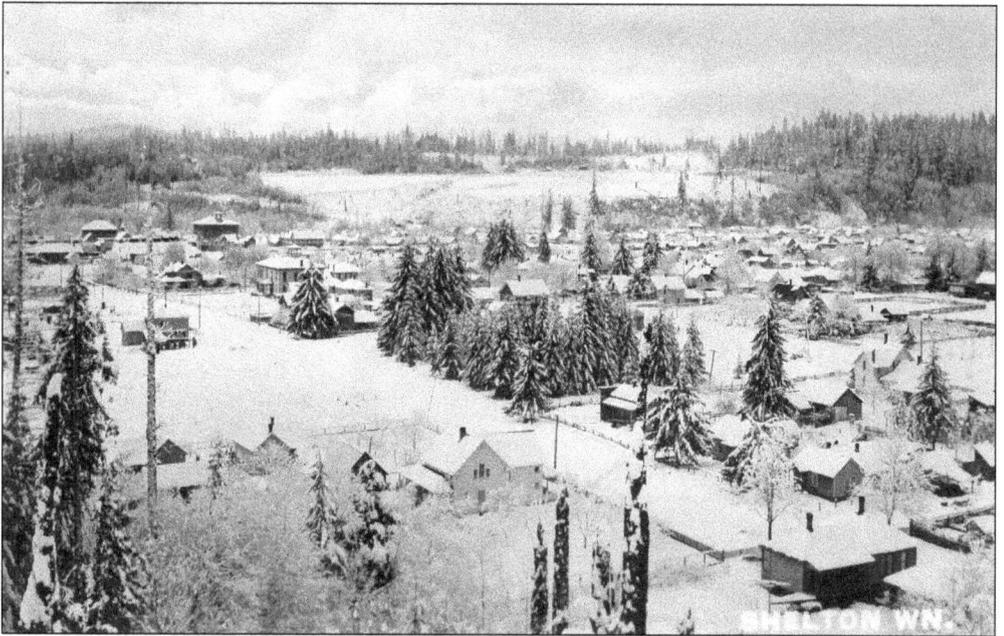

No town is immune from the impact of nature, and when the unusual occurs, it is captured on film for a permanent record. An unknown photographer snapped this shot of downtown Shelton after several inches of snow fell in the winter of 1916. Note the cleared hillside across the valley. Grant C. Angle sold lots for homes here. The subdivision became known as Angleside. (Courtesy of MCHS.)

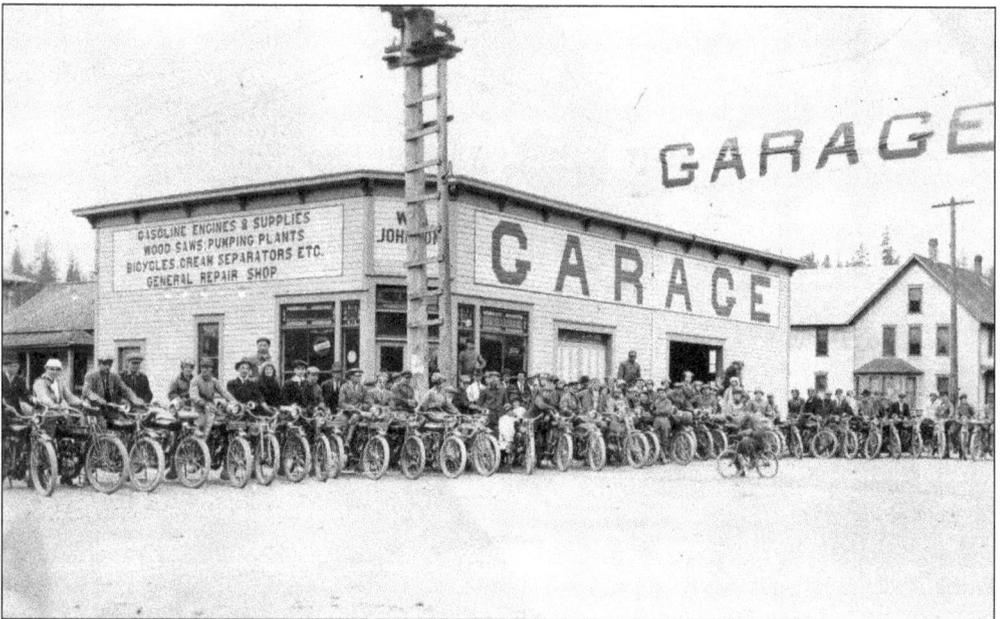

Johnson's garage opened in Shelton to service and to repair the influx of automobiles to Mason County. Motorcycle buffs were also attracted to the garage. Over 30 Harley Davidson owners take a break on their road rally around 1920. (Courtesy of MCHS.)

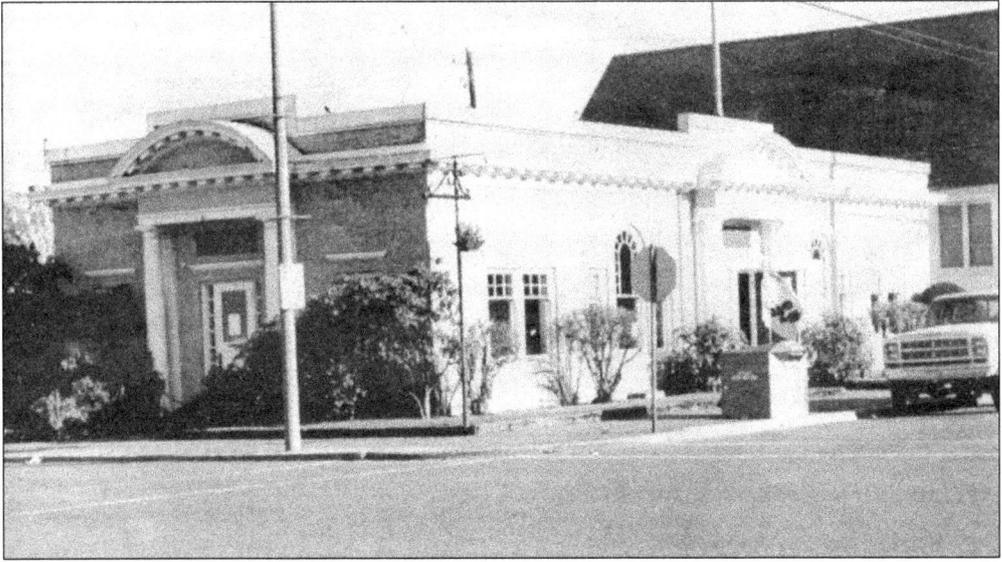

The current home of the Mason County Historical Society was built in 1914 at the corner of Fifth Street and Railroad Avenue. It was initially built to serve as the town hall and library. The building was the generous gift of Mrs. Sol Simpson (Tollie). Mrs. A. H. Anderson (Agnes) furnished the interior in memory of her husband's contribution to the creation of the town. (Courtesy of MCHS.)

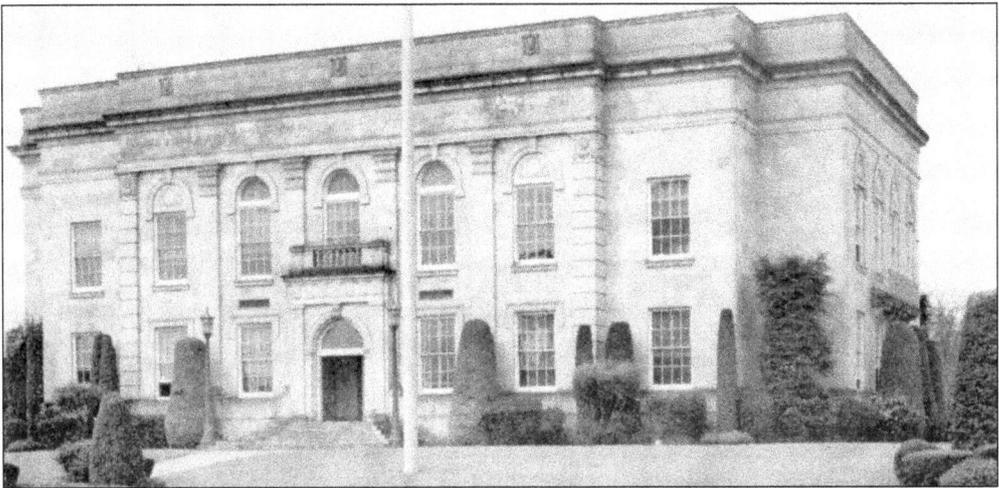

On May 5, 1930, this courthouse opened to replace the first one. The new courthouse and jail were built on property adjacent to the previous wooden structure. It was built of concrete and faced with sandstone to protect it from fire, which had been a constant threat to the wooden structures. (Courtesy of MCHS.)

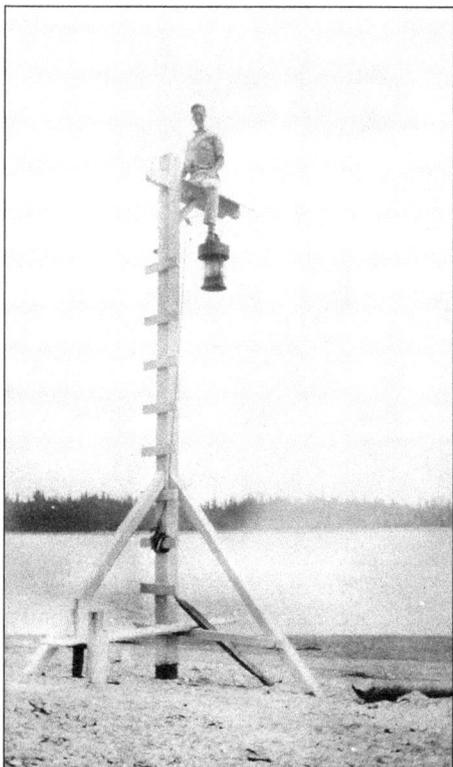

The first navigational light was erected at Arcadia Point on the southern entrance to Hammersley Inlet by the Coast and Geodetic Survey in 1913. Although no light had ever been there previously, it was deemed necessary with the increasing use of the inlet by companies shipping large rafts of logs out of Shelton and stern-wheelers carrying other cargo and passengers from Shelton to Olympia. (Courtesy of John Tegtmeyer.)

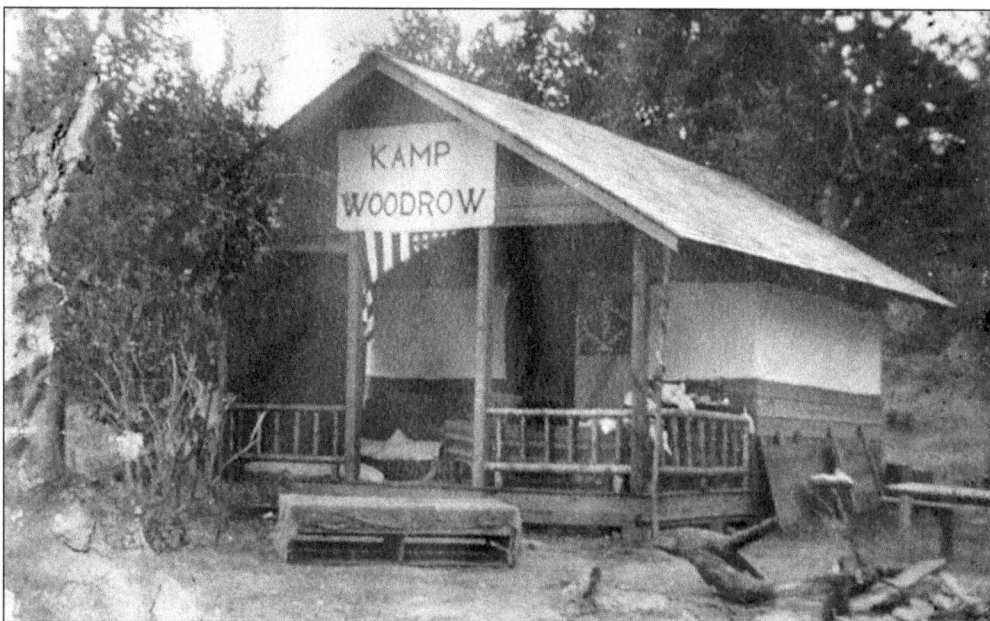

In 1912, Ada (Myers) and Jack Hanscom built this summer cabin on the southeast side of Arcadia (Arkada) Point. The Hanscoms had moved to Seattle, where Ada continued to teach school, but with summer vacations came time to "hold camp" for her own children and those of her sisters. Thirteen cousins enjoyed fishing and frolicking along Hammersley Inlet through the summer months. (Courtesy of Lillian Hanscom.)

Five

WORLD WAR I THROUGH WORLD WAR II

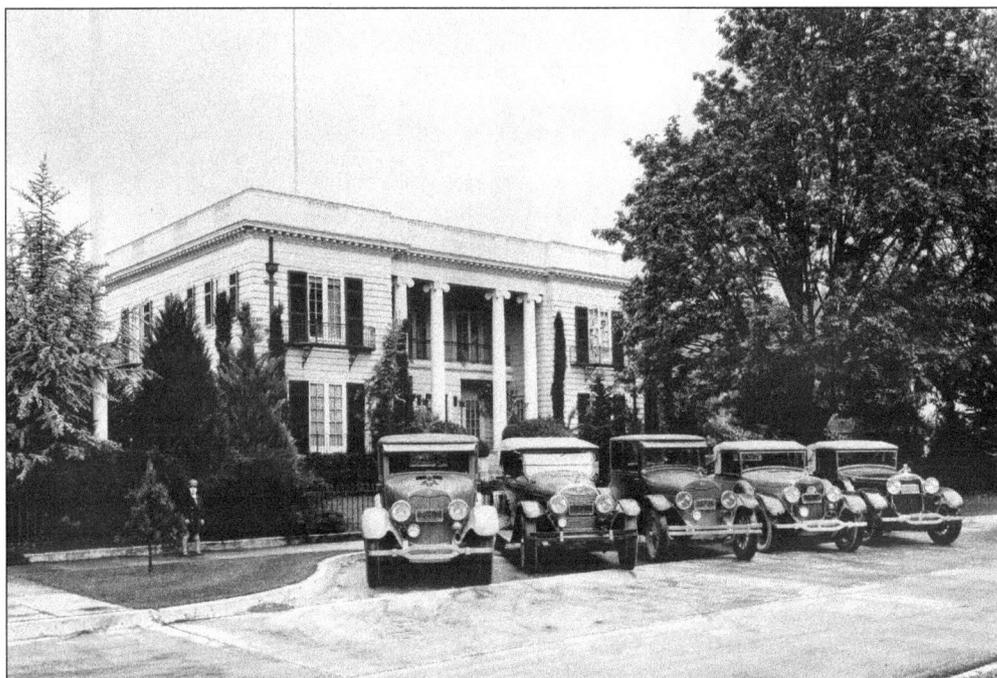

A Shelton landmark built in 1920 by Mark E. Reed and Irene S. Reed at Third and Pine Streets, the Colonial House was the most elegant and formal home in Shelton. The house had seven bedrooms, each with a private bath. The carriage house, stables, and four-car garage were in the next block. The house was also used for entertaining Simpson Timber Company functions. (Courtesy of MCHS.)

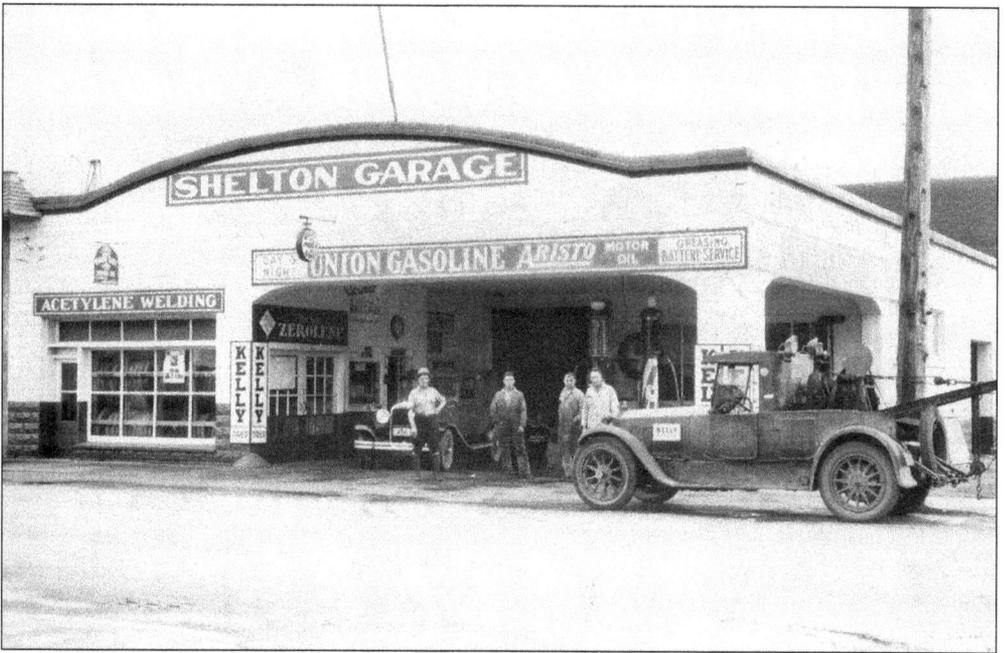

John Courtney Pauley built this building of block at First and Cota Streets before the 1914 fire. After the fire, he ran a garage for the new automobiles coming into the county. Soon, however, he was back in the restaurant business and sold the garage equipment. He leased the building to someone else for the Shelton Garage around 1920. (Courtesy of Don Pauley.)

This plaque was designed from an advertisement in the *Mason County Journal* around 1920. It was presented to Frank D. "Bud" Pauley by his mother, Susie E. Pauley, when he opened his Dodge Plymouth dealership in Shelton on Front Street in April 1951. The Pauley tradition with cars continues with Don Pauley, antique car expert. (Courtesy of Don Pauley.)

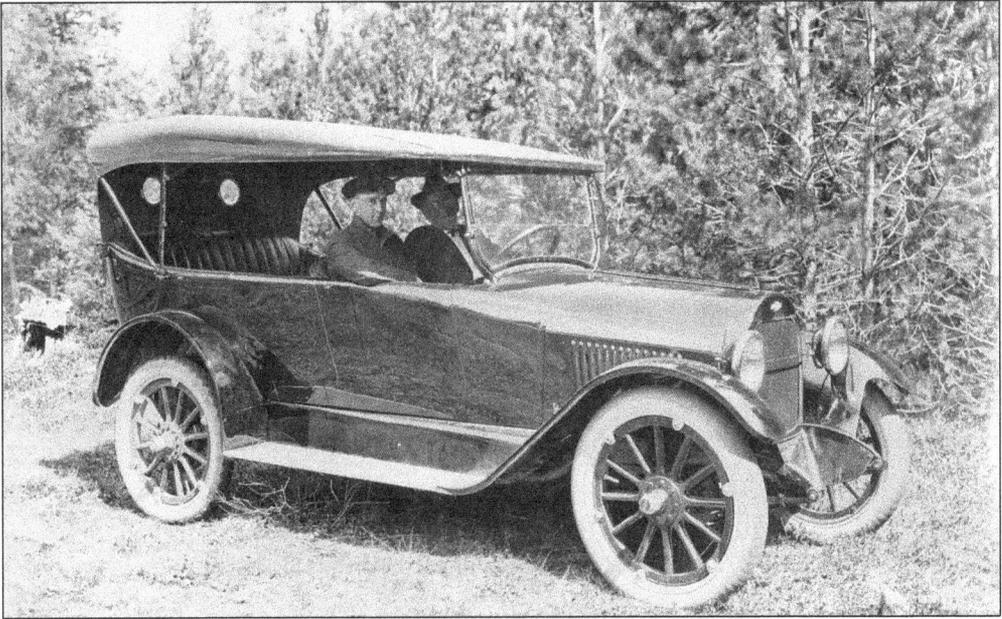

Earl Dunlap (left) and Joseph Lee Pauley try out a new Chevrolet convertible in 1928. The roads around Shelton were slowly improving to accommodate the new vehicles, but many were still not paved. Some were old skid roads that were no longer used by the logging companies as their operations pushed farther into the virgin timber of the Olympic Mountains. (Courtesy of Don Pauley.)

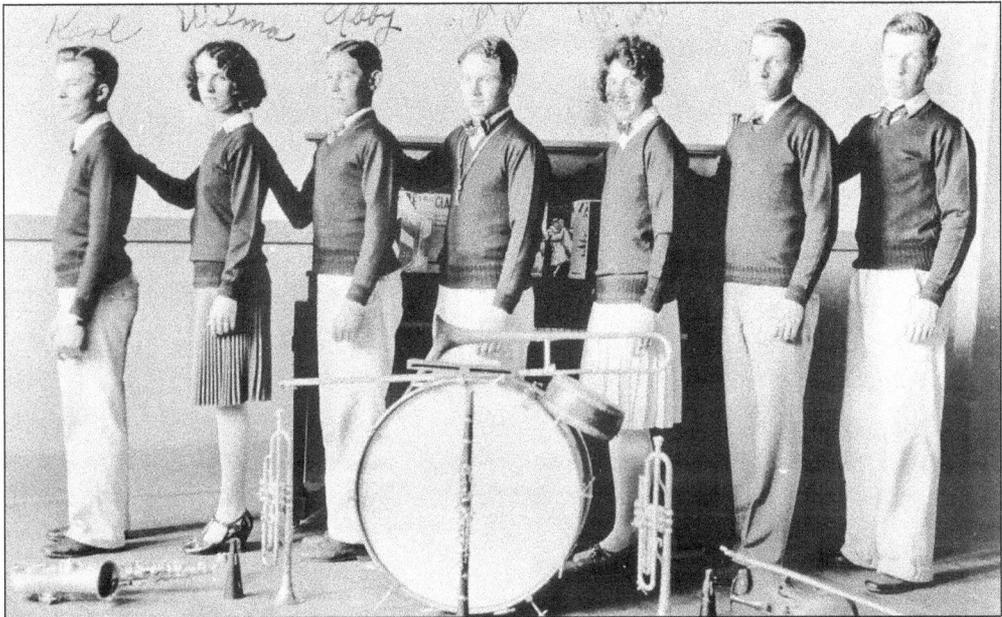

Music continued to be an important part of school and recreational life in Shelton. The 1928–1929 Shabams pictured here played at high school dances and at numerous dances and jazz concerts around town. Members of the band are, from left to right, Karl Sells, Wilma Moffit, Abby Tucker, Cap Bell, Verda Purcell, Joseph Courtney Pauley, and Frank D. "Bud" Pauley. (Courtesy of Don Pauley.)

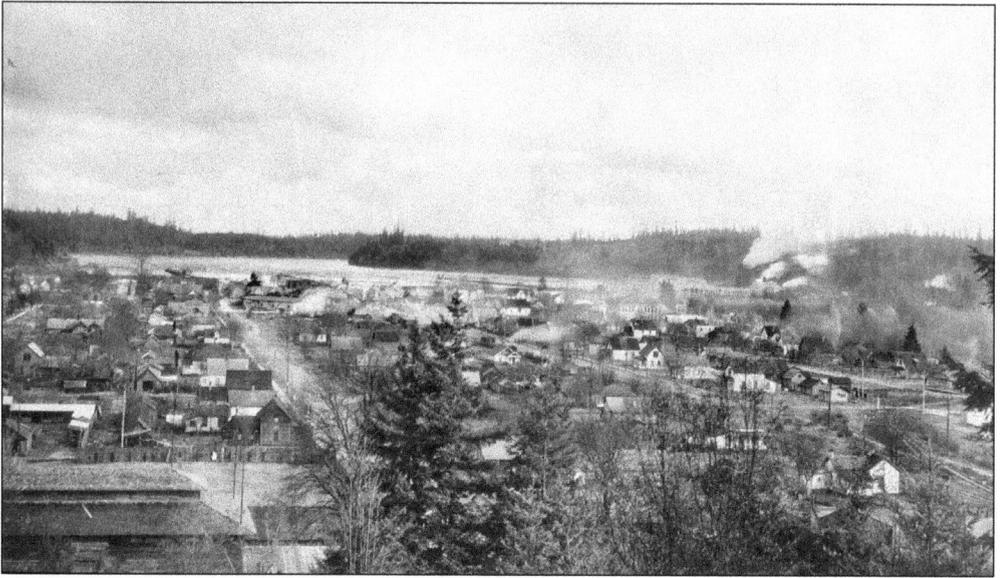

This overview of Shelton around 1930 indicates changes since the beginning of the 20th century. On the bay toward the right are the Rainier Pulp Mill and Reed Mill; the steam cloud in the middle of the picture is from the roundhouse on Railroad Avenue. The street that is clearly seen on the left center is Franklin Street, and Cota Street is to the right of Railroad Avenue. (Courtesy of MCHS.)

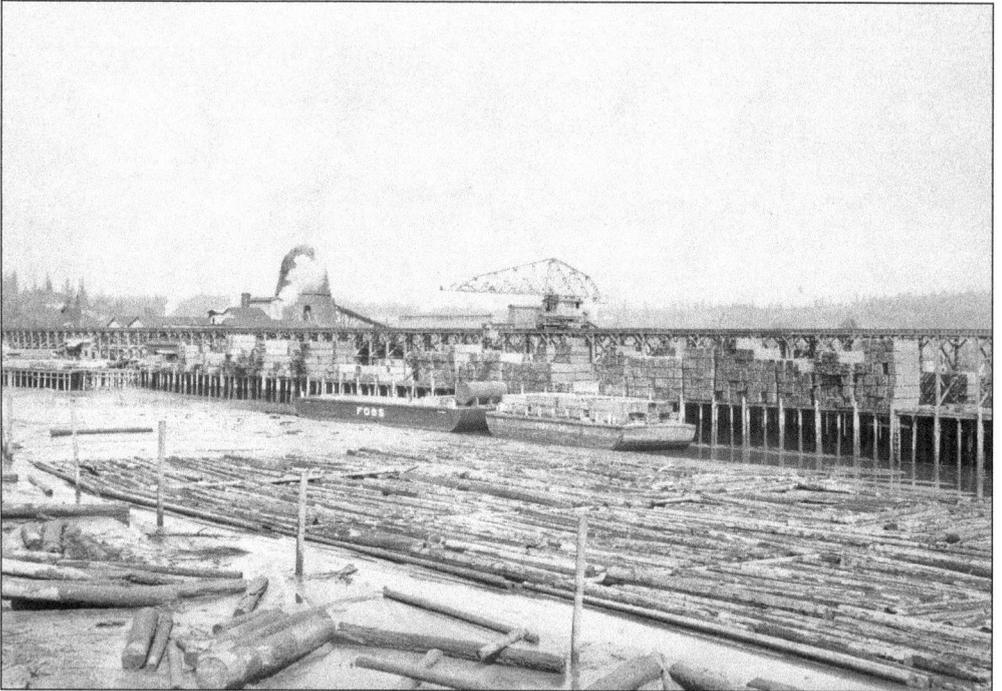

Mark E. Reed organized a sorting system of logs into species and grade out in the woods to make it easier to distribute to mills in town or to bundle in rafts for shipment out of Shelton. Some species of trees are better than others for specific products. The Reed Mill, shown here in 1924, used hemlock and spruce. (Courtesy of MCHS.)

In 1924, Reed was approached by a representative from the Zellerbach Pulp and Paper Company about building a mill next to the Reed Mill that would use waste from his sawmill for pulp production. Reed agreed to the plan. Shown here is the 1925 design for the Rainier Pulp Mill. (Courtesy of MCHS.)

Construction was well underway for the Rainier Pulp Mill in this 1927 photograph. Water pollution in Oakland Bay from the effluent dumped by the pulp mill became a constant source of tension between the shellfish growers and the mill. Rainier, renamed Rayonier in the 1930s, tried several solutions, but none was effective. (Courtesy of MCHS.)

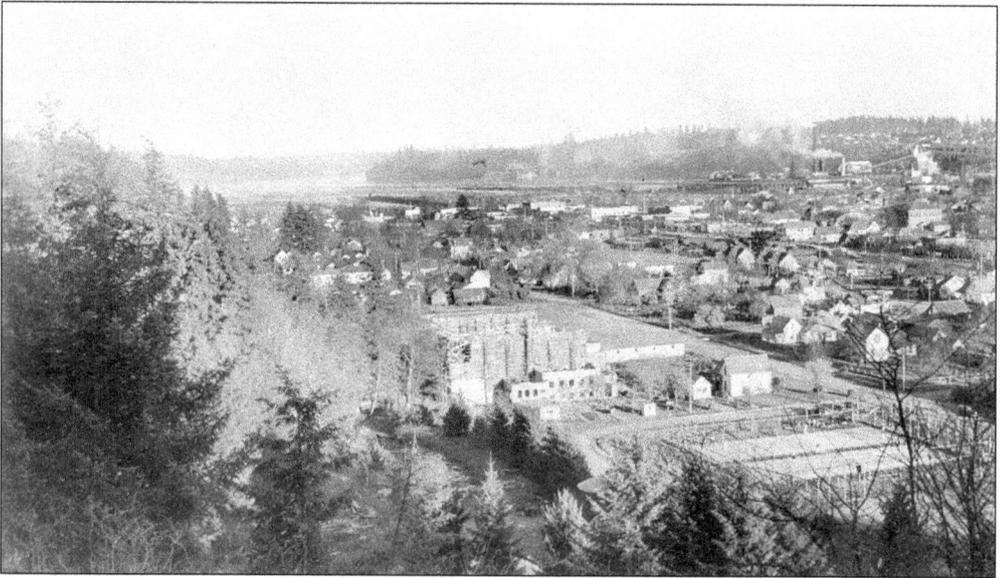

This view of Shelton in the 1930s looking east shows the Rayonier Pulp Mill and its tall stack in the back right of the photograph. The stack was intended to keep the air pollution from the pulping process away from the town. Loop Field is in the lower right corner. (Courtesy of MCHS.)

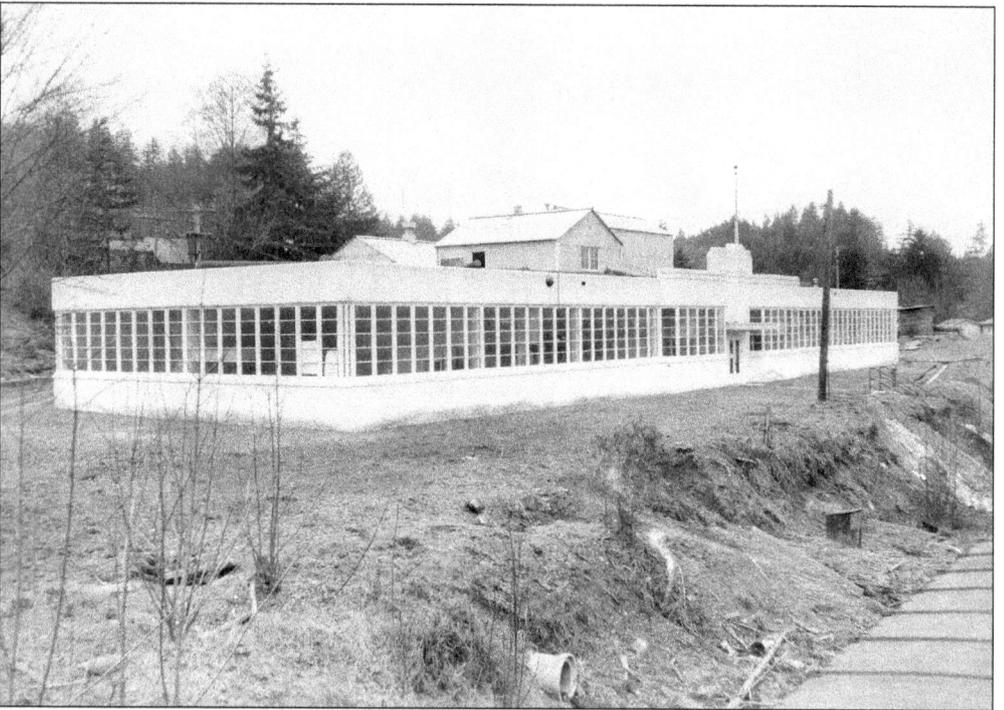

The Rayonier Research Laboratory, pictured in 1935, brought a considerable number of Ph.D. level chemists to Shelton. It was rumored that per capita, Shelton had more doctors than any other town in Washington. New uses of rayon fiber and pulping methods were developed at the Shelton laboratory. (Courtesy of MCHS.)

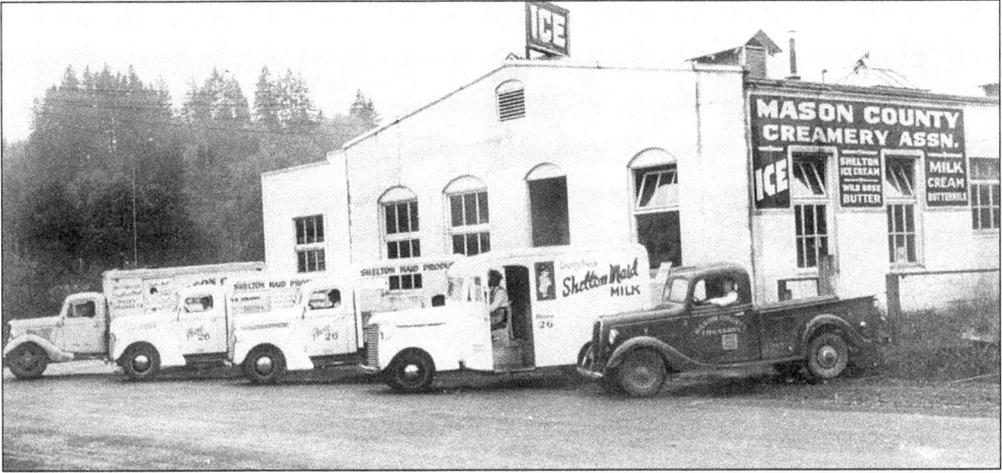

Mason County dairymen formed an association that built a creamery and cannery on the Shelton dock. This creamery, built in 1928, was a busy place as more land was cleared by the logging companies and sold for farming. Even W. H. Kneeland had a dairy herd of Jersey cows. Dairy products were delivered door-to-door. (Courtesy of MCHS.)

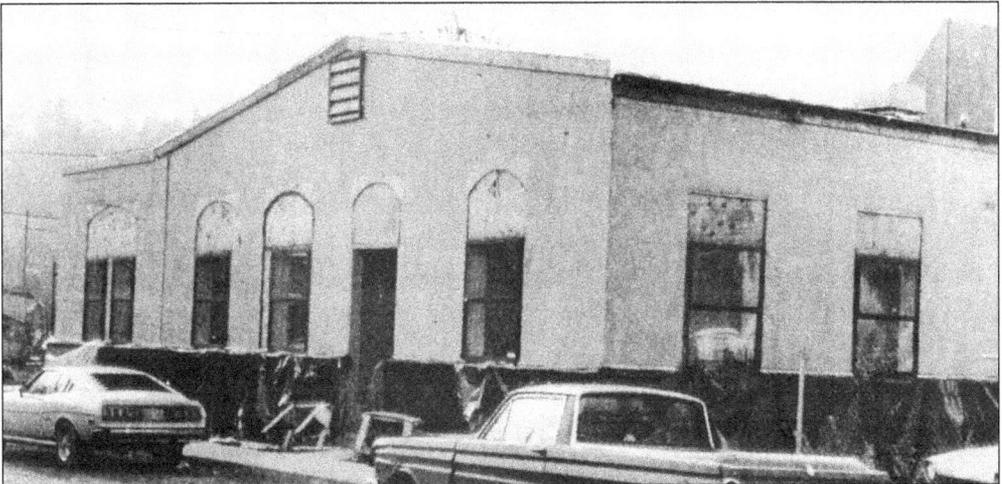

The old creamery at Third and Grove Streets was torn down when a more central processing plant was required. It is pictured being torn down in 1968 as larger dairies took over the market and people could buy milk at the grocery store. (Courtesy of MCHS.)

Celebrate The 4th

with Old Fashioned

Shelton Maid
ICE CREAM

1.25
PER GALLON

PACKED IN ICE AND DELIVERED
Phone 26

We make our own ice cream mix from rich cream produced on Mason County farms. It is not imported from other localities. When you buy Shelton Maid products you keep your dollars working at home.

MASON COUNTY CREAMERY
ASSOCIATION

This advertisement in the *Mason County Journal* from around 1930 praises the products of the Mason County Creamery Association. The July Fourth celebration would soon arrive, and families did not want to be without ice cream for the picnic after the parade. No matter what the economic situation was, ice cream was a must. (Courtesy of MCHS.)

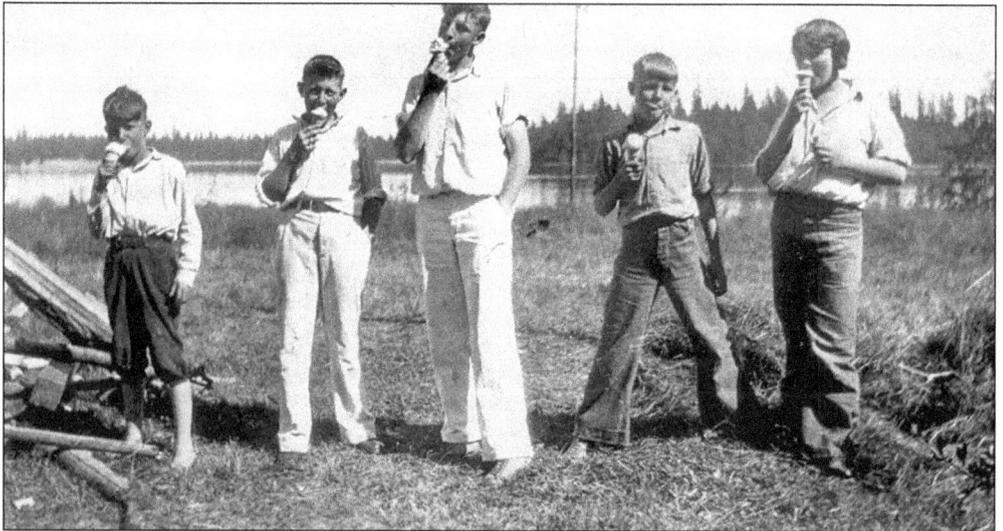

These young people must have read the advertisement in the *Mason County Journal*, or their parents did. Their July Fourth always included ice cream. Enjoying the cones at the Hanscom summer camp are, from left to right, Bob Hanscom, Don Wolfe, Jim Pauley, Herb Hanscom, and Marie Pauley. (Courtesy of Lillian Hanscom.)

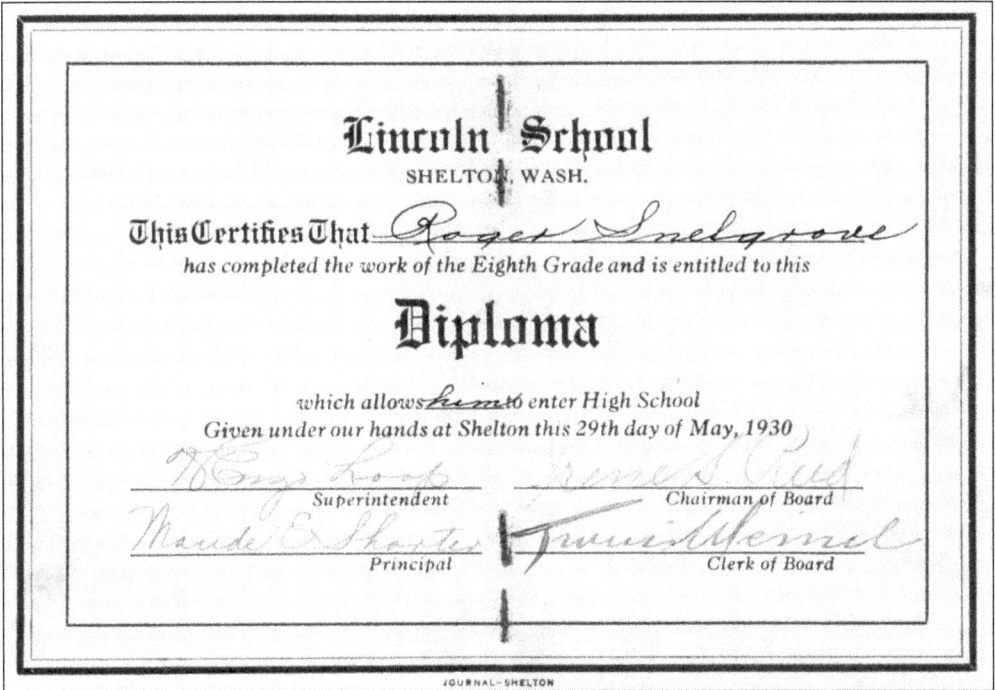

Lincoln School
SHELTON, WASH.

This Certifies That *Roger Snelgrove*

has completed the work of the Eighth Grade and is entitled to this

Diploma

which allows *him* to enter High School
Given under our hands at Shelton this 29th day of May, 1930

_____ _____
Superintendent Chairman of Board

_____ _____
Principal Clerk of Board

JOURNAL-SHELTON

The eighth grade graduation certificate of Roger Snelgrove in 1930 demonstrated the involvement of Irene S. Reed in the Shelton schools even after the high school was named for her. Also note the signatures of H. E. Loop, indicating his career development in Shelton. The *Journal* printing office printed the graduation certificates. (Courtesy of Susan Kneeland.)

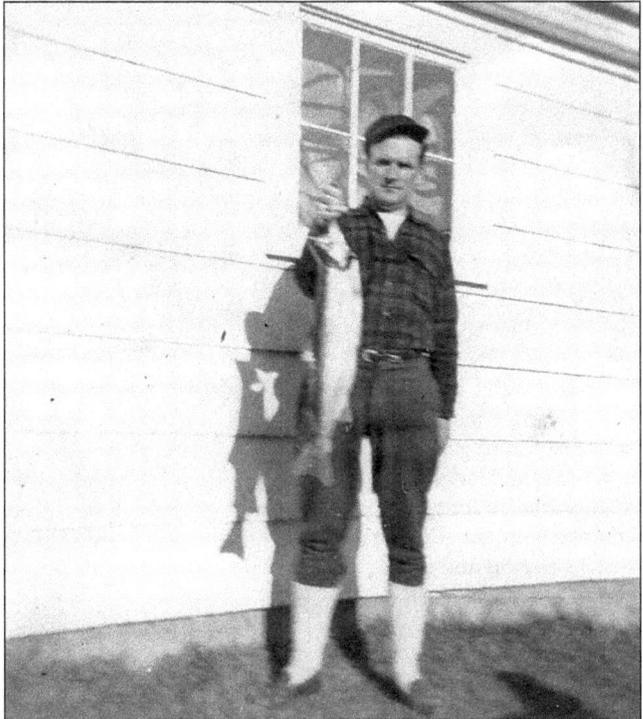

Roger Snelgrove is holding a salmon. Upon his return from Kodiak Island in Alaska, Roger fished during all his leisure time from logging. Early morning on Sunday, June 5, 1948, he drowned in Puget Sound. The *Mason County Journal* ran a front-page story about the search for his body that even overshadowed Pres. Harry Truman's visit to Shelton. (Courtesy of Susan Kneeland.)

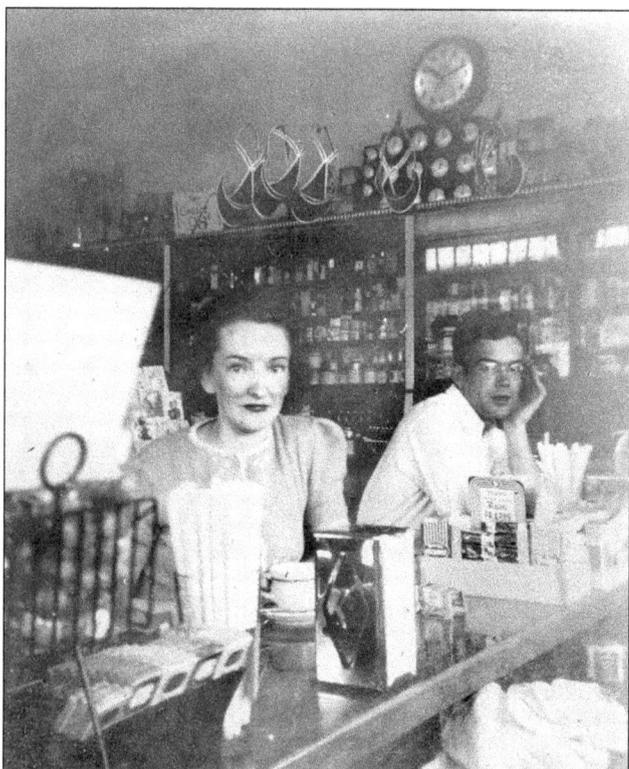

Nita Bariekman and an unidentified man sit at the counter of McConkey's Pharmacy at Third Street and Railroad Avenue around 1934. It would not be long before Nita leased the pharmacy lunch counter from druggist Roy McConkey and launched her own business. She opened Nita's Café a few years later. (Courtesy of Susan Kneeland.)

Juanita Miller worked at McConkey's Pharmacy for many years. The drugstore was a place for many people from Shelton to gather for coffee, a quick lunch, or needed medications for whatever ailment. During the Depression and the war, news traveled faster at McConkey's than in the *Mason County Journal*. (Courtesy of Susan Kneeland.)

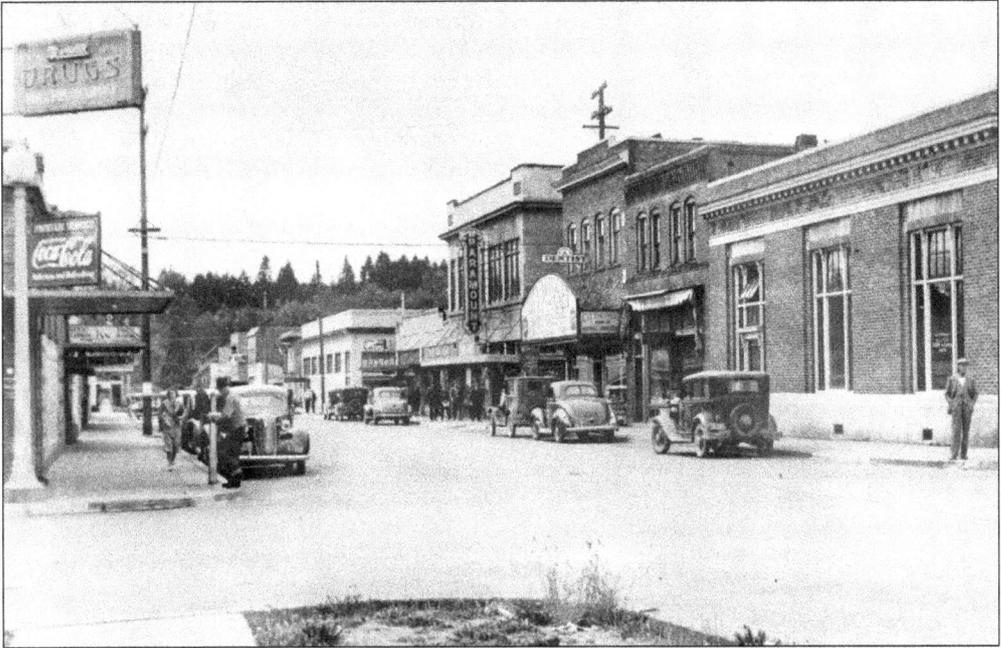

Downtown Shelton, pictured around 1935, was not hit as hard as some small towns during the Depression. There continued to be work in the woods, at the pulp mill, and even, though slower, at the mills. The men at the middle right are waiting for the Paramount Theater to open. (Courtesy of MCHS.)

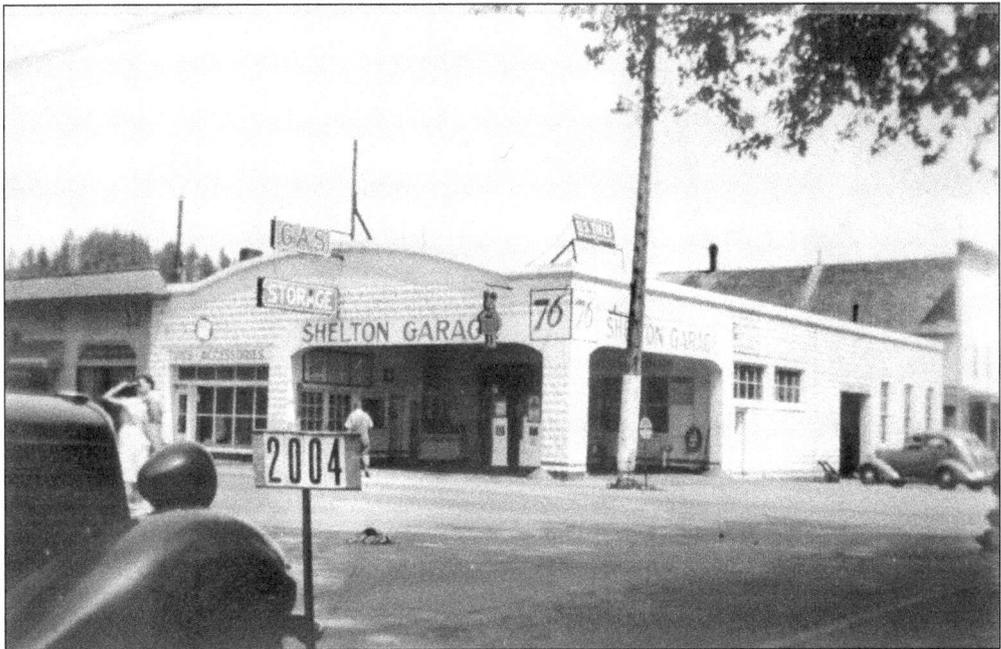

The Shelton Garage was still in business in 1940. Note the bump in the street that says, "STOP." New streetlights were installed that year along Railroad Avenue. Mrs. A. H. Anderson (Agnes), Mrs. Mark E. Reed (Irene), and Mrs. Sol Simpson (Tollie) all passed away in 1940, marking the end of an era. (Courtesy of Don Pauley.)

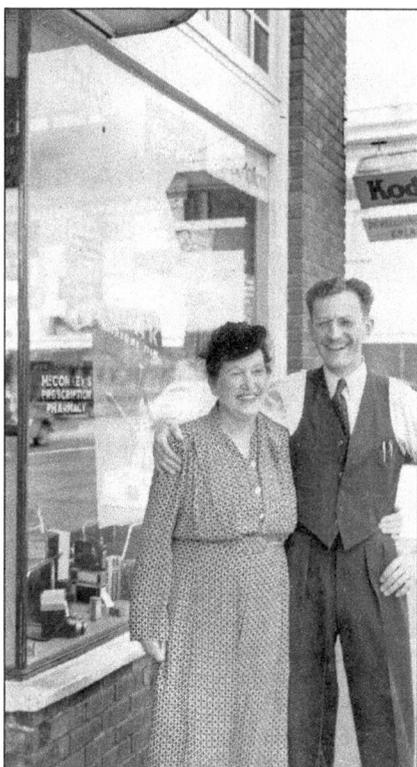

Louis Weinell and an unidentified friend stand outside McConkey's Pharmacy in 1941. The son of a Shelton banker, Weinell spent his teenage years in Shelton. Upon graduation, he went to New York to sing opera. He returned to visit his parents and entertain at Orre Noble's Music Room on Hood Canal. (Courtesy of Susan Kneeland.)

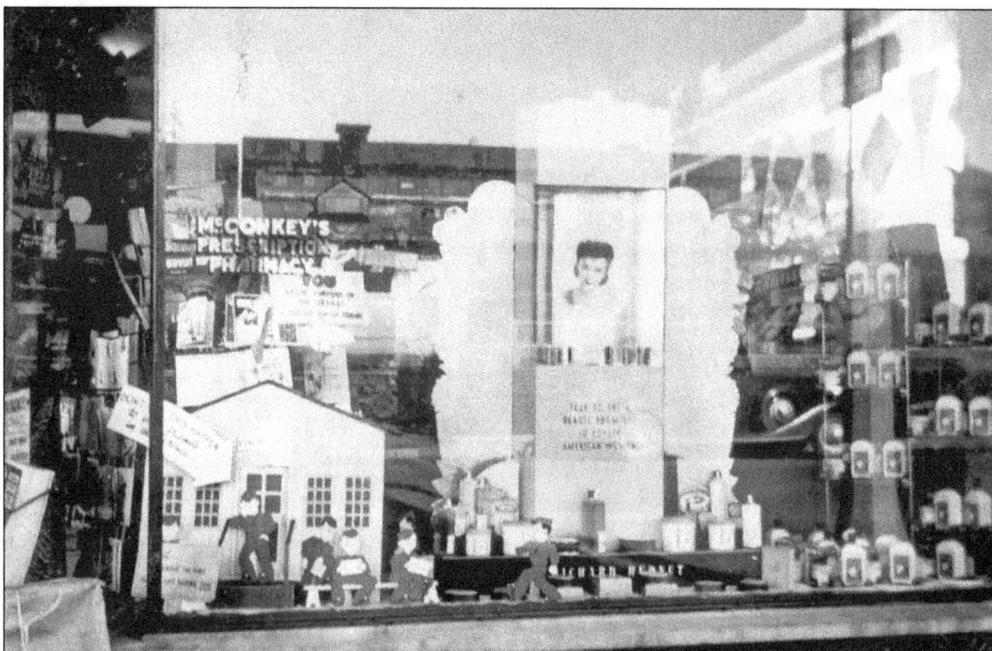

World War II had begun. This display in the window at McConkey's Pharmacy in 1942 encouraged Sheltonians to support their hometown boys. The letters and packages sent from home helped keep up morale for everyone. The ladies were encouraged to keep up with the latest in beauty products as well. (Courtesy of Susan Kneeland.)

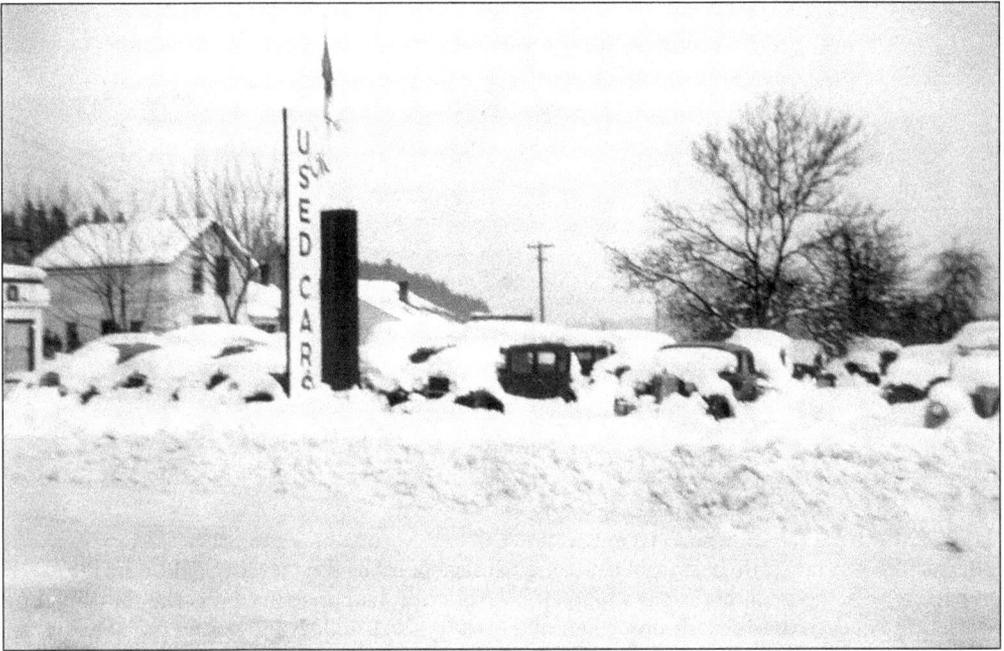

The Mell Chevrolet dealership on the southwest side of First Street and Cota Street opened in the 1920s. Here their used-car lot is buried in the big snow of 1943. Logging was shut down when this much snow hit the area. In 1943, the Rayonier Pulp Mill was also shut down by the Works Progress Administration (WPA) for a lack of hemlock logs. (Courtesy of MCHS.)

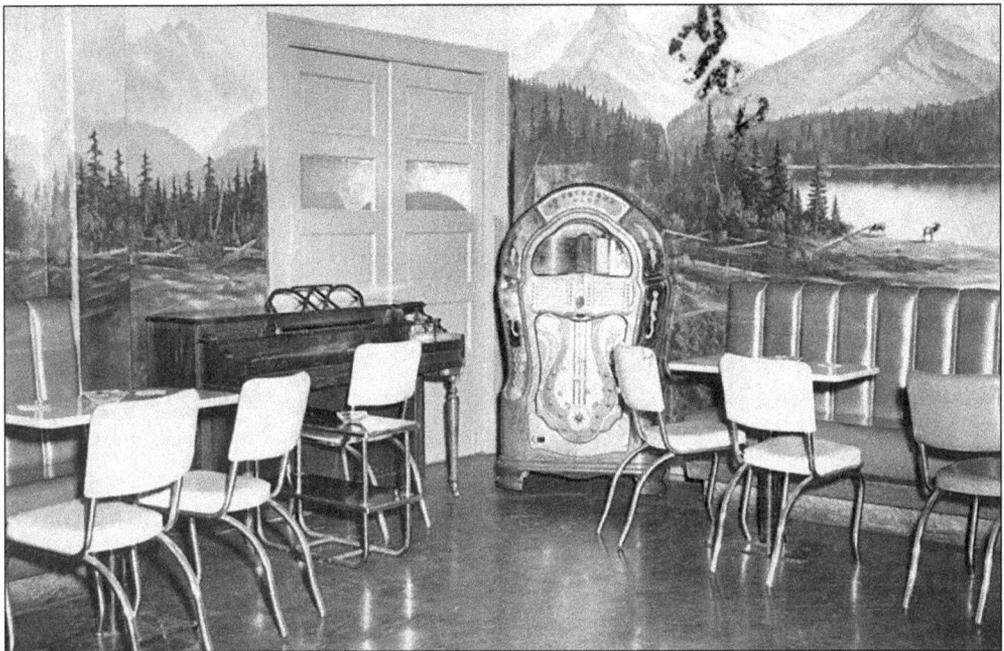

The Shelton Hotel remodeled its dining room to reflect the decor of the 1940s and create a cocktail lounge. In this 1944 photograph, murals of the Olympic Mountains, logged-over land, and elk at the shore created a backdrop for socializing. Jukeboxes were all the rage, and everybody danced. (Courtesy of MCHS.)

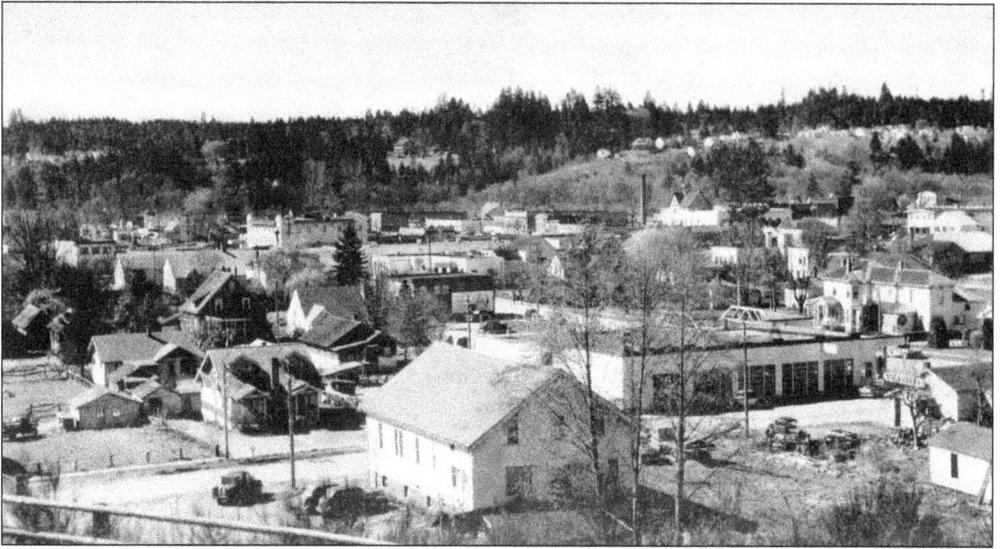

This picture was taken in 1945 from the same vantage point as the view of Shelton in 1887 seen on page 12. The house at mid-right where A. H. Anderson had once lived was the only building remaining, but even this is nearly unrecognizable, as it has been added onto several times. (Courtesy of Simpson Timber Company and Don Pauley.)

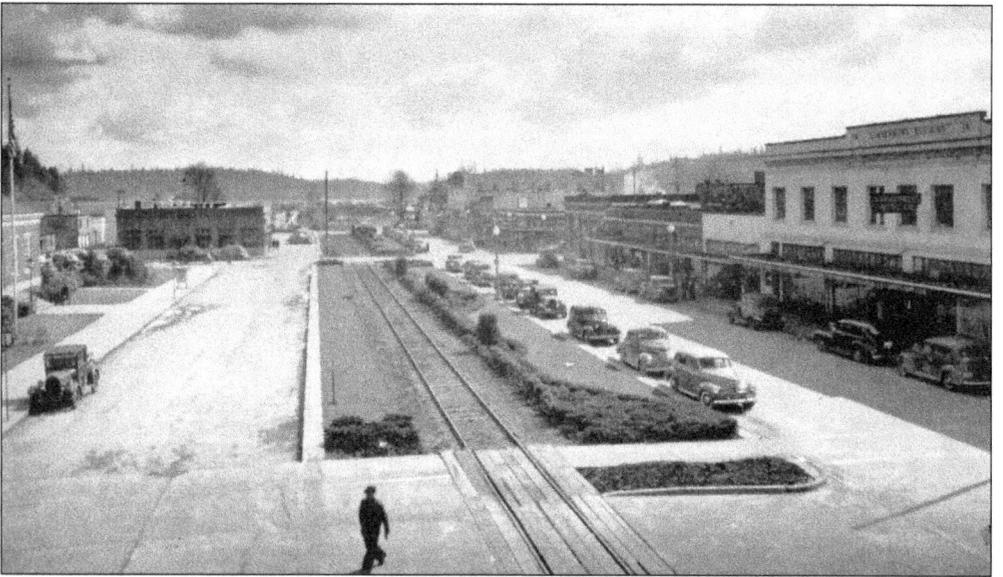

In this 1945 view of Railroad Avenue, the railroad tracks run down the street to Hammersley Inlet, and "Tollie" had yet to retire from hauling logs along this line. The last locomotive used this track on April 7, 1948. The only strip of track left on Railroad Avenue is where "Tollie" and the visitor's center caboose sit. (Courtesy of Simpson Timber Company and Don Pauley.)

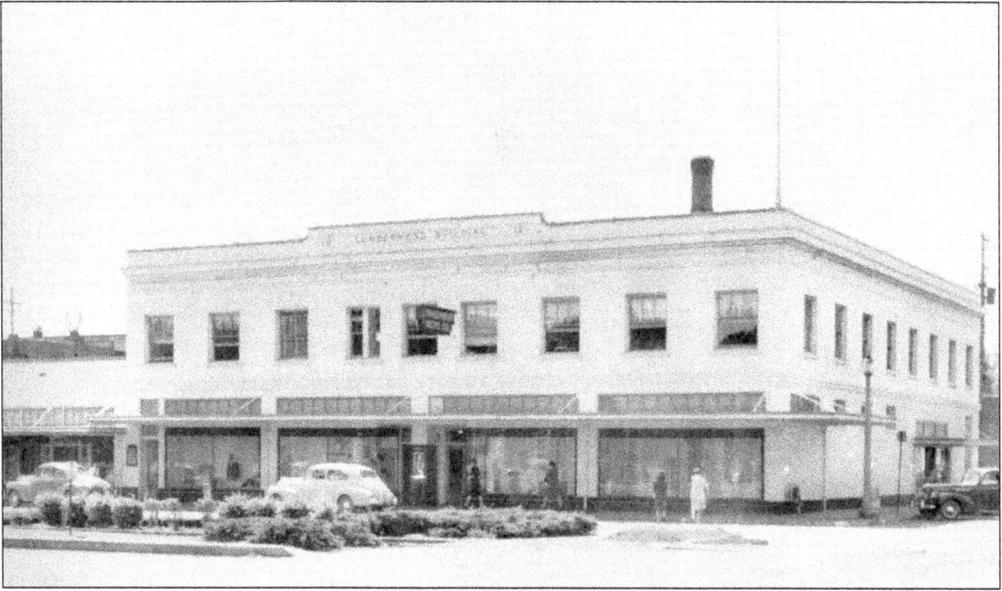

The Lumbermen's Mercantile Building, pictured here, celebrated its 50th year in 1945. For many years, the offices of the Simpson Timber Company were located on the second floor of this building. In the next decade, Simpson Timber Company would build new offices of brick on Cedar Street. (Courtesy of Simpson Timber Company and Don Pauley.)

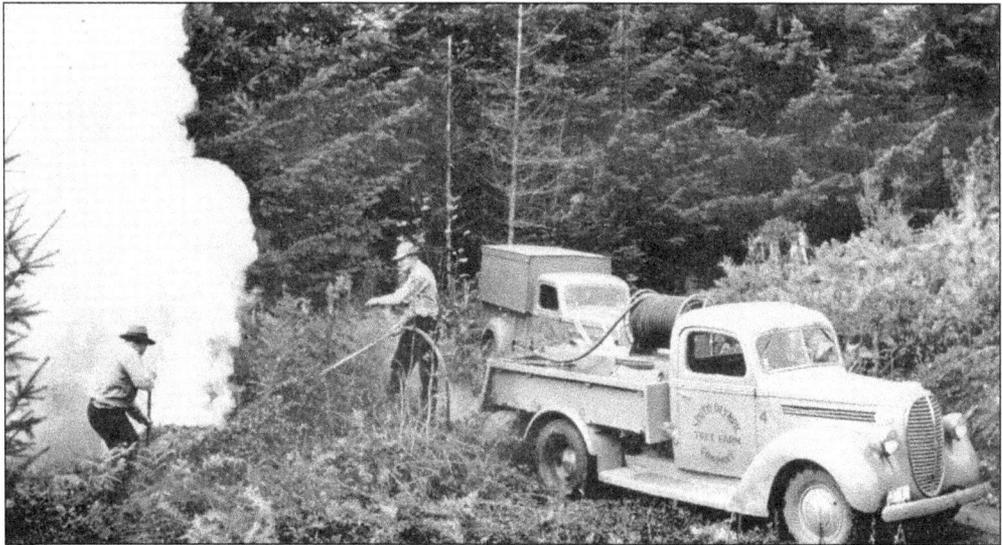

This 1945 photograph shows unidentified workers at Simpson Timber Company's Olympic Tree Farm taking a hand at controlling a blaze. Fire was a constant fear in the region in and around Shelton. The Smokey Bear campaign began in 1944 as a civil defense program in World War II. It is the longest-running public service campaign in the United States. (Courtesy of Simpson Timber Company and Don Pauley.)

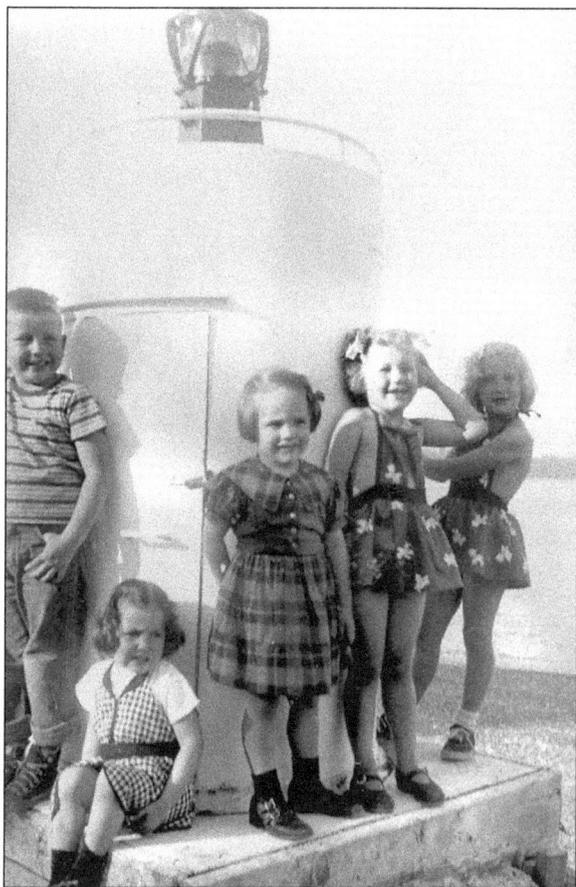

In 1947, this was the lifht at Arcadia Point. It was removed at the beginning of the 21st century by the upland propaerty owner, as satellite and sonar communications were the primary means of navigation for vessels, and the light was deemed no longer necessary. Pictured in 1952 are, from left to right, John Mike McNeil, Patricia McNeil, Susan Kneeland, Carol Hanscom, and Linda Hanscom. (Courtesy of Susan Kneeland.)

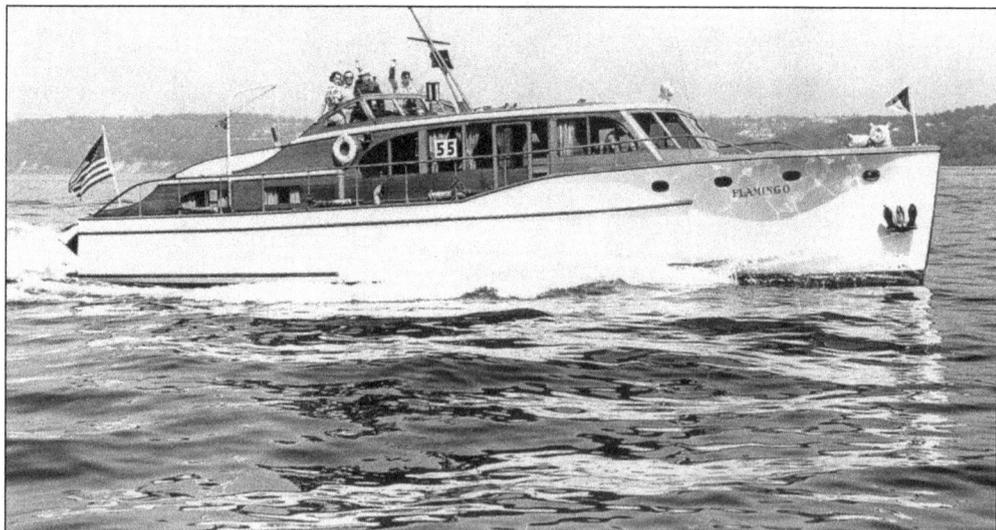

Roy Kimbel, a prominent Shelton businessman and town promoter, built this boat in 1947. The *Flamingo* was a frequent weekend sight along the Upper Sound. The boat was 58 1/2 feet long with twin 6-71 GMC diesel-powered engines. Although built as a pleasure craft, it was seen occasionally towing Kimbel's pile driver to a new work site. (Courtesy of Don Pauley.)

Six

REINVENTING THE TOWN

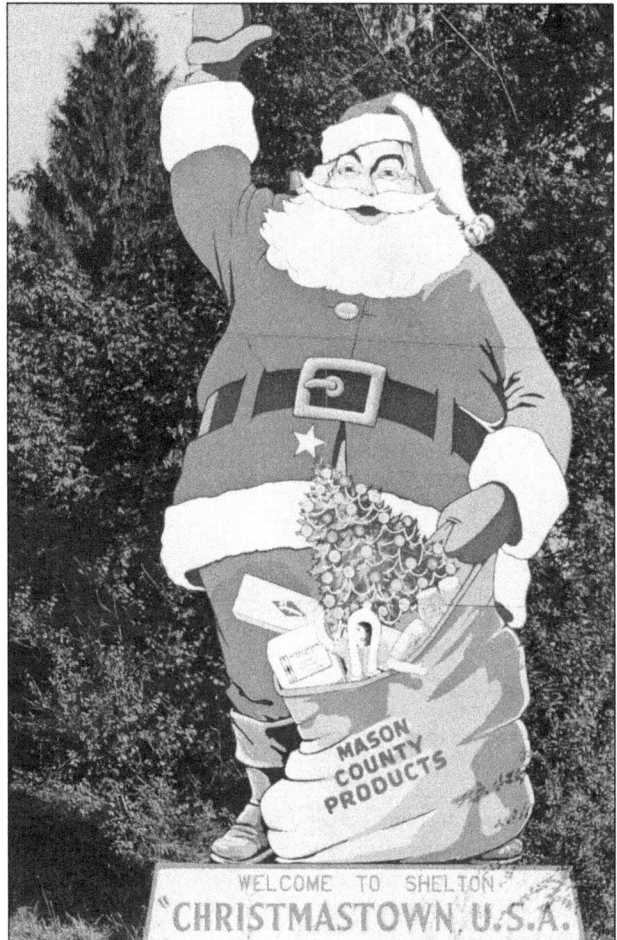

Shelton was dubbed "Christmastown, U.S.A." in 1955 by the chamber of commerce in an effort to recapture a sense of prosperity and community spirit. The timber companies had logged off much of the old-growth forest, and the new trees were not ready to harvest. There had been economic struggles, and the town needed a positive vision. This Santa was a venture into a new future. (Courtesy of MCHS.)

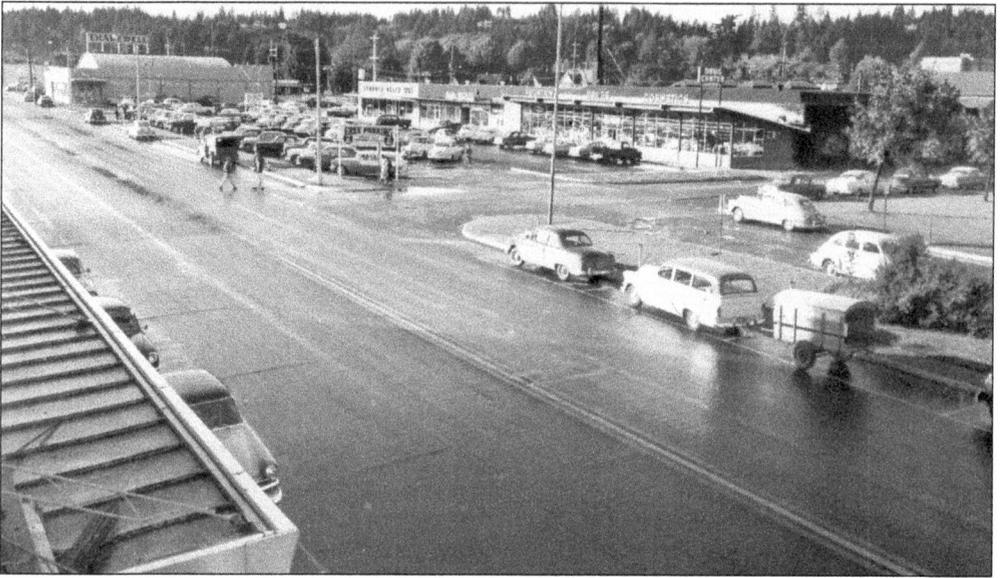

In 1955, Shelton got a face lift with the new Evergreen Square built where the railroad roundhouse had been. McConkey's Pharmacy moved into the east corner of the building, Sprouse-Reitz had a store, and Hiney's Broiler was a place for an upscale dinner. There was plenty of parking in the new shopping area, and it was all downtown. (Courtesy of Don Pauley.)

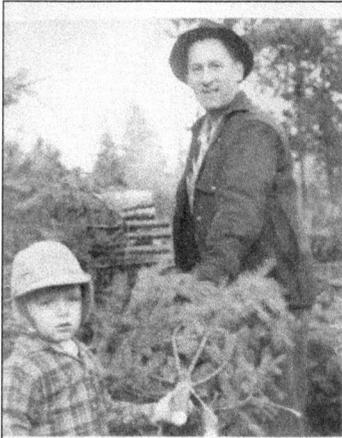

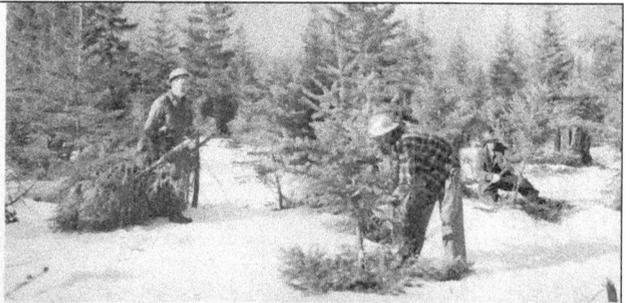

(Above) Cutting and trimming Christmas trees for shipment.
(Below) The ladies lend a helping hand during Christmas tree harvest time.

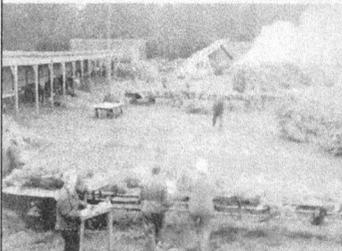

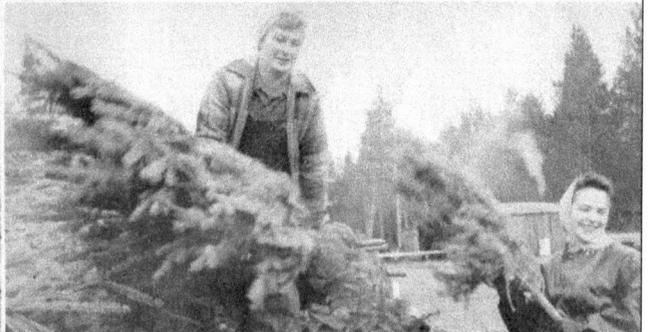

Christmas tree farmers became some of the larger employers. In the months before Christmas, many greens workers were hired for the season. Trees were trucked to the southwestern states, with the trucks returning empty. Some saw an opportunity to buy inexpensive sandstone to fill the Christmas tree trucks on their return trip. This brochure of 1954 shows workers in the new industry. (Courtesy of MCHS.)

NORTHWEST EVERGREEN CO., INC.

Beautiful greens are luxuriant in Mason County. From the delicate, lacy ferns to the more hardy greenery, healthy flora is abundant. Northwest Evergreen Co., Inc. ships these fine specimens. For information call HArrison 6-4562. "When Better Greens Are Shipped We Will Ship Them."

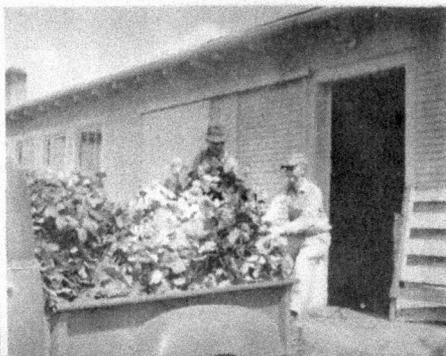

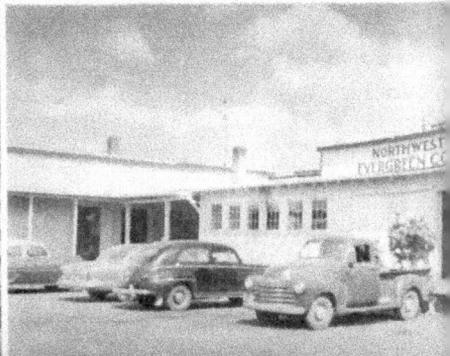

In this brochure of 1958, Northwest Evergreen Company promotes its products. The silviculture industry began 20 years earlier when Simpson Timber Company began leasing rights to open logged-over land to brush and mushroom pickers. The growing floral industry was a good customer for ferns, salal, and some evergreens. Hiawatha Evergreens ships globally and at the peak of the season hires approximately 700 people. With increasing economic prosperity, people and businesses wanted to decorate for the holidays with wreaths, garlands, and other fresh evergreens that they did not have to go into the woods to cut themselves. People were getting busy and did not have time or access to resources to do some of the traditional holiday preparations. Additionally, some folks who had left the northwest wanted fresh greens in their homes, and what better way to "feel like you are home" than to smell a centerpiece of fir or pine sitting on the dining room table? (Courtesy of MCHS.)

Simpson Timber Company vacated the second-story offices of the Lumbermen's Mercantile in the mid-1950s and moved into their new corporate building on Cedar Street. The building incorporated Goldsborough Creek, allowing it to run through the center. In this 1958 photograph, Susan Kneeland (behind) and Barbara Kay Kneeland enjoy watching for fish in the creek at the new Simpson headquarters building. (Courtesy of Susan Kneeland.)

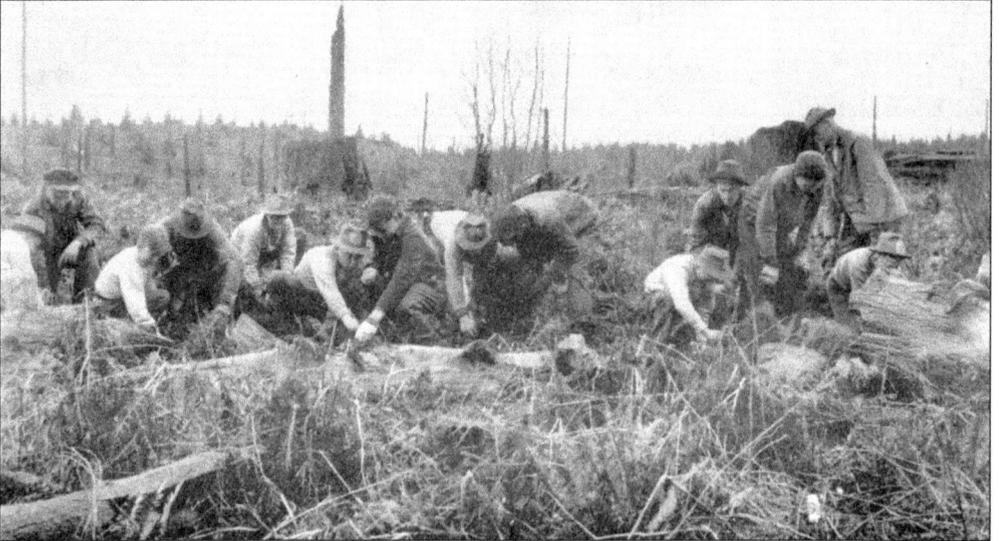

A unique practice that Mark E. Reed and Sol Simpson brought to Mason County was the retention of their logged-off land. Most loggers sold their land to farmers. The Simpson Timber Company knew that planting new trees was imperative. In this 1945 photograph, unidentified youngsters are learning to plant new trees, which would be harvested some 60 years later. (Courtesy of Simpson Timber Company and Don Pauley.)

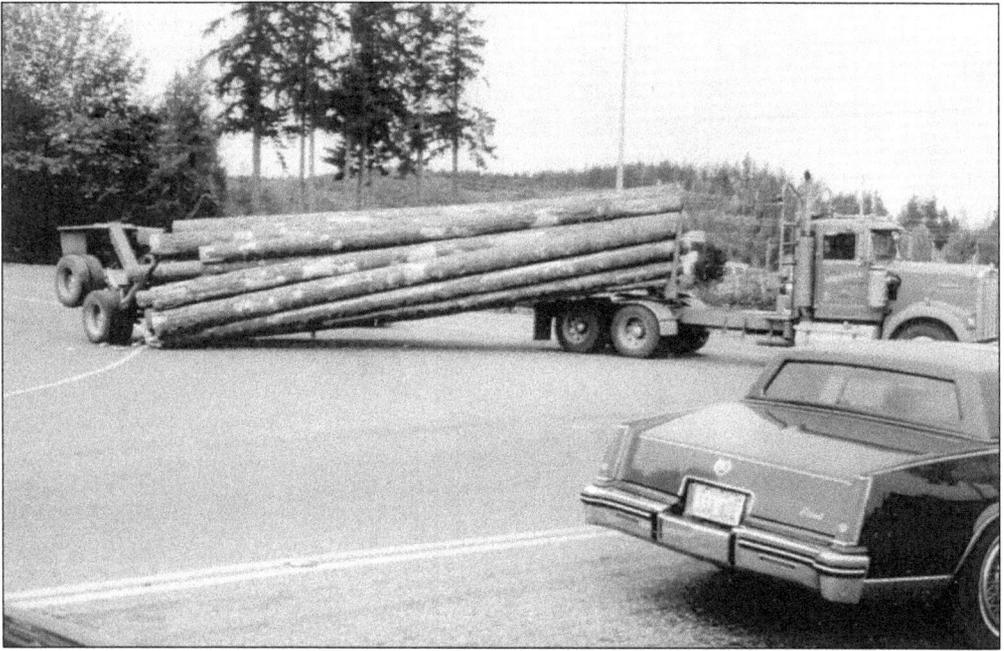

In this *c.* 2005 photograph, a load of third-growth logs fell off the truck. This load is composed of 60-year-old trees that are between 36 and 40 feet long and contains approximately 3,600 board feet of lumber. It was logged from the original William Walter claim of 1864 on Little Skookum. (Courtesy of Frank Bishop.)

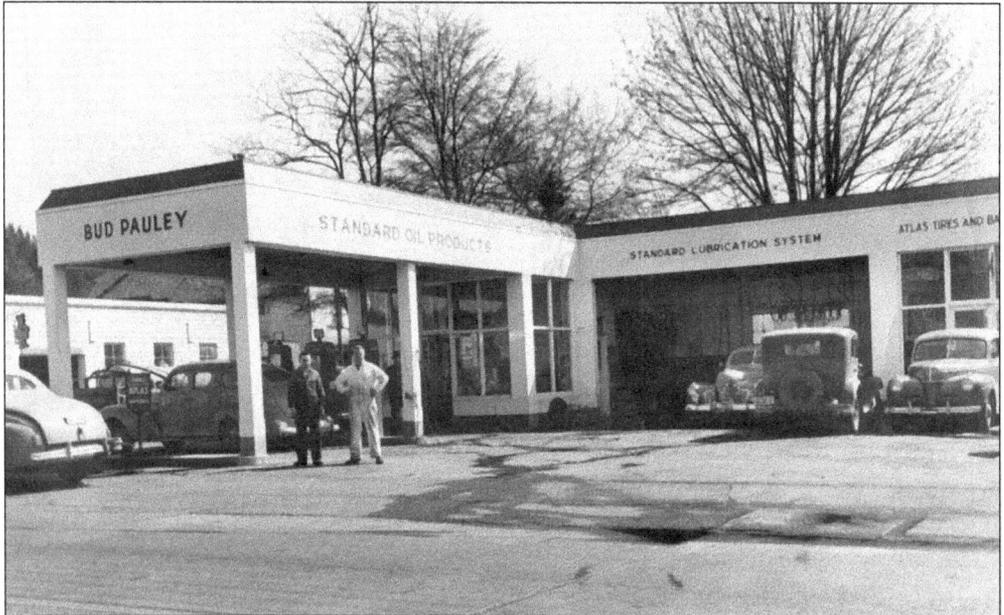

Returning from World War II, the younger Pauley brothers knew they wanted to be in the car business. In this 1950 photograph, an unidentified man (left) and owner Frank D. "Bud" Pauley take a break. The service station at the corner of Franklin Street and Railroad Avenue was a stopping place for a soda and gas before driving to a summer cabin on Mason Lake or out to Hood Canal. (Courtesy of Don Pauley.)

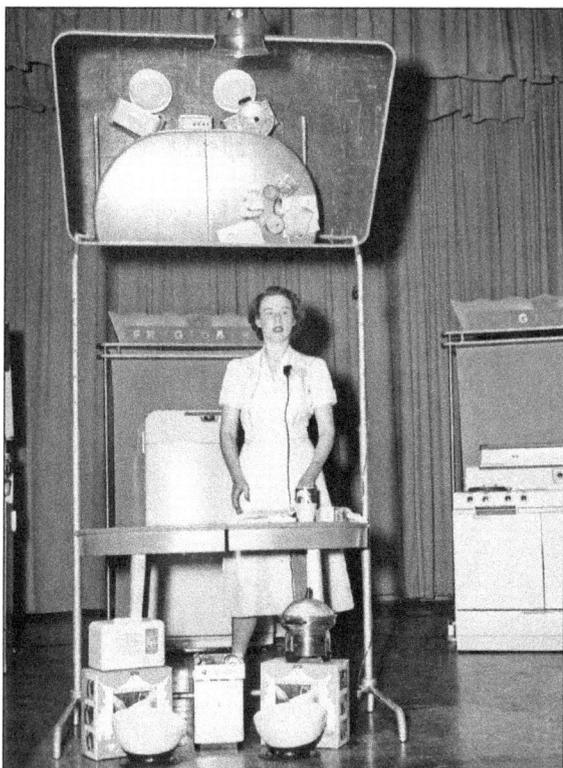

There were all sorts of new appliances for the kitchen soon after the end of World War II. Lumbermen's Mercantile began cooking demonstrations on how to use them; in this 1951 photograph, school is in session. Women were leaving their war work in factories and returning home to raise their families and learn to become consumers. (Courtesy of MCHS.)

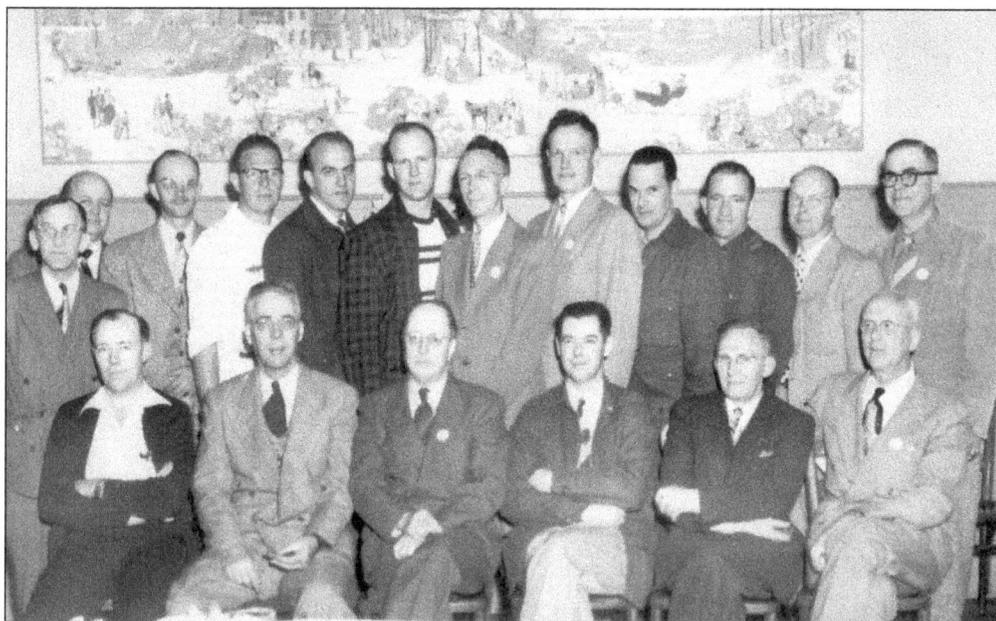

In this picture of the Shelton Chamber of Commerce, taken in 1953 or 1954, are the men who helped reshape Shelton's future. They are, from left to right, (first row) Les Shelver, Jack Catto, Neil Zintheo, Chuck Rowe, Harold Lakeburg, and Maurice Needham; (second row) Jack Shimek, Herb Rotter, Andy Anderson, Jim Pauley, Gil Oswald, Buck Price, Laurie Carlson, Phil Bayley, Gib Frisken, Bill Gott, Hal Olstead, and Ed Faubert. (Courtesy of MCHS.)

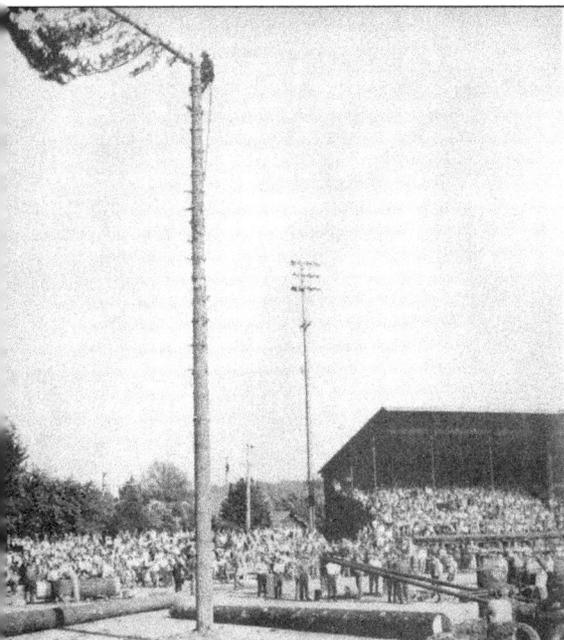

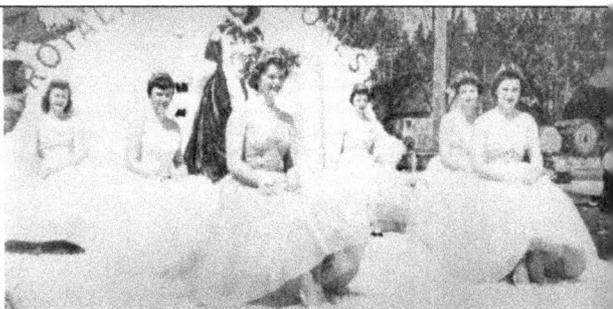

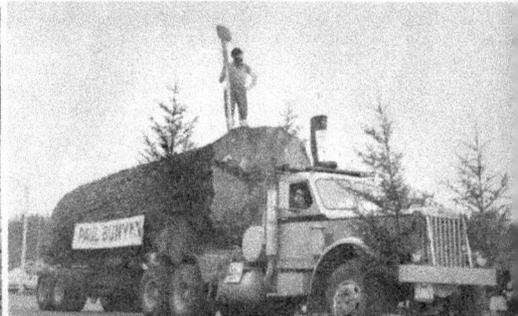

One of the chamber's publications was the Forest Festival brochure seen here. The Forest Festival was created in 1945 to promote Shelton's logging industry and emphasize fire safety. A "Paul Bunyan" and Forest Festival queen with court were selected from Mason County's high schools. The festival began on Friday evening with a pageant. The first scripts for this event were written by the creator of the Paul Bunyan stories, James Stevens. A parade on Saturday morning had everyone lining Railroad Avenue. Saturday afternoon was the "logging show," where loggers from around the state competed in axe throwing, tree topping, bucking, and other contests. A rodeo was added to the festival a few years later. On Saturday evening, there was a street dance to end the festivities. The festival continues in June each year, but the parade is now in the evening and there is no pageant. (Courtesy of MCHS.)

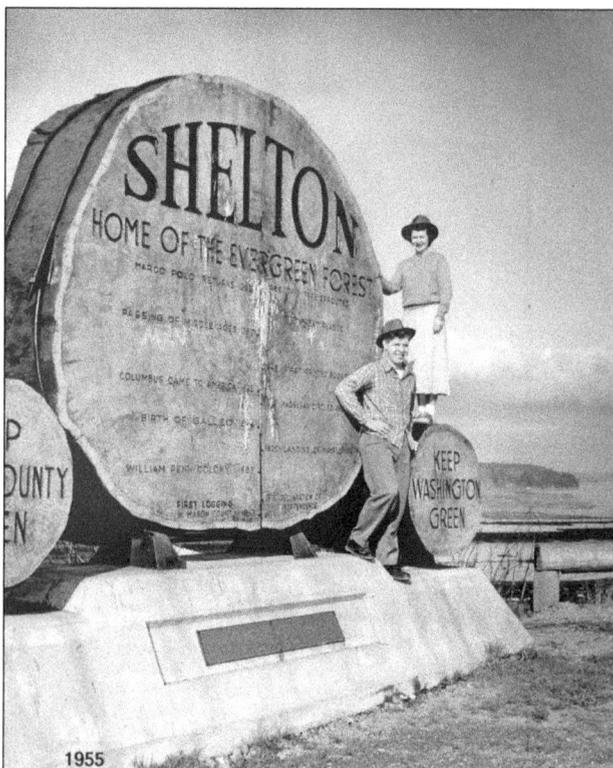

Another promotional activity, seen in this 1955 photograph, was the installation of the Shelton Monument on the right side of Highway 3 as one drives down the hill into town. The monument indicates dates in history when the tree was still growing and adding rings. It is a favorite spot to stop for a picture of the bay. The people on the monument are unidentified. (Courtesy of MCHS.)

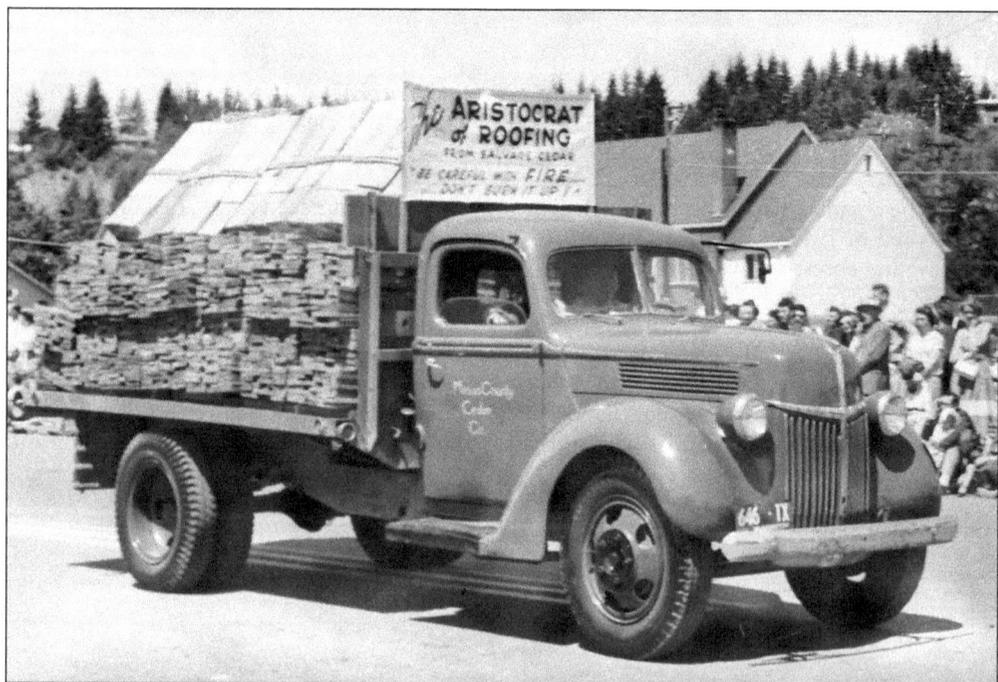

George Smith drives a load of cedar shakes with his dog, Spot, in 1952. Smith owned the Mason County Cedar Company, which went out of business a few years after this event. There were many small shake and shingle operations in the area at that time. (Courtesy of Don Pauley.)

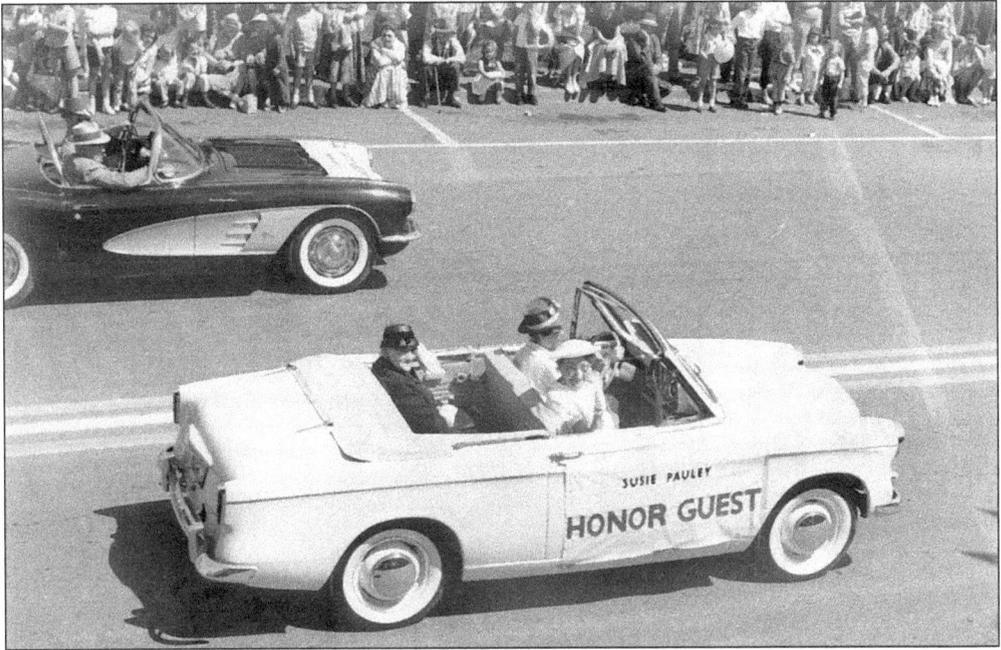

In the 1957 Forest Festival parade, Susie E. (Myers) Pauley is driven by her granddaughter, Margret Pauley, in a car furnished by Frank D. "Bud" Pauley's Dodge-Plymouth Agency. The car is a Renault, however. Susie Pauley was honored as a Daughter of the Pioneers of the State of Washington and for her 34 years of service to Mason County. (Courtesy of Don Pauley.)

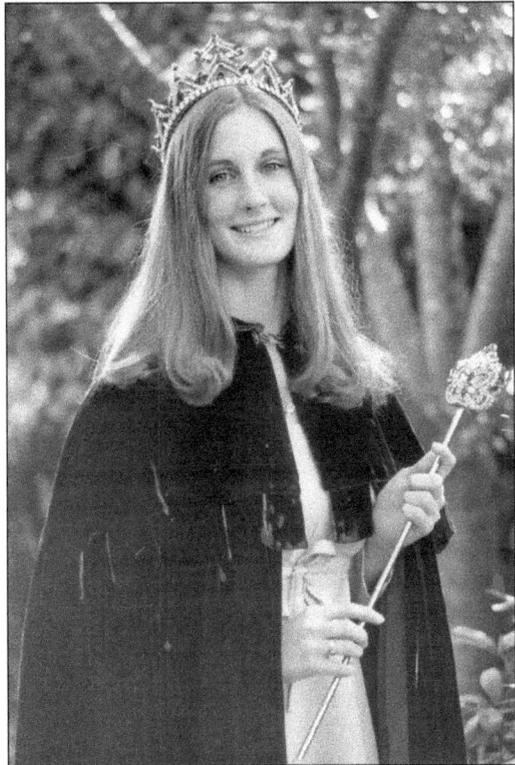

Tami Hanscom was the Forest Festival queen in 1977. In the parade, the queen and her court rode in convertibles or on a float, but the Paul Bunyan had to ride atop a loaded logging truck. Tami went on to continue the tradition of working women in the Myers family by becoming a nurse practitioner. (Courtesy of MCHS.)

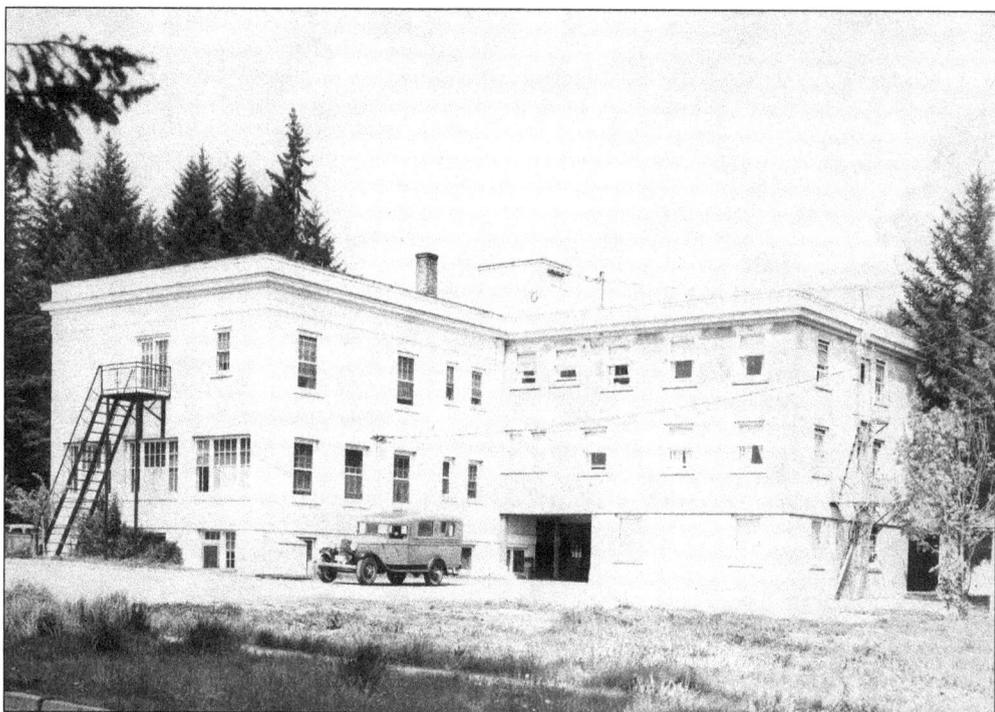

There was no hospital in Shelton until 1920, when Mark E. Reed donated land and money to build one near his own home. When the hospital was built, men hurt in the woods no longer had to make the trip to Olympia or Bremerton to be treated for trauma. The hospital emergency entrance, with an ambulance at the ready, is seen in 1934. (Courtesy of MCHS.)

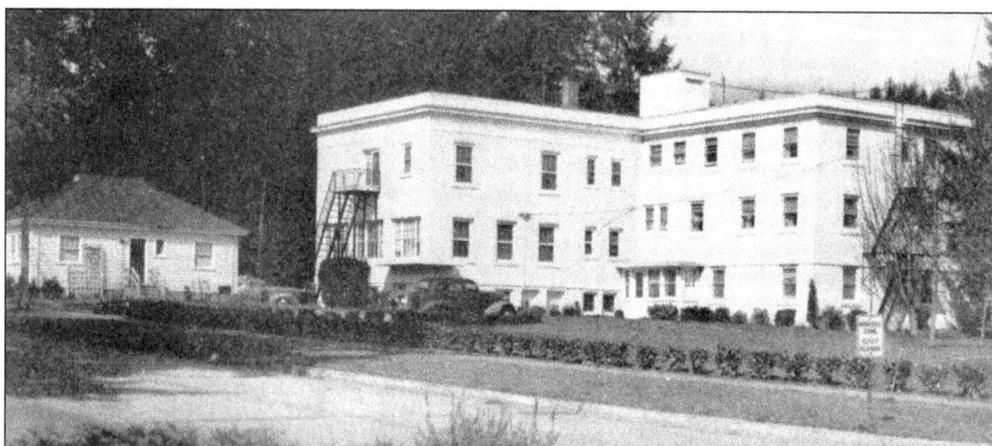

The building on the left of the Shelton General Hospital in this 1934 photograph is a nurses' cottage. The cottage, where single nurses lived, was added to the grounds in 1922. The cost of their room, and sometimes their meals, was figured into their salary. (Courtesy of MCHS.)

94

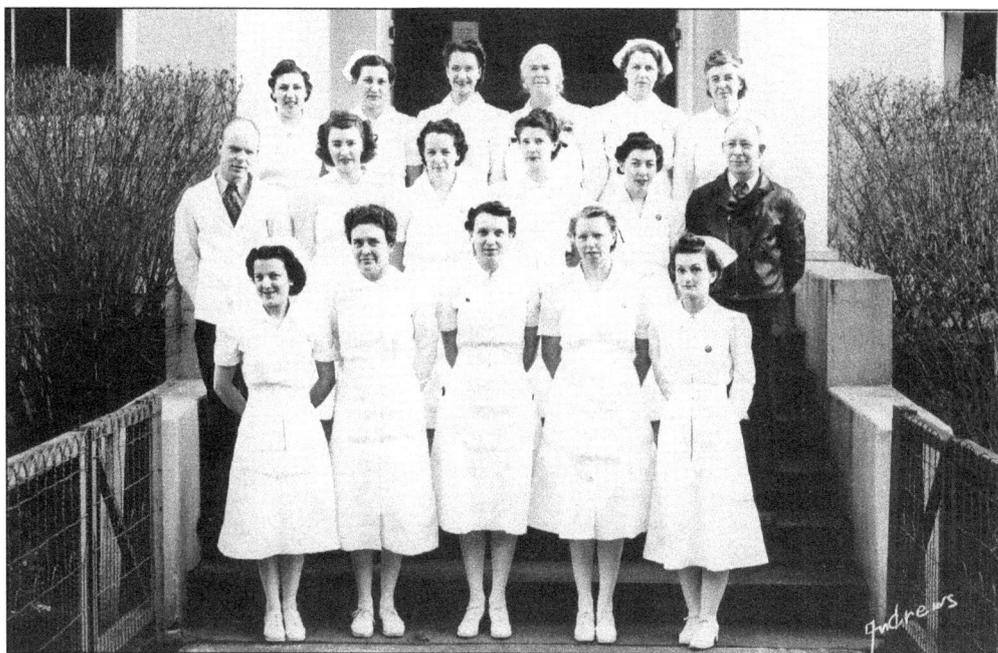

The hospital staff in 1941, excluding physicians, is from left to right (first row) all unidentified; (second row) two unidentified, Marie Able, two unidentified, and Frank Harrier; (third row) Ann Frank, Roesy Smith, two unidentified, Dorcas Myers, and unidentified. The two men worked in the laboratory and x-ray departments. (Courtesy of MCHS.)

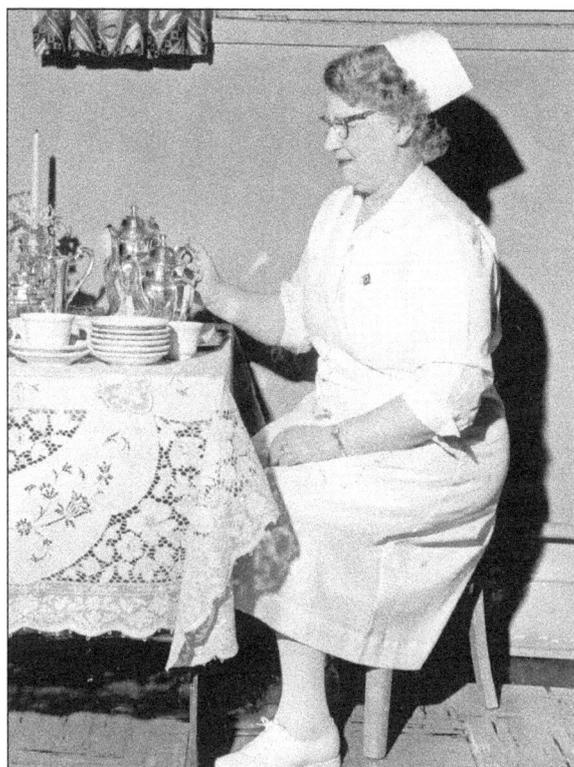

Formal tea was a traditional annual event to raise money for the hospital to purchase specialized equipment or provide some service to indigent patients who could not otherwise pay for treatment. There was little health insurance except through some employers. In 1950, Dorcas (Myers) Smith pours tea for an attendee at a hospital fund-raiser. (Courtesy of MCHS.)

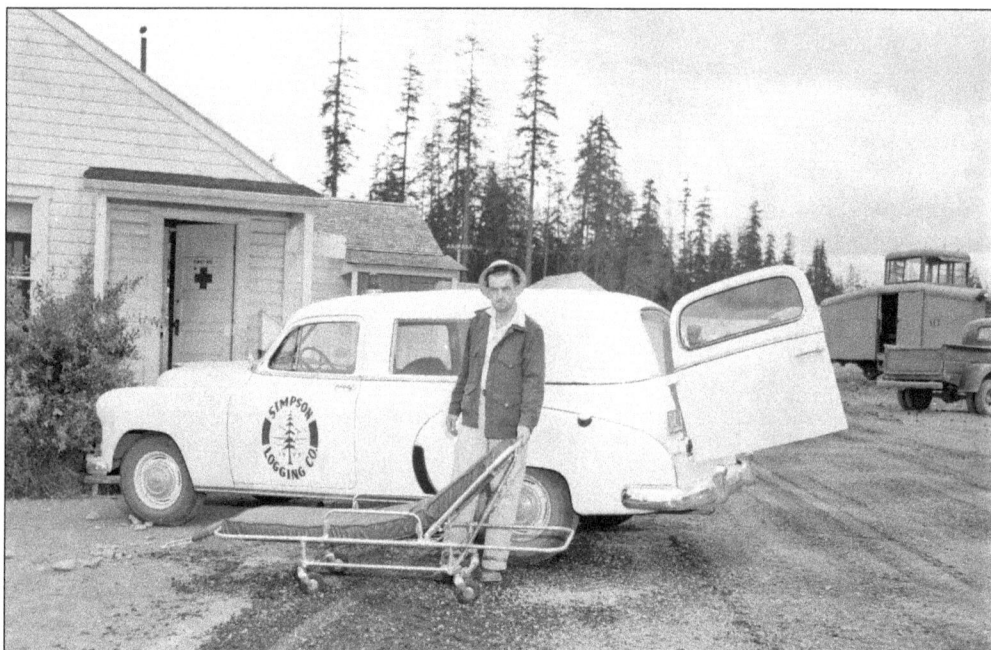

If a man was injured in a logging accident near the camp, an ambulance from Shelton could take an hour to reach him and another hour to transport him back to Shelton, wasting precious time to get him treatment. Simpson bought its own ambulance for Camp 5 in 1943, saving valuable time for an injured worker. Showing off the ambulance is an unidentified man. (Courtesy of MCHS.)

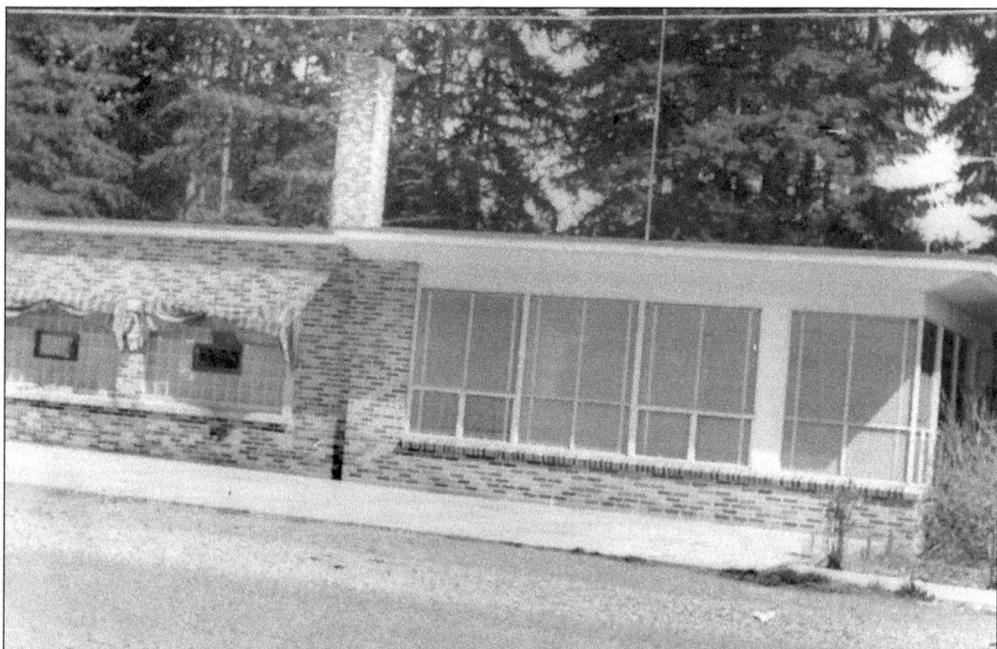

In 1949, Dr. Boy N. Collier, an early physician and surgeon in Shelton, built his own clinic hospital in which to serve patients better and to manage a facility to his own liking. Dr. Collier was board certified in trauma care. Although small, the clinic was able to perform most medical care and dispense medications as well. It closed in 1967. (Courtesy of MCHS.)

In 1965, the people of Shelton passed a bond that allowed a new hospital to be built on Mountain View. The brochure for the dedication shows the new hospital entrance as it appeared in 1968. There was some concern on Dr. Collier's part that physicians' offices also needed to be built near the new hospital. This was eventually accomplished. (Courtesy of MCHS.)

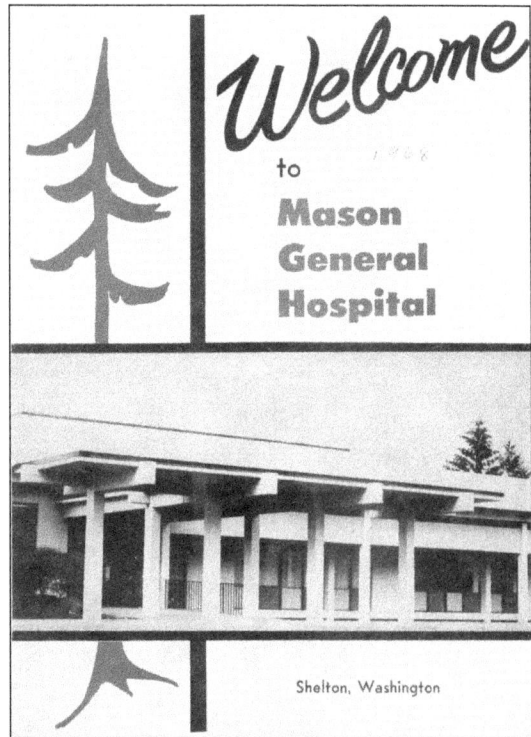

Welcome to **Mason General Hospital**

Shelton, Washington

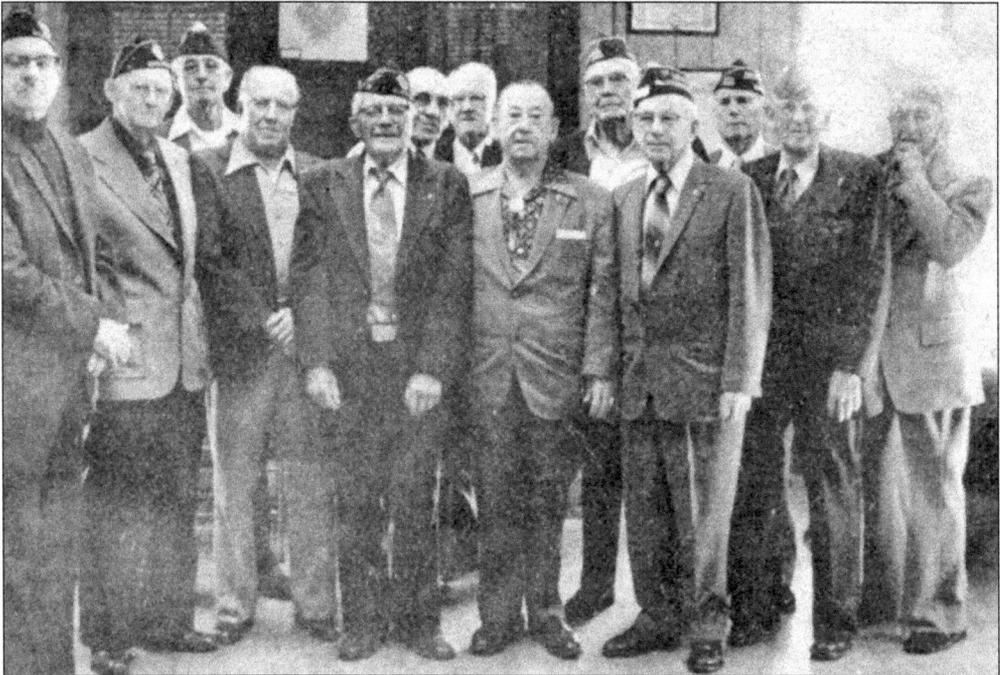

Shelton has a history of honoring people. World War I veterans are honored at a breakfast in 1976. They are, from left to right, Walter Nash, Free Stevens, Orin Brumbaugh, Roland Gearhart, Nel Dobson, Clive Troy, Dr. B. N. Collier, John Batchelor, Howard Ramsey, Bill Batchelor, Herb Angle, Ed Wetmore, and Ray Parr. (Courtesy of MCHS.)

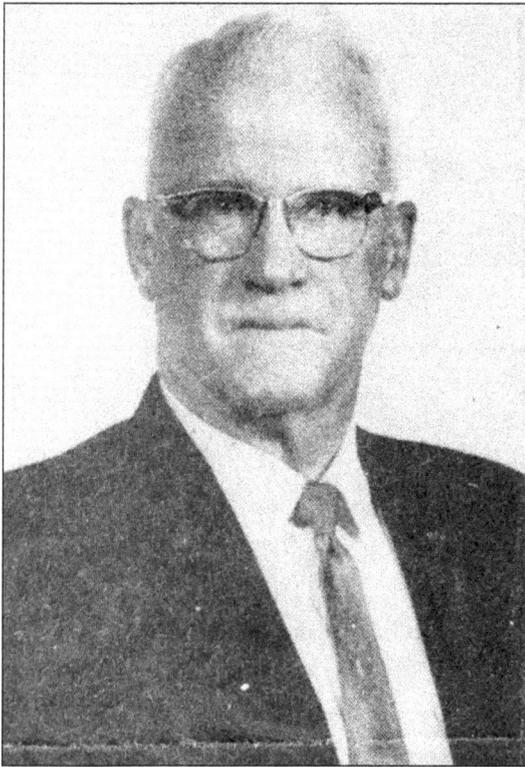

Dr. B. N. Collier retired in 1982 after 50 years in medical practice in the community. He played the violin, flew a plane, hunted polar bears in Alaska, and belonged to numerous organizations. He and his wife, Myra, retired to Arcadia Point in a house built of Arizona sandstone. (Courtesy of MCHS.)

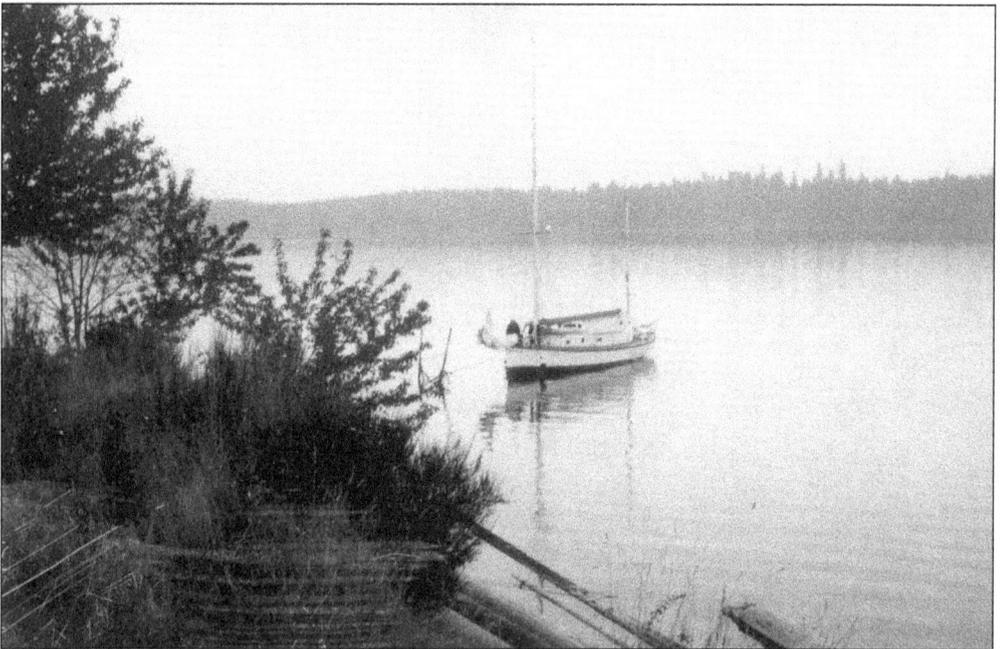

This was Dr. Collier's sailboat, and when he retired, he could be seen sailing the waters of the Upper Sound, usually in the evening, as his days were full of numerous activities even after retirement. There were few sailboats around Arcadia Point, as the wind is fickle and the currents are swift. It is not for the inexperienced captain. (Courtesy of Lillian Hanscom.)

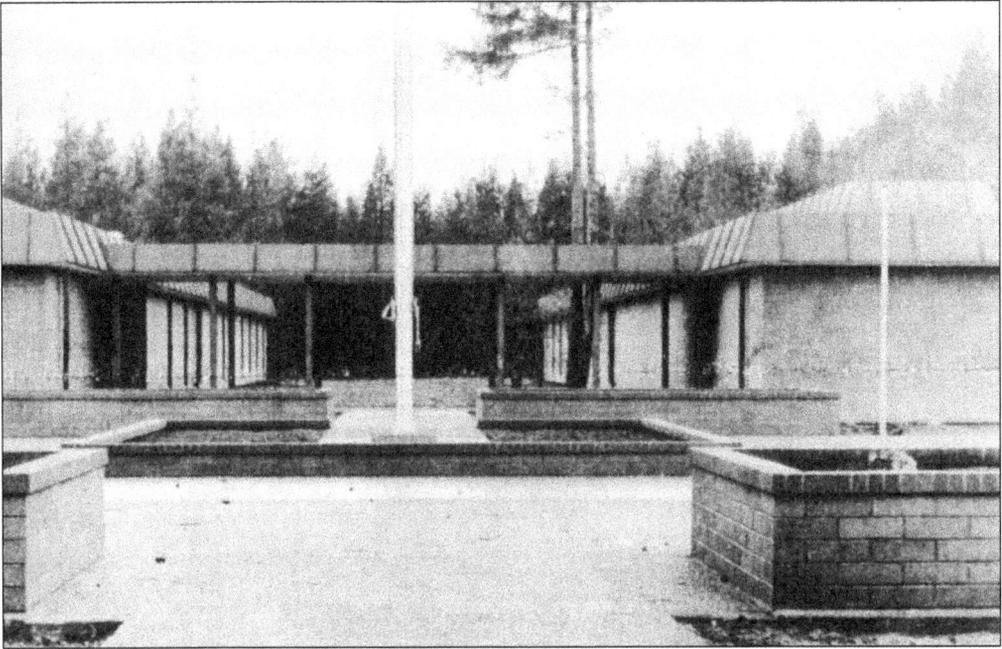

The Washington State Patrol Academy built a new facility near the Shelton airport in 1968. The buildings incorporated classrooms, a dining hall, and barracks for 96 resident cadets. There is a firing range for training in marksmanship and a pool for training in extricating people from cars that have landed in the water. (Courtesy of MCHS.)

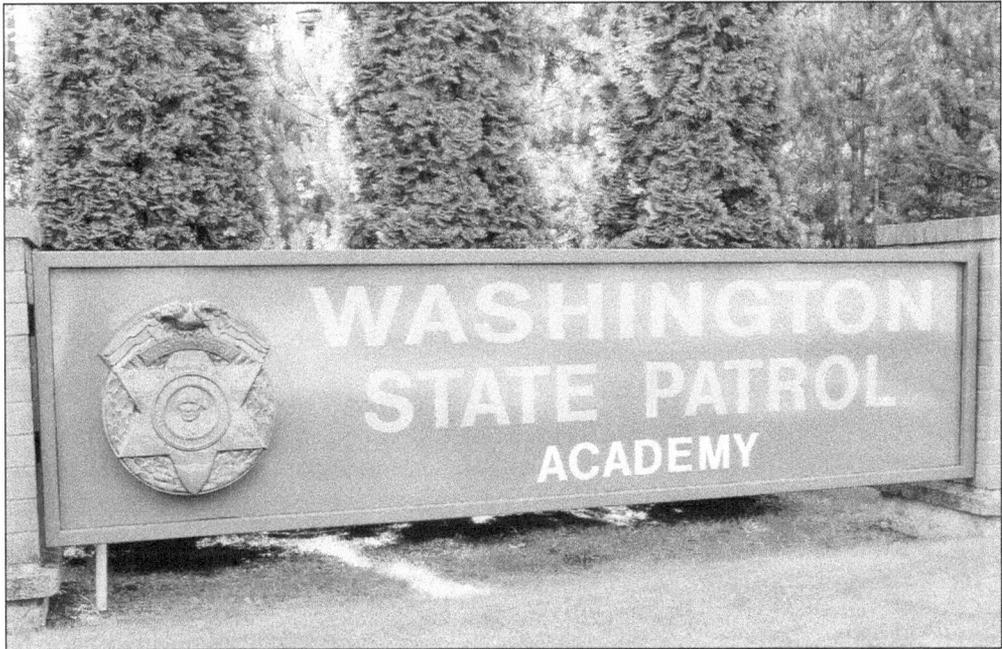

This sign greets visitors to the Washington State Patrol Academy, which was dedicated in 1969. Every trooper in the state is trained at this facility, and additional courses are offered to upgrade skills on a regular basis. As many as 120 people can attend classes or meetings on the campus at one time. (Courtesy of Weldon Wilson, Washington State Patrol [WSP] photographer.)

99

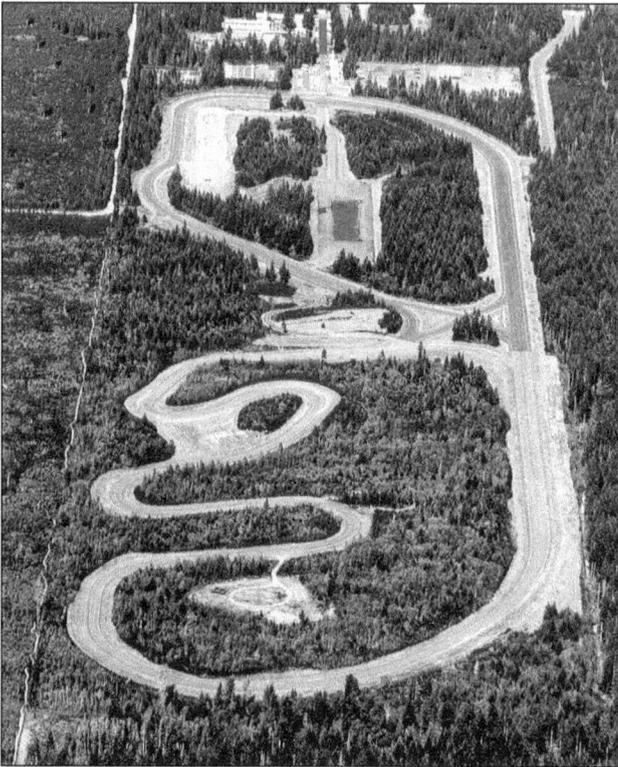

In 2008, this aerial view was taken at 3,000 feet and shows the Washington State Patrol Academy driver training course. The many curves in the course are indicative of the roads in the state of Washington, with its mountainous terrain, winding coastlines, and narrow back roads. (Courtesy of Weldon Wilson, WSP photographer.)

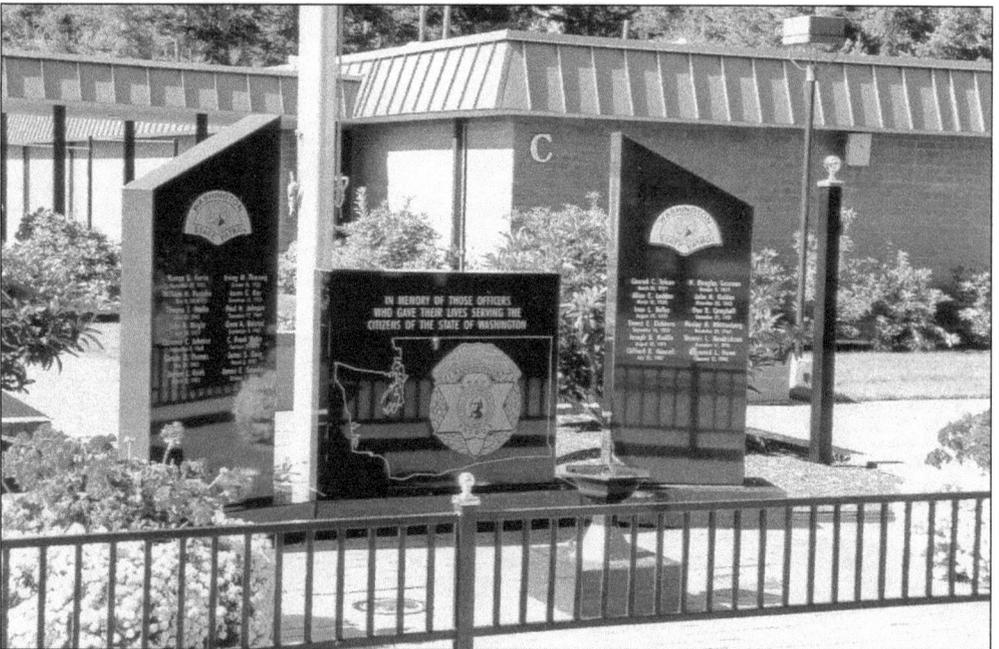

This memorial was dedicated in 2004 at the Washington State Patrol Academy for 26 troopers who had lost their lives in the line of duty. The academy has been near Shelton for 35 years, yet there are many people who do not even know it is there until another trooper looses his or her life. (Courtesy of Weldon Wilson, WSP photographer.)

Seven

THE SHELLFISH INDUSTRY

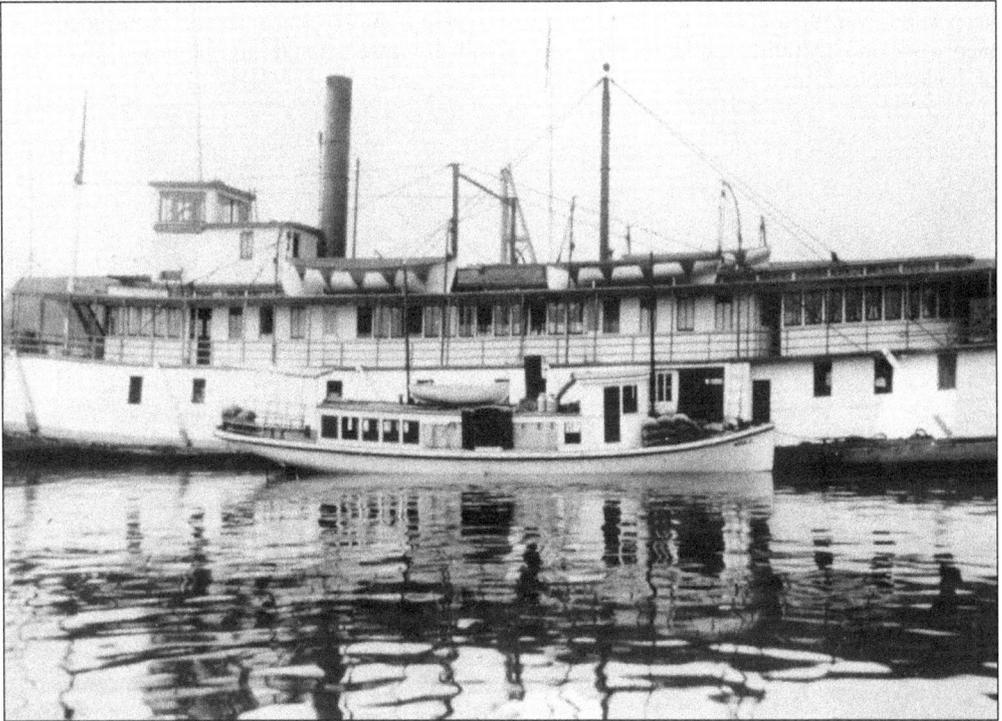

Oysters are being loaded onto the larger boat for shipment to Olympia and Seattle around 1900. As early as 1859, oysters had been harvested for sale, but organized oversight was not begun until 1902 with a Board of Oyster Land Commissioners. Thirty acres of land along Hammersley Inlet and over 100 acres on Hood Canal were under the control of the commissioners. (Courtesy of Taylor United, Inc.)

Although called the French dike system, it is not clearly known where the idea originated to keep water over the oysters at all times, protecting them from freezing and sun. Two unidentified men work on expanding a dike in 1910, after shellfish growers could buy the beach. (Courtesy of Taylor United, Inc.)

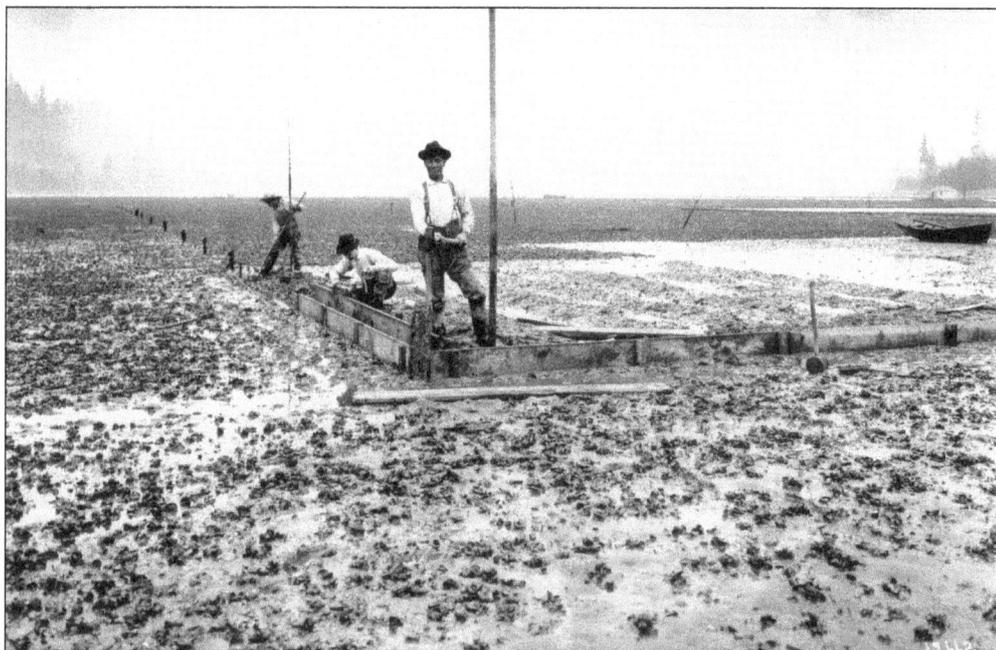

Three unidentified men are building forms for a new concrete dike along the gently sloping beach at Little Skookum in 1920. The man at the right foreground appears to be Japanese. Japanese workers were commonly used in the shellfish industry until their internment during World War II. (Courtesy of Taylor United, Inc.)

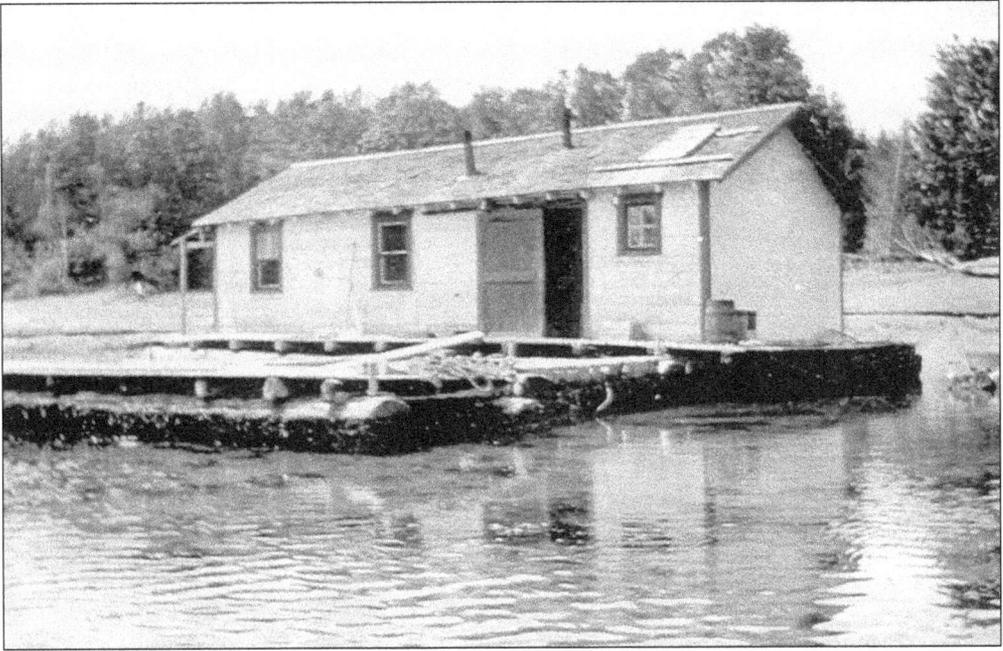

A float house on Jeremiah Lynch's oyster beds was used to shuck the oysters and sort them by sizes and grades for shipment. In the early 1900s, some families lived in these houses year-round. During World War II, the oyster business of Frank and Marguerite (Lynch) Bishop closed, as there were no Japanese workers available. (Courtesy of Frank Bishop.)

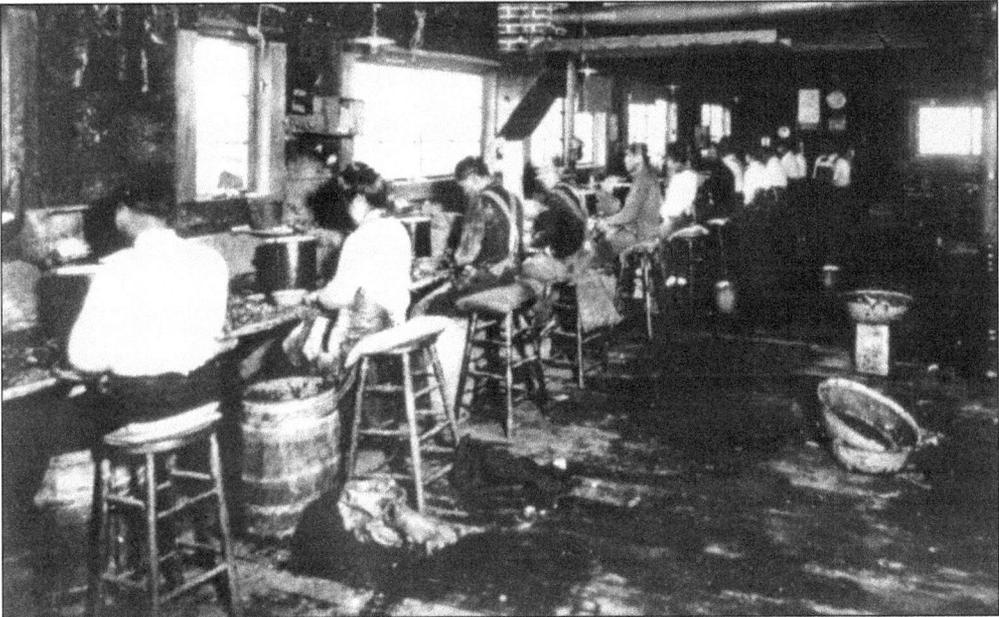

An early oyster shucking operation in Olympia, pictured around 1900, processed oysters for canning and delivery fresh to markets in Tacoma and Seattle. Many oysters from the Shelton area found their way to this table. In an article from the *Mason County Journal* of March 7, 1902, S. K. Taylor reported that oysters were selling around $4.25 per sack, and the market was good. (Courtesy of Taylor United, Inc.)

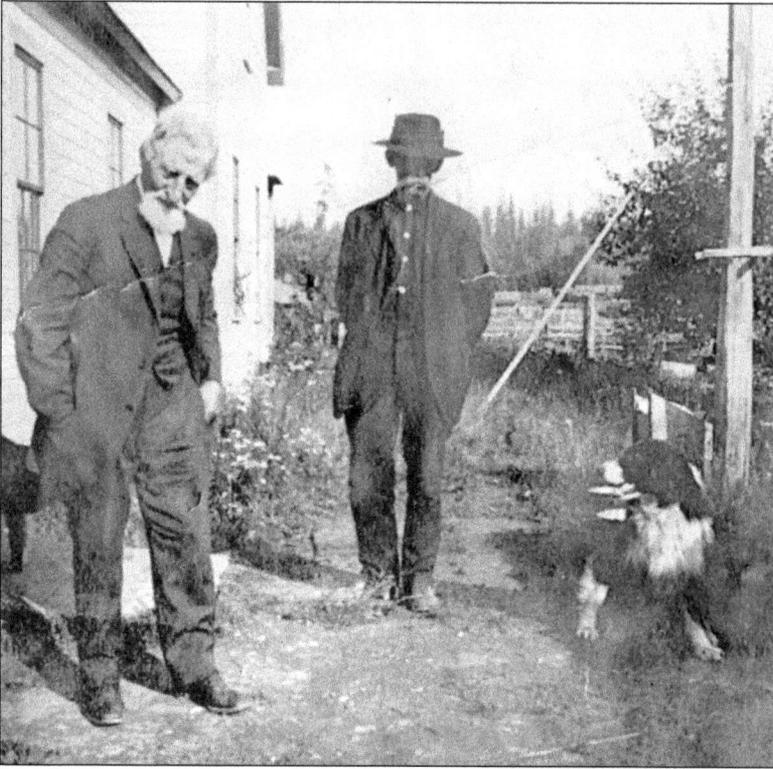

In this picture from 1910, Jeremiah and Dan Lynch stand outside the house on their farm. The two farmed the land and the beaches on the claim that Jeremiah bought from William Walter in 1883. Later Dan Lynch, Jeremiah Lynch's grandson, inherited the land, but his sister, Marguerite (Lynch) Bishop, sued him and received half the property. (Courtesy of Frank Bishop.)

This man is thought to be Jeremiah Lynch standing in his clam beds in 1920. The little Olympia oyster was prolific on Little Skookum beaches, but no less prolific were littleneck clams and geoducks, which were also harvested and sold. Oysters and clams were removed from the beach in the shells, requiring new shellfish to be seeded back on the beach. (Courtesy of Frank Bishop.)

Map of
J. M. LYNCH'S OYSTER CLAIM.

Scale 3chs = 1 inch. TWP19N.R.3W. W.M.W⁵ L.L.Hunter Surveyor.

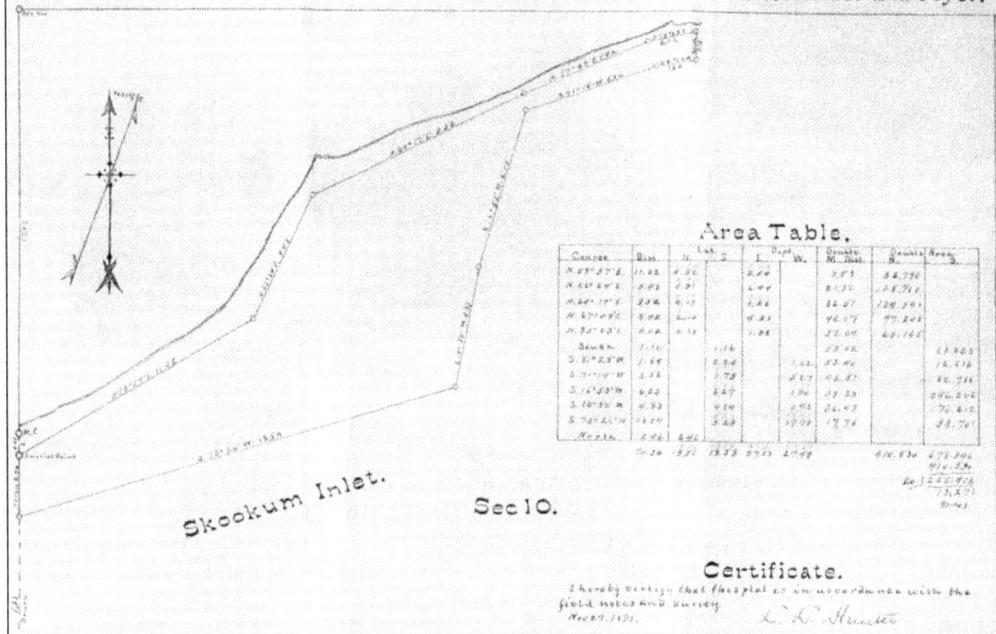

Area Table.

Skookum Inlet.

Sec 10.

Certificate.

This copy of the survey certificate for Jeremiah Lynch's tide lands to establish title is dated November 27, 1895. It was common practice for farmers owning land along the shoreline to also claim the beach in front of their property for shellfish production. Interestingly, it is reported that by 1887 much of the Upper Sound oyster beds had been depleted. (Courtesy of Frank Bishop.)

Jeremiah Lynch claimed the water flowing from Lynch Creek across his property for irrigation purposes. A use claim was allowed when a person had continually and with knowledge of others used water for a minimum of 10 years. This 1907 certificate gives legal grounds to the claimant if deemed necessary later. (Courtesy of Frank Bishop.)

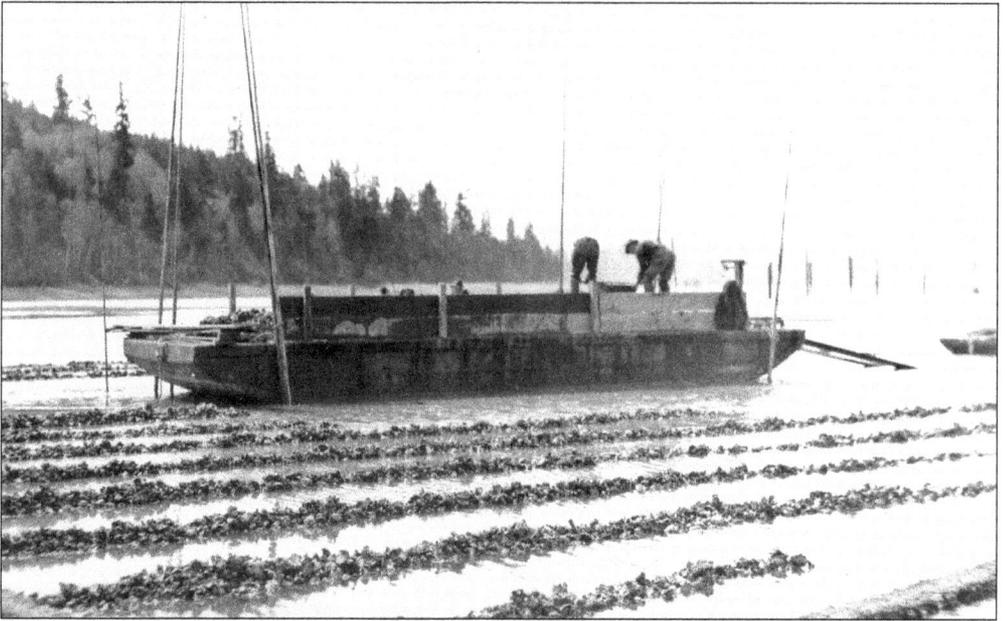

Two unidentified men work on an oyster barge at low tide around 1920. The oyster beds were continually reseeded from oysters taken from the narrower channels of Big Skookum, North Bay, and Mud Bay, keeping the industry viable for many years. In 1902, there were a dozen oystermen, including S. K. Taylor, J. A. Gale, and A. J. Smith, who formed the Puget Sound Oyster Association to reseed depleted beaches. (Courtesy of Taylor United, Inc.)

The *Lark*, pictured around 1920, waits to be loaded with sacks of oysters to take to Olympia. An unidentified man in the wheelhouse is likely the skipper of this boat. Where there was a deep-water dock, like at New Kamilche, sacks of oysters could be loaded directly onto the large stern-wheelers. However, where no dock was available, smaller boats were used for transport. (Courtesy of Taylor United, Inc.)

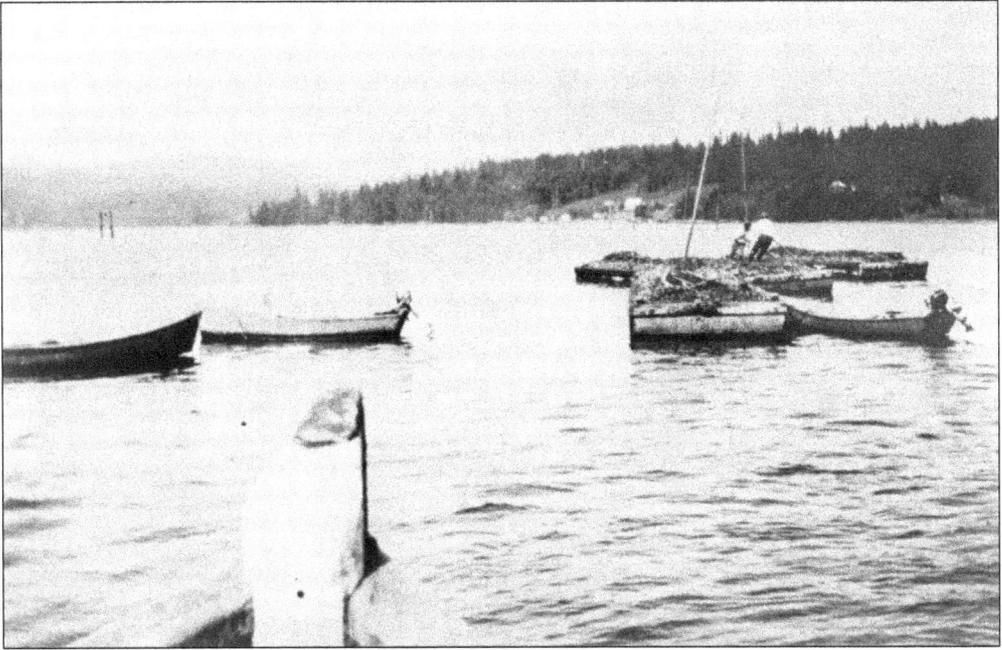

Small boats hover around an oyster barge like chicks around a hen. In this 1930s picture, note the outboard motors on some of the skiffs. No longer did an oyster worker have to row to and from the barge. Barges could be placed anywhere there was water, so that no dock had to be built. (Courtesy of Taylor United, Inc.)

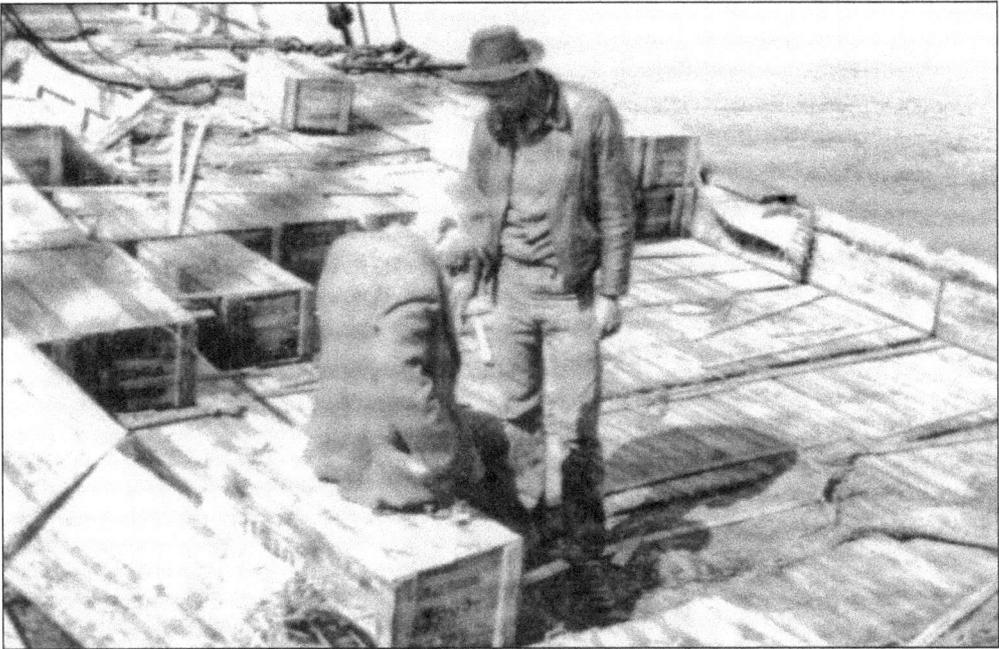

When the oyster beds were depleted and all the viable seed oysters had been taken from other areas on the sound, seed oysters were brought in to revitalize the beds. This c. 1920 picture shows sacks of Japanese oysters arriving for just that purpose. The Manila clams hitched a ride with the oysters and became part of the habitat. (Courtesy of Taylor United, Inc.)

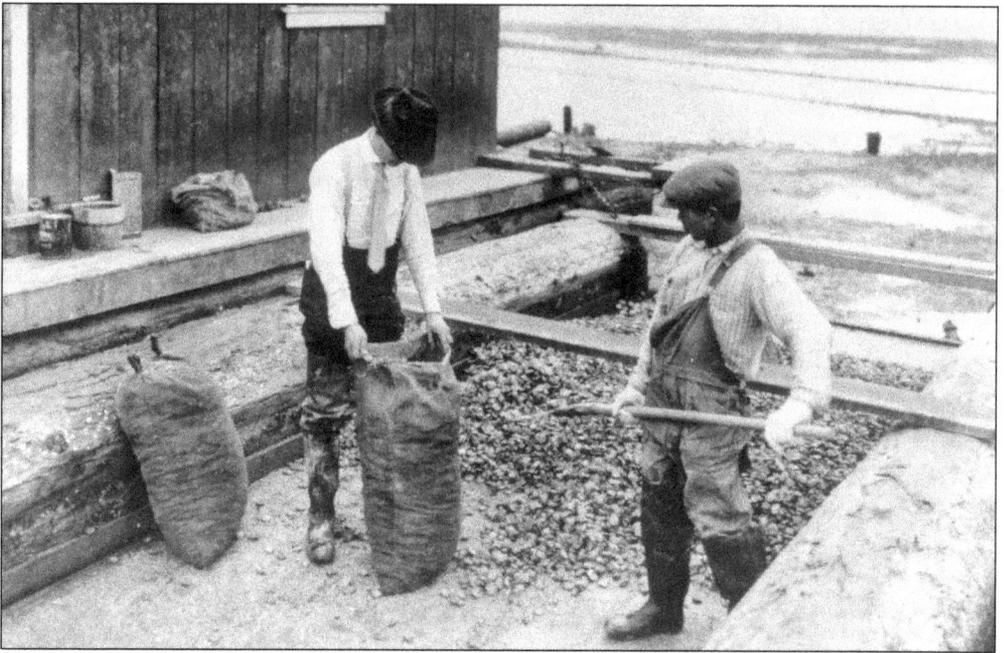

Two unidentified men load sacks with oysters for shipment around 1930. Burlap sacks called gunnysacks were used. These could retain moisture while allowing air to circulate, and the shellfish would not suffocate. Oysters could arrive to sell at a market still alive and fresh. (Courtesy of Taylor United, Inc.)

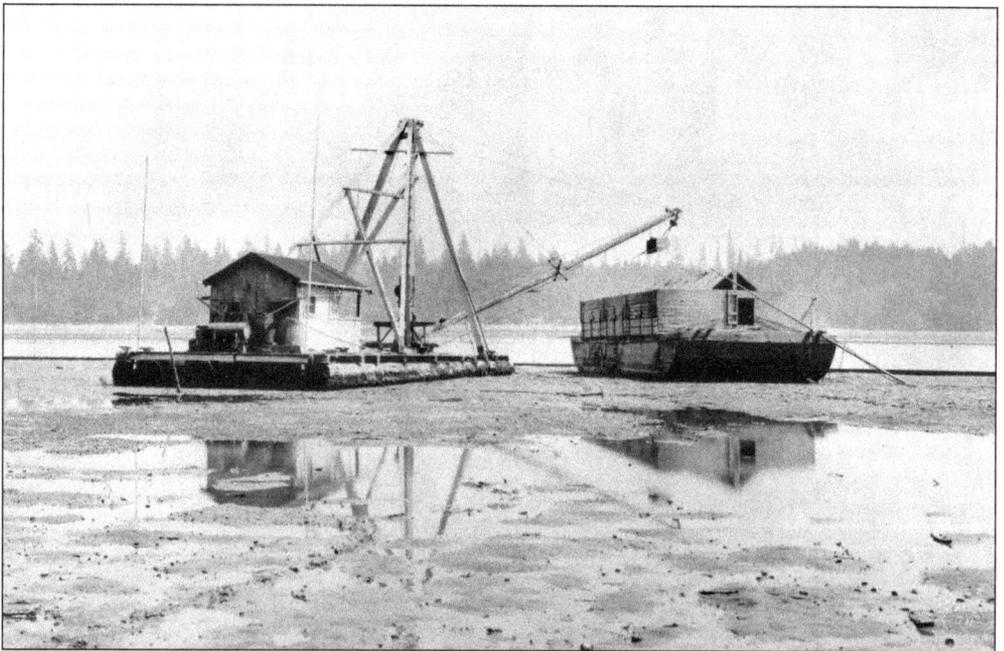

Taking advantage of a low tide in this 1930s photograph, work can continue with the equipment parked on the beach while the tide is out. Some things are more easily done while the float house and barge are grounded, such as moving sacks of clams and oysters with a crane. (Courtesy of Taylor United, Inc.)

Marguerite Lynch Bishop is pictured around 1914, approximately 20 years old, before her marriage. She and Frank W. Bishop retained interest in the land of her grandfather, Jeremiah Lynch. Their son and daughter-in-law created Little Skookum Shellfish Growers Association and live on the original Walter claim. (Courtesy of Frank Bishop.)

The *Oyster-man*, as this boat was named, plied the waters between Shelton, Little Skookum, and Olympia during the early 20th century. It was equipped to haul sacks of oysters from barge to dock or barge to market in the often-swift current and shallow waters of the oyster beds. (Courtesy of Taylor United, Inc.)

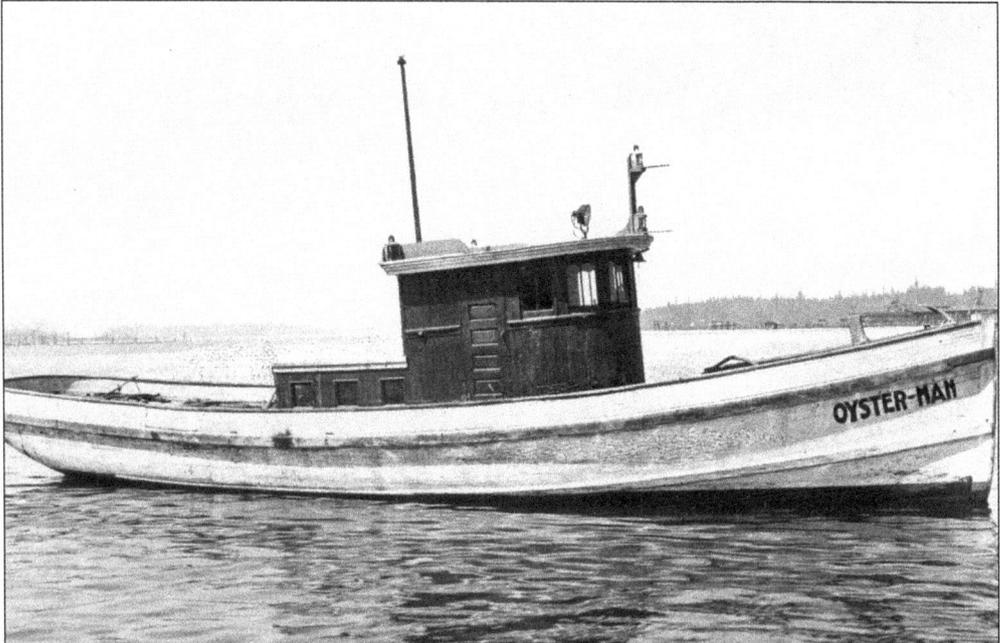

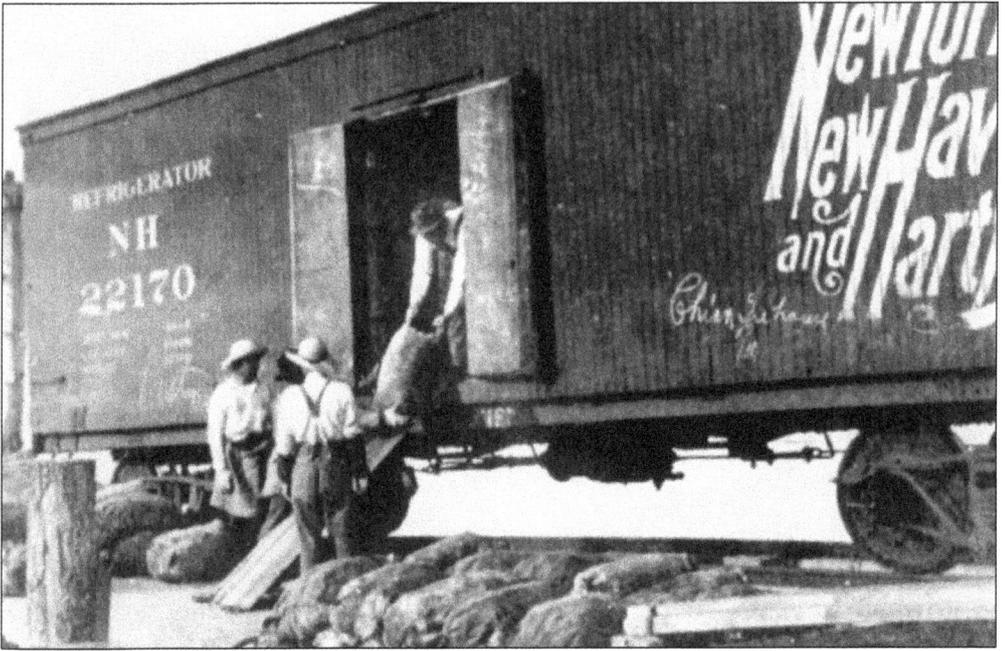

The Japanese oysters were not the only imports to the beaches along Puget Sound. The Chesapeake Bay oyster and oysters from Cape Cod in Massachusetts were also imported to replenish the beaches of the Upper Sound. Here a shipment of seed oysters is unloaded around 1920. (Courtesy of Taylor United, Inc.)

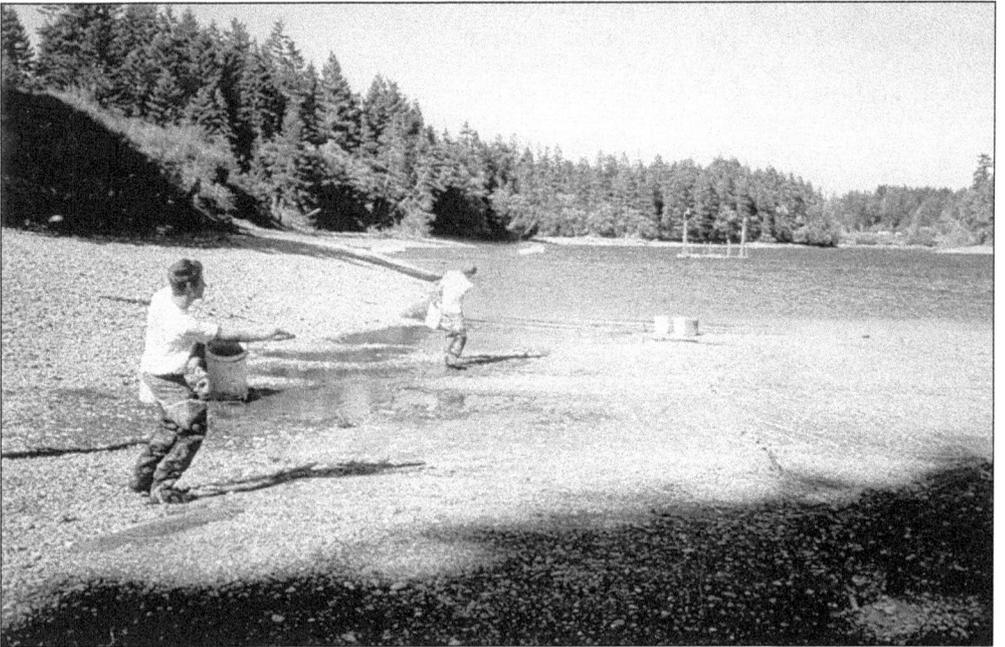

Clams are another shellfish that need to be seeded onto the beach. In 1980, two unidentified men work on Little Skookum to make sure there will be another crop of clams to harvest. The dike systems were mostly abandoned in the 1930s, as silt was retained by the dikes and did not allow for the natural flow of water to carry away waste. (Courtesy of Frank Bishop.)

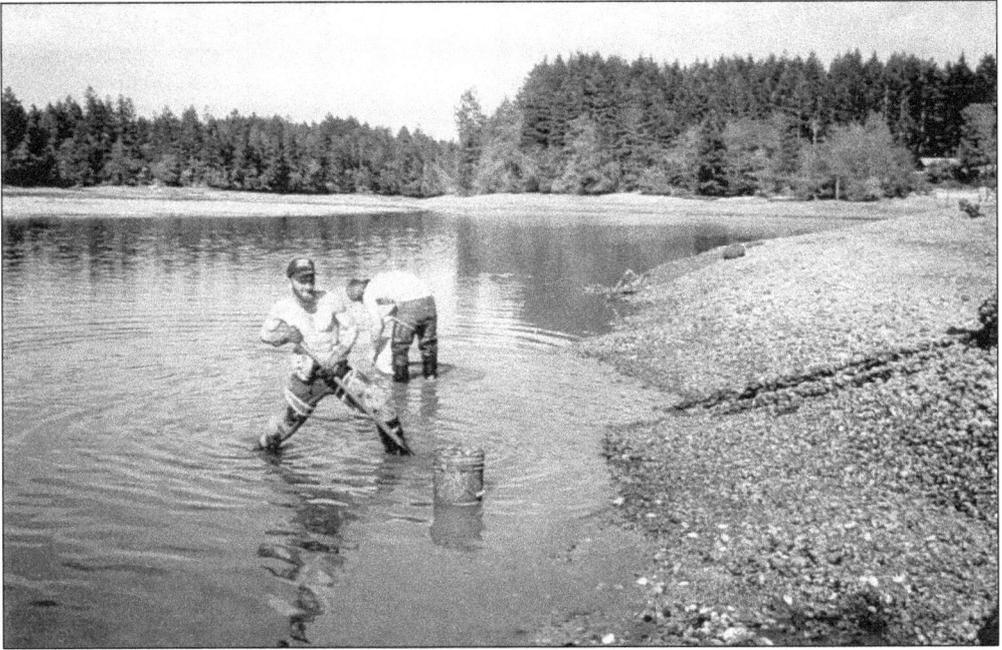

Two unidentified men dig clams at Little Skookum in 1980. This gravelly beach is a perfect growing spot but makes the digging tough. Note the possible remnants of a dike on the right of the picture. "When the tide is out, the table is set" was a truism often heard by families living along the shoreline. (Courtesy of Frank Bishop.)

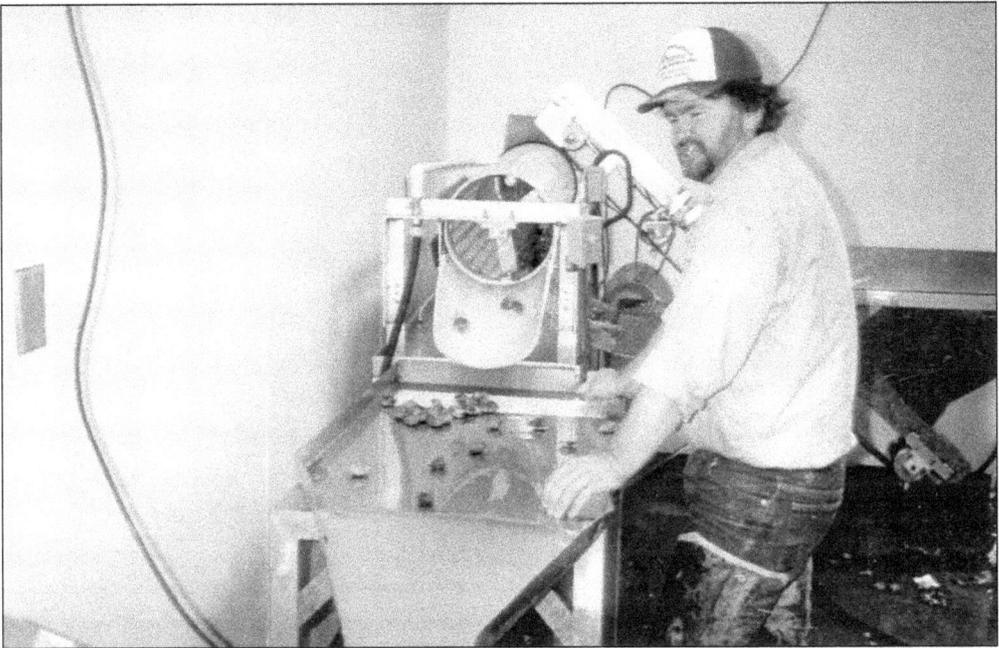

Clams need to be washed and graded before they can be shipped off to market. Carl Barringer, foreman for Little Skookum Shellfish Growers, takes care to wash a few clams at a time so as not break the shells. From here, the clams are wrapped into packages or loaded into buckets to ship to market. (Courtesy of Frank Bishop.)

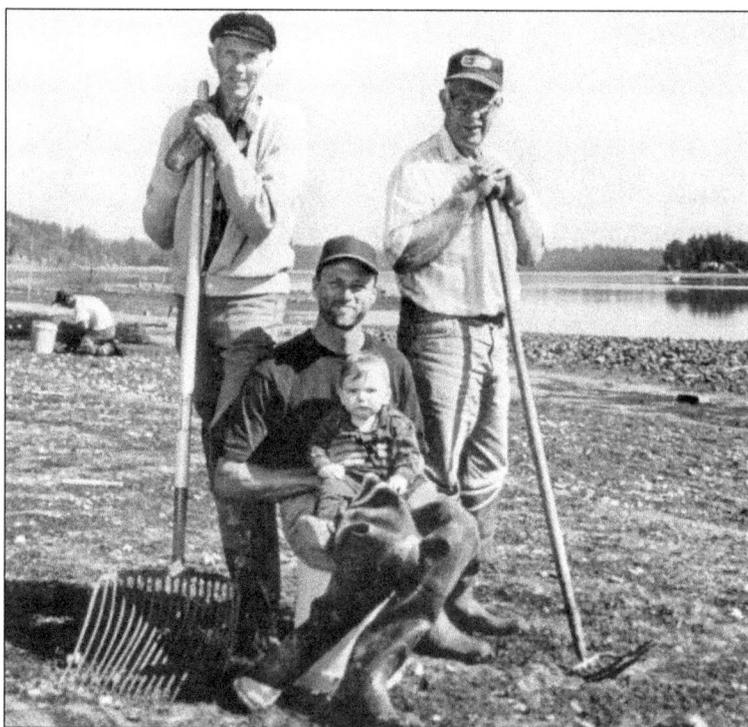

This 1997 photograph shows two shellfish tycoons of the Upper Sound, sometimes rivals and competitive but always friends, whose mailing addresses are in Shelton. Their relationship is reminiscent of the early timber barons. They are, from left to right, an unidentified worker, Frank Bishop, Brett Bishop, Jeremiah Bishop on his father's lap, and Justin Taylor. (Courtesy of Frank Bishop.)

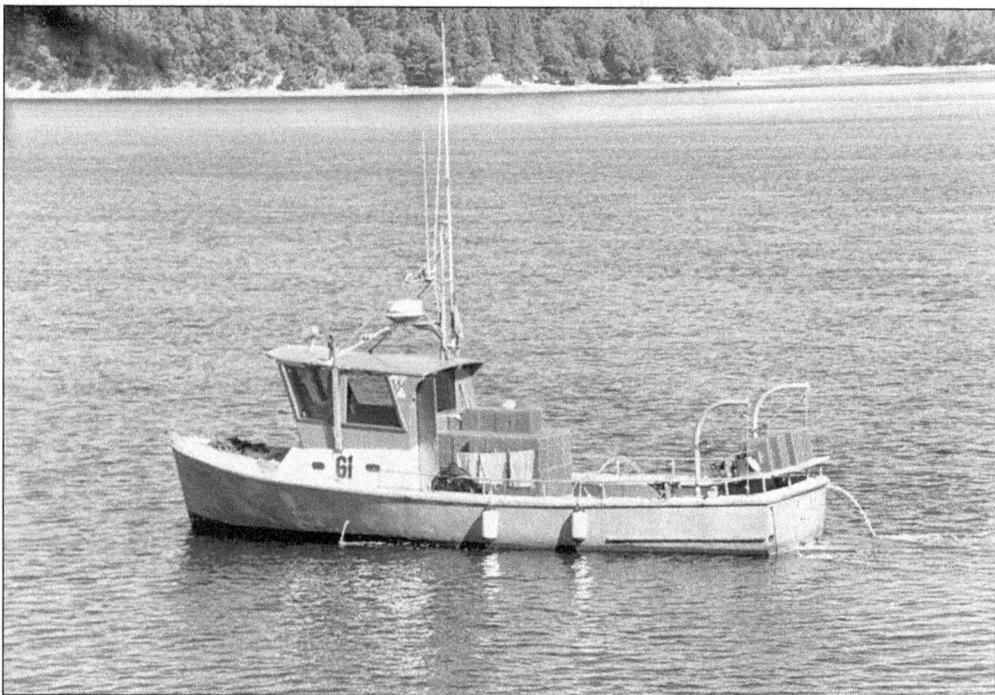

In 1980, this boat began mooring off the boat launch ramp at the end of Lynch Road. Wet suit divers are harvesting geoducks in the middle of the channel between Hope Island and Arcadia Point. Soon this shellfish was added to others turning a profit from foreign markets, maintaining the future of the shellfish industry. (Courtesy of Margret Kingrey.)

Eight

THE EXCEPTIONAL FORESTERS

The original
members of the
Exceptional
Foresters are
pictured in 1982 in
front of their new
home in Shelton.
The Exceptional
Foresters began
in 1957 with
the premise
that mentally
handicapped men
could learn to work
and participate
in community
activities. They
are, from left to
right, (first row)
Norman Dillon,
Bobby Kunkle,
Ken Kimbel,
Bob Kimbel, and
Randy Chapman;
(second row) Ed
Kroh. (Courtesy
of Exceptional
Foresters, Inc.)

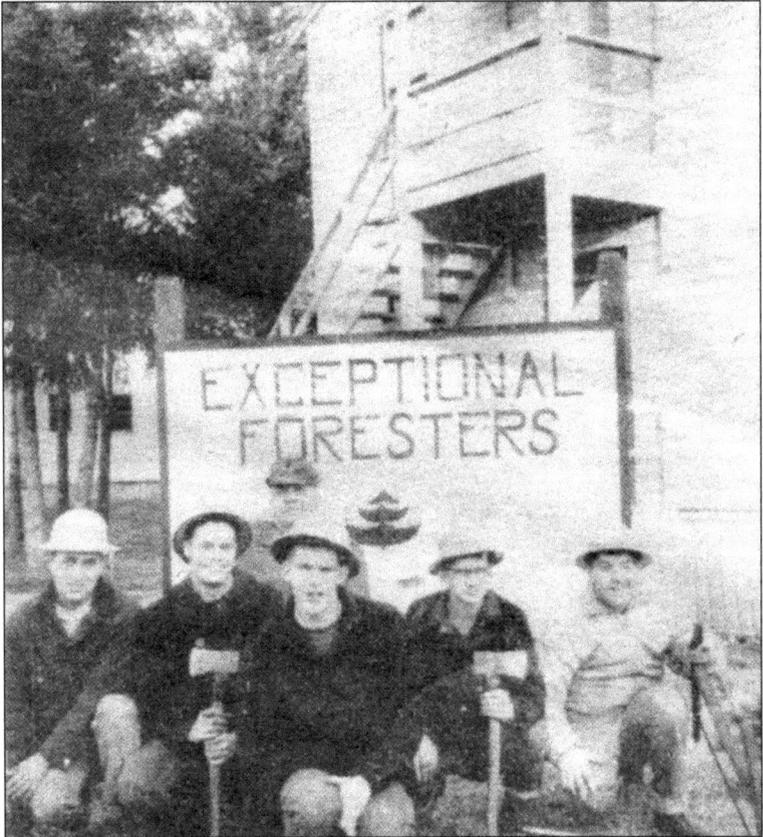

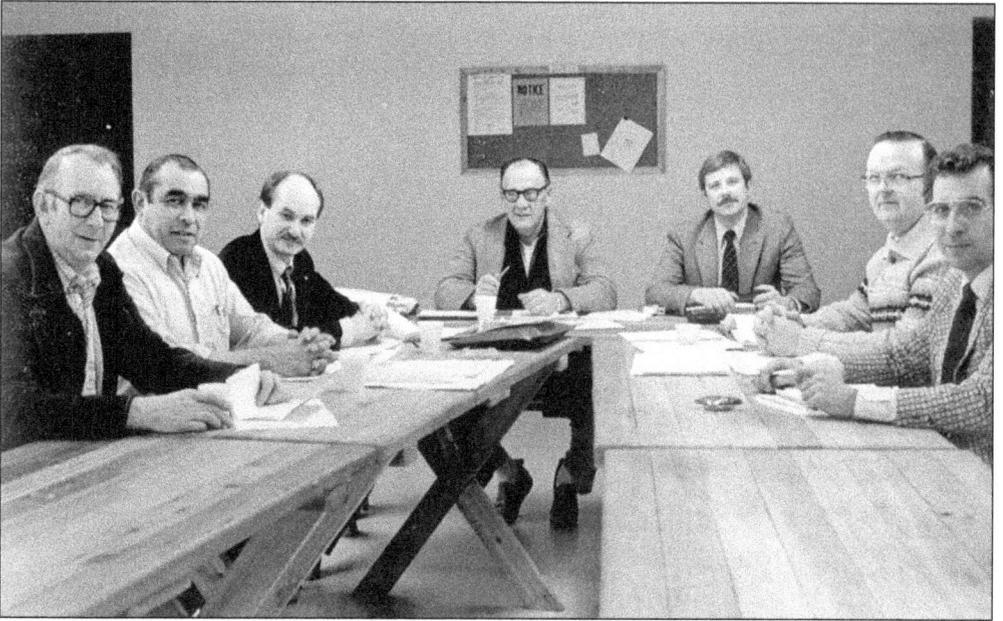

After Bob Kimbel's children finished school, he was told there were no programs for handicapped adults, so Bob Kimbel started a unique program of his own. The Board of Directors for the Exceptional Foresters, Inc., meeting here in 1970 are, left to right, Ken Breidenstein, John Marron, unidentified, Bob Kimbel, unidentified, Ray Smith, and unidentified. (Courtesy of Exceptional Foresters, Inc.)

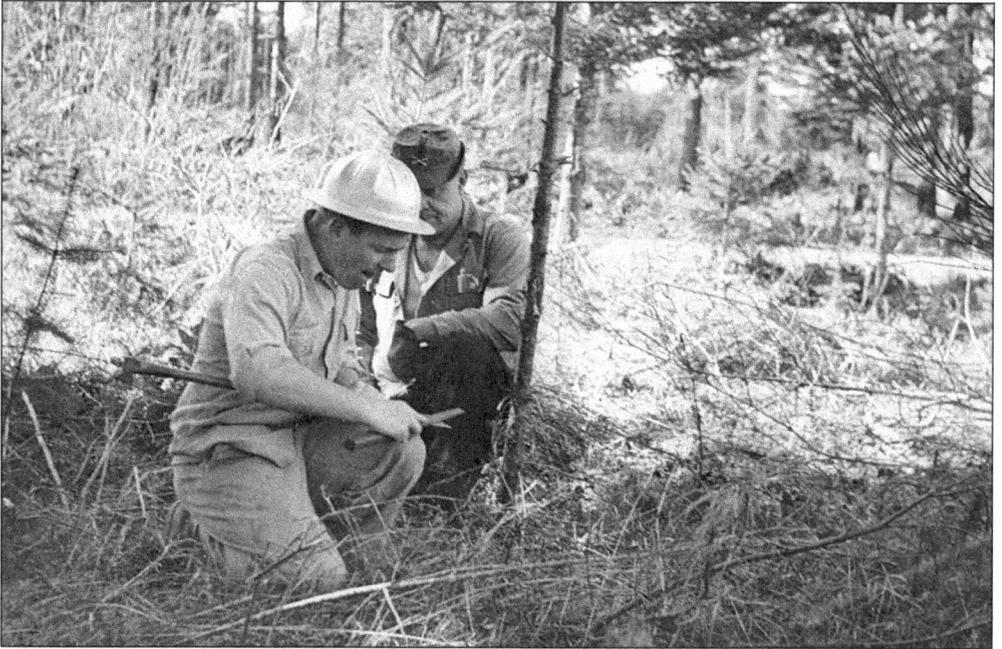

In the late 1950s, when this program was developed, many institutions for the mentally handicapped were being closed. No one expected that handicapped people would learn work and leisure skills or adapt to living in the community. Here an unidentified man works to sharpen a saw with instructor John Schreiber around 1960. (Courtesy of Exceptional Foresters, Inc.)

Driving a bulldozer was an important skill to learn and not beyond this man's capability. The land around Sanderson Field, where the foresters lived, was turned into a productive Christmas tree business pointing the organization toward a financial base beyond donations. (Courtesy of Exceptional Foresters, Inc.)

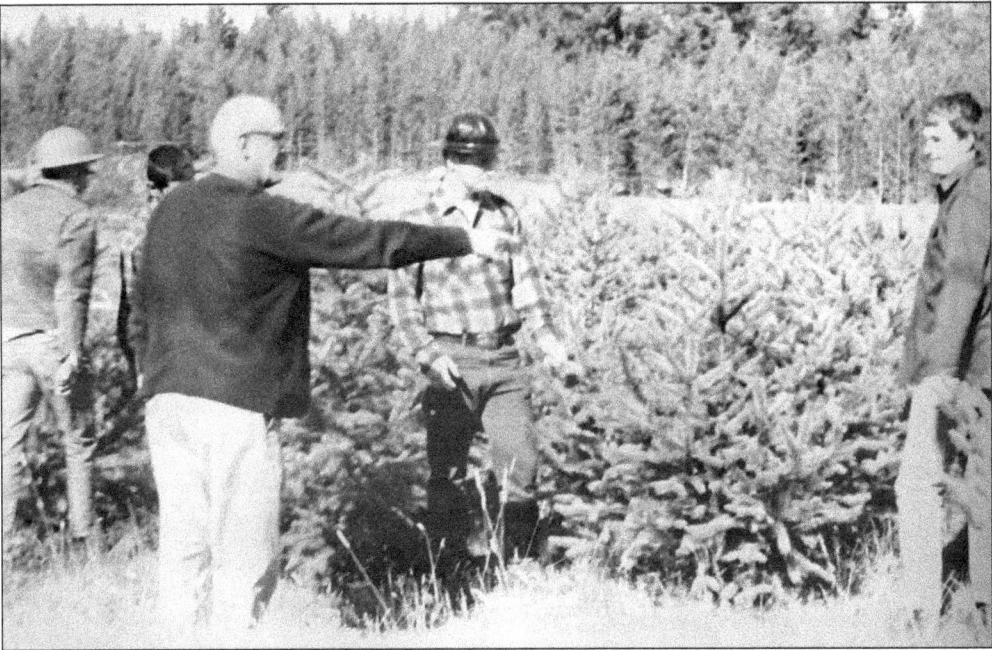

Under the direction of Ed Kroh, land was logged of second-growth timber and then cleared to plant Christmas trees. Additionally, the men in the program learned janitorial skills, first by sweeping the city streets and then working in crews to clean businesses in town. Here John Schreiber, the third director, teaches trainees about Christmas trees. (Courtesy of Exceptional Foresters, Inc.)

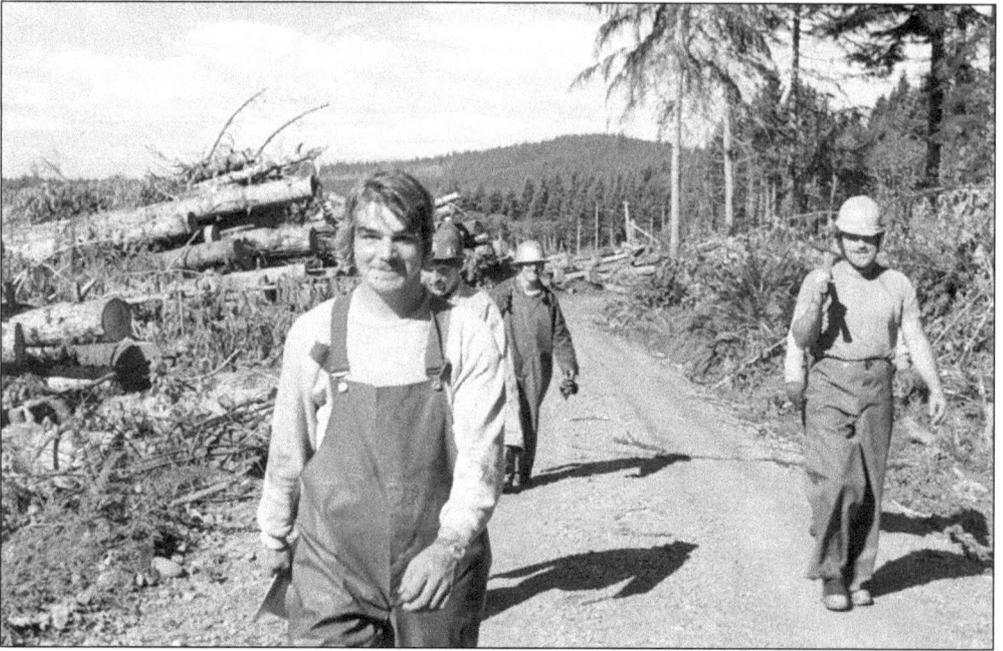

Ending a day's work in the woods around 1966, the expression on this man's face says it all—meaningful work is its own reward and provides dignity to everyone. The Exceptional Foresters heading home are, from left to right, Rick Moore, Bob Kimbel, Clell Oldaker, and unidentified. (Courtesy of Exceptional Foresters, Inc.)

In 1966, several men from Olympia were added to the program, and the Olympia Brewery became a sponsor as well. A choir was formed that entertained at several functions around the community. Here they are entertaining in 1970 at the dedication of their new living quarters, Schreiber Hall. (Courtesy of Exceptional Foresters, Inc.)

116

Noting that women were being underserved, the Exceptional Foresters decided to develop a program for women. They purchased a facility on the south side of Shelton that had been a former nursing home. Receiving the keys in this photograph are, from left to right, Betty and Lester Krueger, Bob Kimbel, Mrs. Richard Wonner, and John Schreiber. (Courtesy of Exceptional Foresters, Inc.)

Once the new facility was opened, activities of daily living were incorporated into the program. This was especially important for women who had been previously institutionalized, as they had never learned to cook for themselves. Sheryl Johnson is learning to prepare a meal for herself and some new friends. (Courtesy of Exceptional Foresters, Inc.)

In the large activities room, there was space to set up a quilting frame. A craft shop was opened to sell items made by both the women and men to the larger community. Here several unidentified women prepare to work on a quilt around 1975. (Courtesy of Exceptional Foresters, Inc.)

Other needle crafts were taken up by the group. These items could be entered into competition at the fair. Here a hooked wall hanging is displayed. The design is interesting in that it incorporates motifs from the local Native American culture. Several local Native Americans were participants of the foresters. (Courtesy of Exceptional Foresters, Inc.)

Another popular design was a more traditional Native American style of wall hanging. These crafts were seen not so much as recreational or leisure activities as work. Foresters were expected to show up to work at these crafts just the same as those who went out into the woods. (Courtesy of Exceptional Foresters, Inc.)

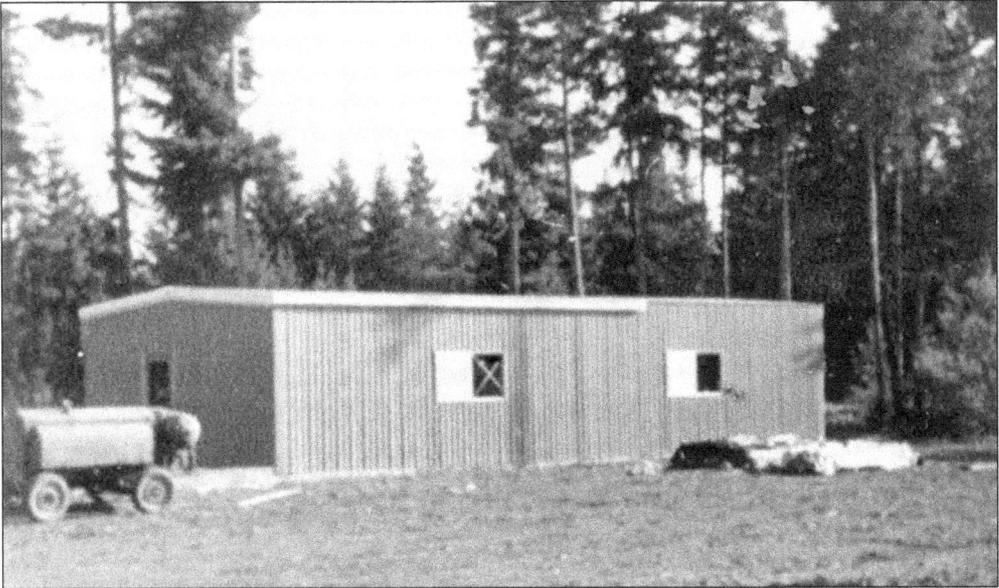

This building was used by the Exceptional Foresters for several purposes around 1966. The building housed many woodworking tools, which most clients learned to operate. They built wooden furniture, made wooden pallets, and later developed a recycling program here. These programs helped support the Exceptional Foresters program, which tried to be at least 25 percent self-supporting. (Courtesy of Exceptional Foresters, Inc.)

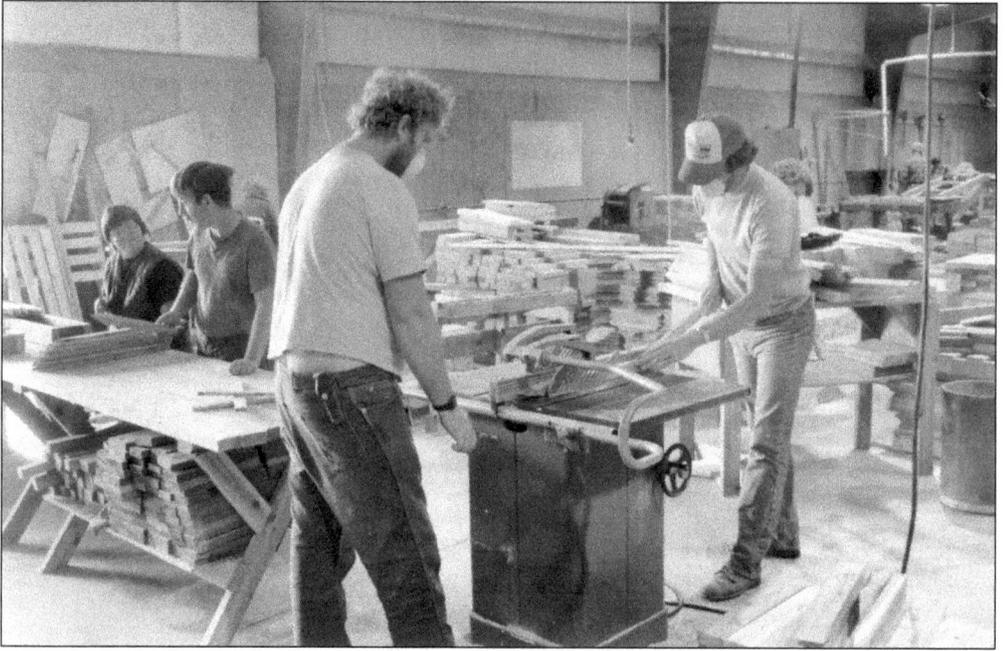

In this photograph from 1970, Mort Jahnsen (in the hat) learns to safely use a saw. He uses this skill in his work building furniture and pallets. Others in the picture are unidentified. Note that the men at the saw are wearing protective masks but do not appear to be wearing protective goggles. (Courtesy of Exceptional Foresters, Inc.)

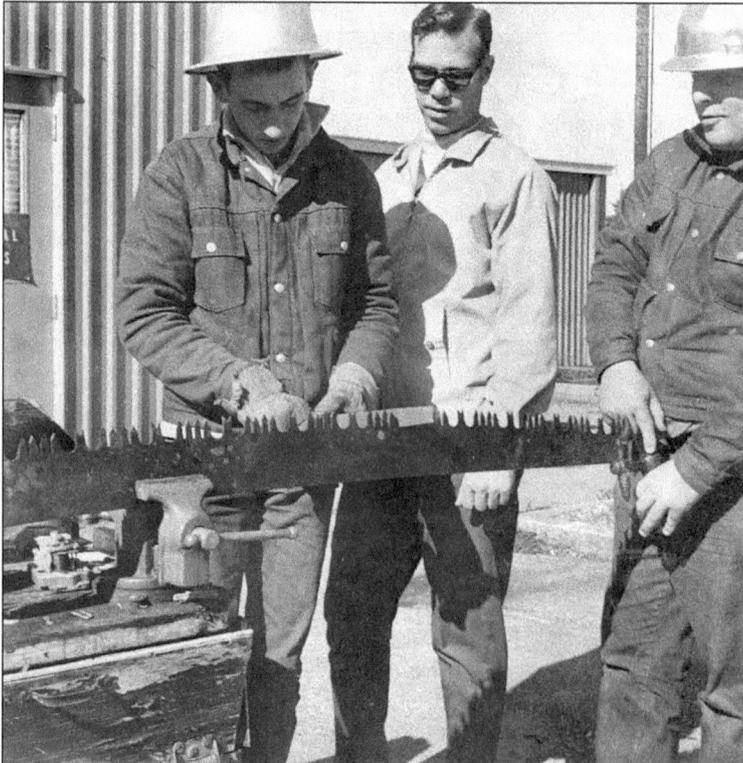

Three unidentified clients work on sharpening a crosscut saw around 1965. In striving to be part of the community, many skills were learned that were common to Shelton and the surrounding timber industry. Learning these skills opened the door to work but also gave the men a means of socializing with others in town who did the same kind of work. (Courtesy of Exceptional Foresters, Inc.)

Mary Engebretson works on the recycling line. This was another way that the programs were becoming more self-sufficient and moving away from federal and state funding sources. Recycling was a bigger business in the Pacific Northwest than other areas of the country in the 1960s and 1970s. Another business to recycle metals from Boeing planes opened operations in Shelton as well. (Courtesy of Exceptional Foresters, Inc.)

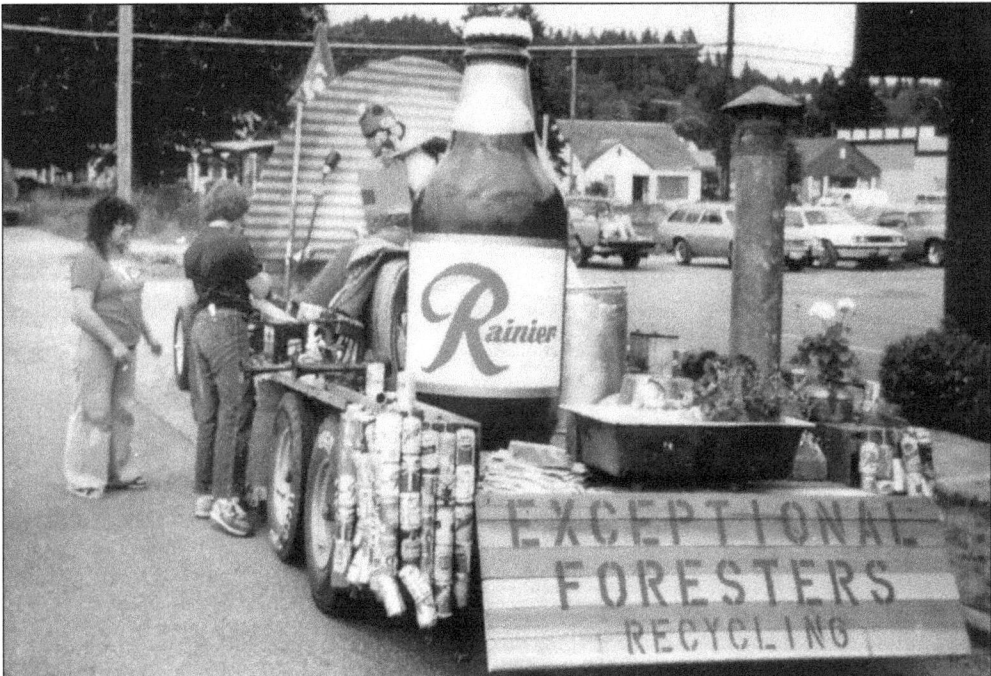

The Exceptional Foresters members participated in community events. Here they ready their float for the Forest Festival parade in 1973. The theme, of course, is recycling, and it is right up their alley. The clients in the picture are unidentified. (Courtesy of Exceptional Foresters, Inc.)

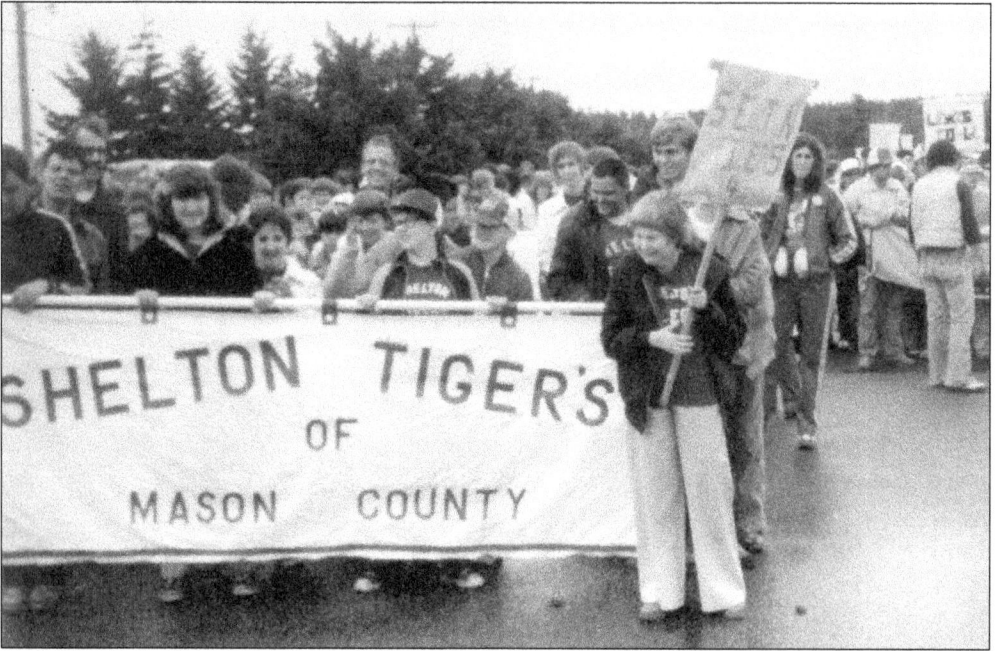

The date on this photograph is April 1964, and members of the Exceptional Foresters hold a banner for the Shelton Tigers track team. Recreational activities—picnics, fishing, and dance—were all part of a well-rounded program and a fully developed life for a mentally handicapped person. (Courtesy of Exceptional Foresters, Inc.)

Part of the Shelton Tigers track team, members of the Exceptional Foresters compete in the Special Olympics. In 1971, six men from the group were sent to the Region I games. Although none won their events, it is reported that they still talk fondly about the experience. (Courtesy of Exceptional Foresters, Inc.)

John Schreiber had been the director of the Exceptional Foresters for many years. With the program growing, a new facility was needed, and in this picture at the dedication he is honored with his name on the old state patrol building. At the dedication in 1969 are, from left to right, Bob Kimbel, John Schreiber, Bob Lettbetter, and Representative Paul Connor. (Courtesy of Exceptional Foresters, Inc.)

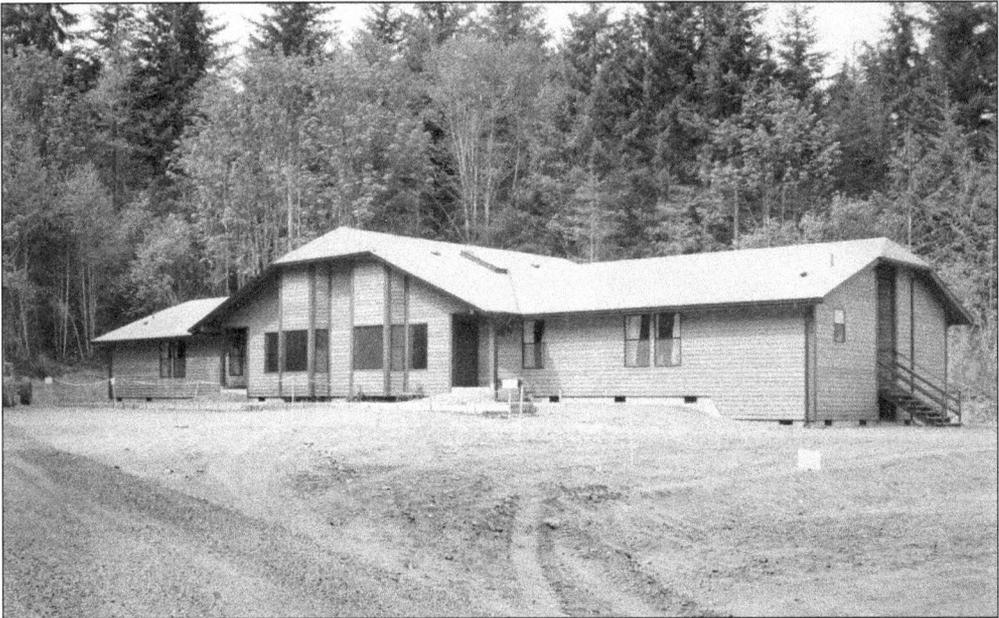

New living quarters were acquired for the growing number of men in the program. This building was acquired from the former state patrol academy and renovated to fit the needs of the Exceptional Foresters. With a large dining area, kitchen, and several classrooms, the male clients could eat together and cook together as well. (Courtesy of Exceptional Foresters, Inc.)

Here David Briedenback fixes a bit of broccoli for the group for supper. The homes were often given deer, bear, and produce from local gardeners who grew more than enough for family and friends. These gifts relieved the operating budget at unexpected times, and the clients ate well. (Courtesy of Exceptional Foresters, Inc.)

Cliff Harris is pictured mopping the floor. Part of the activities of daily living is keeping the place clean. These skills can often be transferred to job skills as well, as in this case, mopping a floor can be used in janitorial work outside the client's living quarters. This can be another step to self-reliance. (Courtesy of Exceptional Foresters, Inc.)

The next development was the acquisition of an adult family home where those who had learned sufficient skills could live with little supervision. Some of the clients had learned enough in the way of independence that only weekly assistance was necessary. Some of the men who had been in the program for years were able to get themselves up, off to work, and fix their own meals, but they needed some assistance with grocery shopping and staying within a budget. Some needed to be reminded to clean the bathroom. Those things did not require a live-in house attendant. With the purchase of this house located downtown within walking distance of most businesses, the adult family home was born. In 1975, the organization bought Dr. Collier's clinic building and leased some of the space to the county and other parts to doctors. This put the Exceptional Foresters on a more solid financial basis. Programs continue to expand, and some of the first clients have retired from their jobs, as they are now over 65 years old. (Courtesy of Exceptional Foresters, Inc.)

BIBLIOGRAPHY

Bishop, F. *Bishop Family Pictorial Biography.* Rochester, WA: Gorham Printing, 2006.

————. *History of Little Skookum Shellfish Growers Tideland.* Rochester, WA: Gorham Printing, 2005.

Chase, C. G. *The Oyster was Our World: Life on Oyster Bay 1898 to 1914.* Seattle, WA: The Shorey Book Store, 1976.

Cowling, J. *Farming Timber: The Influences of Public Law 273 and the Cutting of the Olympic National Forest.* Lacey, WA: Unpublished thesis, St. Martin's University, 2008.

Findlay, J. C. and Paterson, R. *Mosquito Fleet of South Puget Sound.* Charleston, SC: Arcadia Publishing, 2008.

Fredson, M. *Beast-Man: A Historical Account of John Tornow.* Shelton, WA: Mason County Historical Society, 2002.

————. *Log Towns.* West Olympia, WA: Minuteman Press, 1993.

————. *Oakland to Shelton: The Sawdust Trail.* Shelton, WA: Mason County Historical Society, 1976.

Holbrook, S. *Green Commonwealth.* Shelton, WA: Simpson Logging Company, 1945.

Thomas, B. B. and F. Perry. *Shelton: The First Century Plus Ten.* Shelton, WA: Mason County Historical Society, 1996.

Wilkinson, C. *Messages from Frank's Landing: A Story of Salmon, Treaties, and the Indian Way.* Seattle, WA: University of Washington Press, 2005.

About the Mason County Historical Society

The Mason County Historical Society (MCHS) plays a prominent role in the life of Shelton and Mason County. The staff is continually busy verifying the historical facts of the area, answering questions of drop-in visitors to the museum or callers, and providing information to the *Mason County Journal* or other organizations that ask. Besides these daily activities, the museum participates in local events such as the Forest Festival, the Mason County Fair, the antique car show, the Oyster Fest, and their own holiday open house with cookie exchange.

Interest in the history of Mason County runs deep. Grant C. Angle, originator of the *Mason County Journal*, began the practice of preserving the stories of early pioneer families. He, along with photographer W. S. Heckman, documented occurrences of the area on a regular basis. A formal organization focusing on the history of Mason County began in the early 1950s, when Leo Livingston gathered a group of like-minded citizens in Belfare on Hood Canal. Irene Davis provided space in her home for pictures and other files. In November 1958, the Shelton Chapter was organized. Both chapters operated independently until 1975, when they merged to begin preparations for the U.S. bicentennial celebration. The two groups merged their respective archives and memberships. A museum building on the Mason County Fairgrounds was opened for the bicentennial celebration in 1976 and continues to operate for the Mason County Fair and other celebrations. In 1990, with the purchase of the former Shelton City Hall and Library building on Fourth Street and Railroad Avenue, the historical society acquired a permanent home for the archives and an exhibit area accessible to townspeople and tourists alike.

Besides participating in the local events of Shelton and the county, MCHS provides monthly educational meetings on a variety of topics, conducts walking tours of Shelton during the summer months, prints a monthly newsletter, and prints books of local interest that cannot be found anywhere else. These books are available at the museum at 427 West Railroad Avenue, Shelton, Washington. The MCHS mailing address is: P.O. Box 1366, Shelton, WA, 98584. Its phone number is (360) 426-1020. Hours of operation are Tuesday through Friday, 11:00 a.m. to 5:00 p.m., and Saturday, 11:00 a.m. to 4:00 p.m. Currently there is no Web site; however, that is in the process of being remedied. Donations and visitors are always welcome.

Visit us at
arcadiapublishing.com